IMAGES
of America

CENTRAL AMERICANS
IN LOS ANGELES

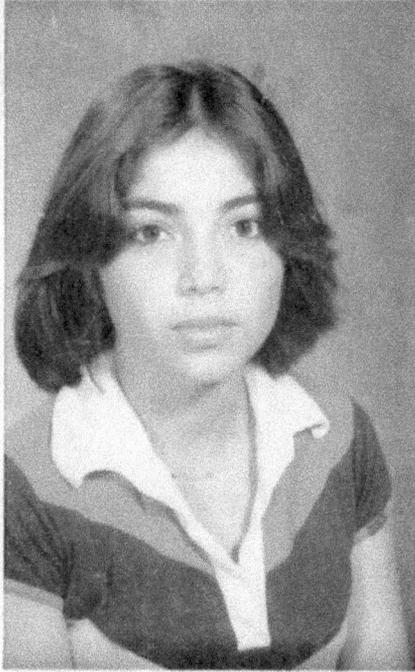

JOHN ADAMS

JUNIOR HIGH SCHOOL
LOS ANGELES, CALIF.

1977-1978

STUDENT CARD

Rosmary Segura
NAME

C 20

HOME ROOM GRADE

The author's mother's dream was to live in the United States, and so she chose English names for her children. The author was named Rosmeri (Rose Mary), and the older siblings were named Herbert and Gladys. She thought that with those names it would be easier for her children to integrate into this society. This school identification card was taken while the author was attending John Adams Junior High School (during her first visit to Los Angeles in 1977). (Courtesy of the Segura collection.)

ON THE COVER: This image was photographed by Octavio Gutierrez in 1953. This Salvadoran family included, from left to right, (first row) Roberto Gutierrez, unidentified, Luz ?, Mauricio Rodriguez, and Gloria Rodriguez; (second row) Miguel Angel Gutierrez, two unidentified people, Lillian Rodriguez, and Teresa Gutierrez. (Courtesy of Gloria Gutierrez.)

IMAGES
of America

CENTRAL AMERICANS IN LOS ANGELES

Rosamaría Segura

ARCADIA
PUBLISHING

Published by Arcadia Publishing
Charleston SC, Chicago IL, Portsmouth NH, San Francisco CA

Library of Congress Control Number: 2009931119

For all general information contact Arcadia Publishing at:
Telephone 843-853-2070
Fax 843-853-0044
E-mail sales@arcadiapublishing.com
For customer service and orders:
Toll-Free 1-888-313-2665

Visit us on the Internet at www.arcadiapublishing.com

For my children Camilo, Dinorah, Maureen, and Roberto

CONTENTS

FOREWORD

With this beautiful volume of photographs and carefully researched text, Rosamaría Segura provides us with a compelling and singularly important contribution to our understanding of Central American life in Los Angeles. Weaving together the unique stories and images of immigrants from across Central America and their families with the broader history of Central American immigration and social movements in Los Angeles, Segura succeeds in highlighting the intersections of the personal and political, the local and the global, the mundane and the profound. She helps fill a gap in the documentation on Central American life in the United States. Not surprisingly, Segura is herself an immigrant from El Salvador who experienced much of this history firsthand; she joins the ranks of Central American writers, photographers, artists, activists, and scholars who have struggled against the forces that would ignore, erase, and submerge the important story of Central American immigration to the United States.

While a picture can sometimes speak a thousand words, the descriptions accompanying these photographs provide a rich history of Central American life in Los Angeles and the struggles and triumphs of Central American immigrants and their contributions to life in the city. It would be difficult to understand the political, cultural, and social history of Los Angeles from the 1980s to today without learning about the contributions of Central Americans to local politics, social movements, labor organizing, economic development, art, and culture. The photographs and stories that appear in this book speak to the modern experience in American cities like Los Angeles and their deep connection to places far away like El Salvador, Belize, Honduras, Guatemala, Nicaragua, Costa Rica, and Panama, drawn together through the struggles and dreams of immigrants and their children.

—Beth Baker-Cristales
associate professor, Department of Anthropology; associate director,
Latin American Studies Program; California State University, Los Angeles

The Immigrants
by Alfredo Gonzalez y Aguilar

The immigrants are shadows that walk.
They are a sorrow wrapped in broken blankets moving in the darkness.
In the desert through every step they leave their suffering and
 laments, or a son abandoned buried along the path.
The immigrants walk alone. They carry the solitude on their shoulders.
What a pity for the illegal fellows!
Crossing the river, if they get to big cities they
 bear the face of the marginal people.
We know about the fear of walking on the streets selling fruit, ice
 creams, "pupusas," in spite of the implacable terror that assaults us.
What more can I do? I have to continue!
Tomorrow is very near, the sun is coming.
I cannot be tired, I have to follow a dream!
I bring hope and faith in my fingers.

ACKNOWLEDGMENTS

This collection of memories would have not been possible without the efforts of numerous individuals and organizations that have collected and safeguarded the images and stories of these Central American immigrants. I am indebted to all my friends who enthusiastically guided me and connected me with others. I am grateful to those, my new friends, who opened their homes to me, trusted me with their cherished memories, and dedicated time to this project.

I would like to thank the following people for sharing their stories and for their insight and guidance: Roberto Alfaro, Pedro Arias, Isabel Cardenas, Francisco Carias Méndez, Omar Corletto, Juan Carlos Cristales, Rony Figueroa, Mario Gee Lopez, Alfredo Gonzalez y Aguilar, Victor Grimaldo, Jose E. Gutierrez, Sandra Gutierrez, Sergio Lewis, Fred Lugo, Elio Martinez, Andres Montoya, Guillermo Palencia, Roland Palencia, Salvador Sanabria, Carmen Suazo, Teresa Tejada, Silvano Torres, Leoncio, Velasquez, Nestor Villatoro, and to all of those who shared their photographs to make this book possible.

I would also like to thank the first people that I sought for support, who embraced this idea, including Stephen Mulherin and Ester E. Hernandez, and especially those who were willing to support me during the initial plans of this book, including Marvin Andrade, Gilda L. Ochoa, Nicolas Orellana, and Horacio N. Roque Ramirez.

I am grateful to Jerry Roberts for believing in this project and for his desire to publish this book and to Arcadia Publishing for providing the opportunity to publish the story of Central Americans.

My appreciation goes to Wayne Goto and Tad Keyes for their expertise in digitizing the images used in this book, photographers Joaquin Romero and Remberto Diaz for their enthusiasm and support, artists Ricardo O'Meany and Pehdro Kruhz for their valuable knowledge and referrals, geographer Angie Saldivar for her maps, and professor Beth Baker-Cristales for taking the time to read this text and for her opinion.

Special appreciation goes to POT, who has always respected my work, encouraged me, and given me uplifting words. I am also especially grateful to my friend Rochelle MacAdam, who helped me proofread and gave me her motherly support; I could have not done it without you.

My final gratitude and love goes to Fernando for his support and caring; and lastly to Dinorah for being there when I needed her.

INTRODUCTION

Central American immigrants are second only to Mexican immigrants in the number of Latinos present in Los Angeles. Without a doubt, Los Angeles is preeminent for Central Americans living outside their respective countries. While Central Americans have been coming to California since the late 1940s, the majority arrived during the late 1970s and 1980s, fundamentally altering the face of Los Angeles. Salvadorans and Guatemalans came in large numbers in the 1980s, escaping political persecutions and devastating civil wars. Today these groups constitute the largest Central American populations in Los Angeles. Their presence is most conspicuous on the streets of the Pico-Union neighborhood in downtown Los Angeles. However, their influence is apparent throughout Los Angeles County.

The photographs collected in this book are an attempt to offer a glimpse of the lifestyles, growth, and gradual blossoming of Central American cultures within Los Angeles. While Central Americans have immigrated to California during different periods for different reasons, they have often faced many obstacles and hardships after arrival. This book is not intended to portray all of the immigrant experiences but rather to celebrate the resilience of these immigrants who have integrated into Los Angeles's urban life. The complexities of each Central American nation are numerous, yet these populations share customs and histories. After collecting the images, it seemed as if some of the photographs illustrated moments that required a book of their own. Perhaps this book will inspire others to create a more comprehensive collection and more of the stories that have been lived by each group of Central Americans in Los Angeles.

This book is given as an homage honoring each immigrant mother and father who found the courage, when faced with no other option, to leave their loved ones behind; it also has been composed for all the children who yearned for the day when they could be reunited with their parents. Lastly, it is to honor all of those who lost their lives on the perilous voyage.

One

CENTRAL AMERICAN IN LOS ANGELES

As early as the 1930s, Central Americans belonging to coffee growers' elite families traveled to California for vacations and business trips. When the global depression of the 1930s hit the coffee market, it affected the regional economies of these countries. Later, small numbers of upper class and middle-class people immigrated to San Francisco and Los Angeles. By the 1940s and 1950s, another small group of Central Americans came to Los Angeles. This time it was the immigrants from the working class; a number of them came with work permits to fill vacant jobs in a variety of industries. Throughout the 1960s and early 1970s, additional immigrants traveled to Los Angeles. Some came to study or to visit relatives and later returned to their native countries, and others stayed and integrated into the working and social life of Los Angeles. After the late 1970s, most Central American migration was related to the civil wars in some countries and the resulting economic devastation.

In general, when Central Americans came, many of them ended up living in the Westlake and MacArthur Park neighborhoods, better known as Pico-Union. These neighborhoods are located in the urban core of Los Angeles south of the Hollywood Freeway and north of the Santa Monica Freeway but west of the Harbor Freeway and east of Hoover Street. The area is surrounded by Silverlake and Echo Park to the north, the West-Adams district to the south, Koreatown to the west, and the downtown district to the east. The neighborhood was at its greatest development in the 1930s; it had a predominately white population, and it was a bedroom community for those who worked downtown. With the proliferation of the automobile, whites began to move west to newly developed suburbs. At the same time, Mexicans and Mexican Americans, who were displaced from agricultural land that had been taken for new suburban development, moved to the Pico-Union area. Since then, it has become a transient neighborhood for recent Latino immigrants, starting with many Mexicans who later moved to other areas, such as the already well-established Boyle Heights and East Los Angeles. For the newly arrived Central Americans, the neighborhoods around Pico-Union have always been attractive because of the abundant multifamily residential buildings and the already established Latino community.

CENTRAL AMERICA

Mexico

Belize

Guatemala

Honduras

El Salvador

Nicaragua

Caribbean Sea

Pacific Ocean

Costa Rica

Panama

Sout Amer

0 100 200 300 Miles

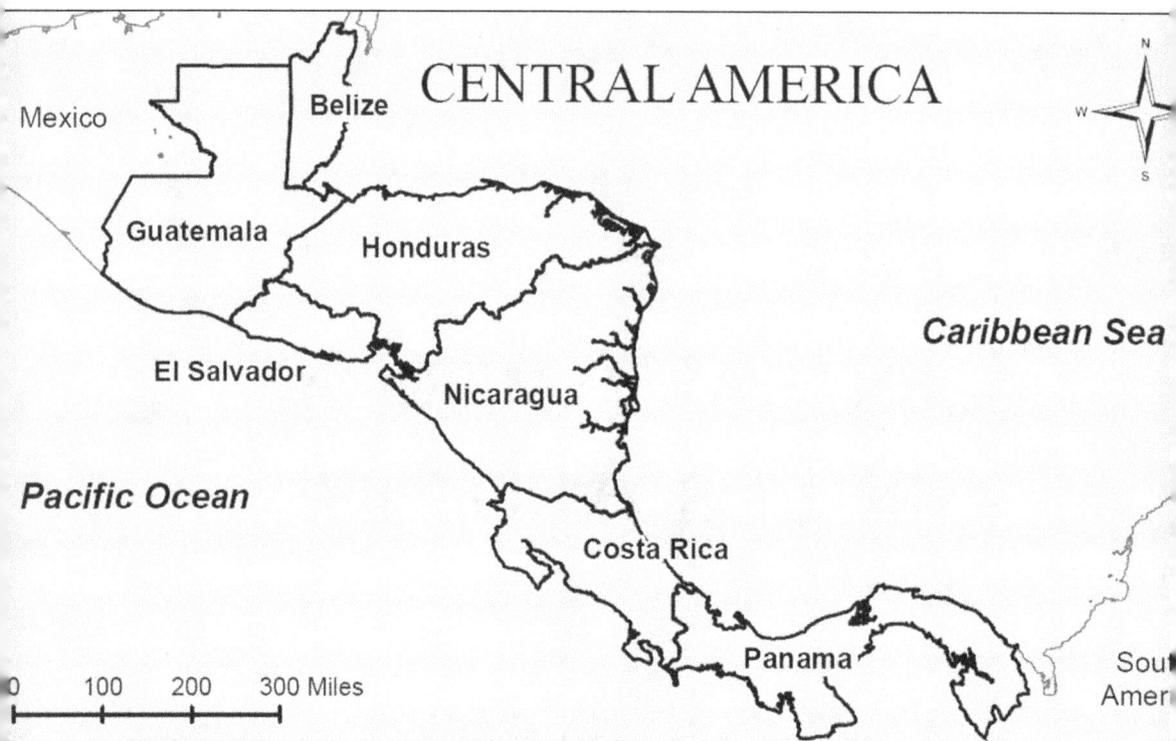

The Central American region is of relatively small size in contrast to the rest of the continent; however, its geographic location plays a significant role because it is like a bridge linking North and South America and therefore its peoples. The total area of Central America is 523,780 square kilometers, as compared to the United States, which has approximately 9,826,675 square kilometers. The region, in spite of its small size, has numerous political, economic, and cultural complexities. The pre-Columbian period coincided with Mesoamerican civilization, which occupied much of the northwestern areas from Guatemala through Honduras, Belize, El Salvador, Nicaragua, Costa Rica, and Panama. Mesoamerican and Andean cultures met somewhere between Costa Rica and Panama; however, this unity was mostly cultural rather than political. The post–Christopher Columbus discovery period was dominated by Spain's influence for nearly 300 centuries until each of these countries won independence from Spain in 1821, with the exception of Belize, which was part of the British Empire and did not become independent until 1981. After the Central American region gained its independence, there were several attempts to unite the region as whole country; however, to this day, each country remains separate, independent entities. (Courtesy of Angie Saldivar.)

Angelina Valle Argueta immigrated from Morazán, El Salvador, to San Francisco in 1942, joining her family who had established themselves a few years earlier. Argueta's first job was repairing warships damaged during World War II. There, because she was a petite woman, she was assigned to weld the difficult-to-access interiors of the ships. In 1946, she moved to Los Angeles and worked in the restaurant industry. Two years later, after saving enough money, she opened her own restaurant on San Julian Street and Pico Boulevard in downtown Los Angeles. The restaurant was called La Golondrina (the Swallow), and served Mexican and Salvadoran dishes. In the same year, 1948, she brought her daughters, whom she had left in El Salvador, to Los Angeles. The family resided in downtown Los Angeles near the restaurant. From left to right are Isabel Paiz Argueta, who later became Isabel Cardenas; Angelina Valle Argueta; and Marina Paiz Argueta. (Courtesy of Isabel Cardenas.)

In 1945, Miguel Angel Gutierrez immigrated to Los Angeles from San Miguel, El Salvador. He worked for the Southern Pacific Railroad. A year later, he brought his wife, Lydia, and their children. The Gutierrez family opened the first Salvadoran restaurant in Los Angeles in 1950. Despite the fact that the Salvadoran population was small, their entrepreneurial nature and enthusiasm for Salvadoran food helped them establish a successful business. This portrait was taken in 1948 in Los Angeles. (Courtesy of Gloria Gutierrez.)

Estella Simo Shellman (left) was born in Sonsonate, El Salvador. She immigrated to Los Angeles in 1943. A few years after her arrival, she married a Los Angeles police officer, Otis Shellman. Her family in El Salvador joined her during the following years, including Gloria Rodriguez Simo, her younger cousin, posing in this photograph during a visit to Knott's Berry Farm in 1949. (Courtesy of Gloria Gutierrez.)

Teresa Gutierrez arrived in Los Angeles in 1945. She attended Poly High School in Los Angeles, where Los Angeles Trade Tech City College is currently located, and graduated in 1954. (Courtesy of Gloria Gutierrez.)

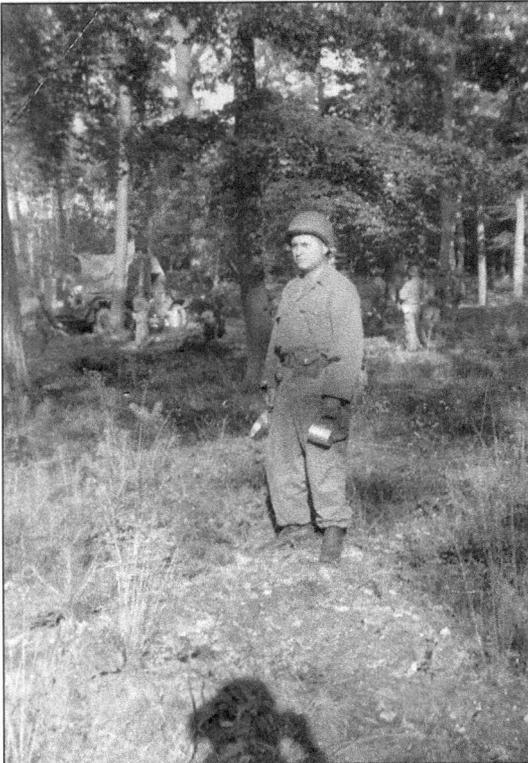

Octavio de la Paz Gutierrez, originally from La Union, El Salvador, immigrated to Los Angeles in 1947. The following year, he was drafted by the U.S. Army, and in 1950 he was deployed to Germany; one of his many duties included cooking for the troops. (Courtesy of Gloria Gutierrez.)

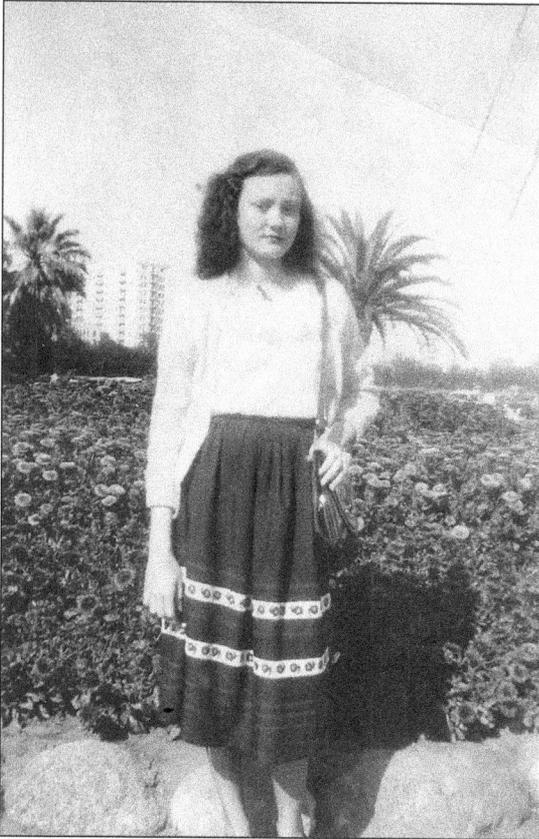

Gloria Rodriguez Simo came from El Salvador and arrived in Los Angeles in 1947. Her family settled in a house on Ninety-sixth Street near the Los Angeles airport. From there they moved to Boyle Heights while it was still predominately a Jewish neighborhood and later moved to the Pico-Union area. Upon her arrival, she began working in the garment industry, making men's shirts on Santee Street in downtown Los Angeles. This photograph was taken during a weekend stroll in Long Beach. (Courtesy of Gloria Gutierrez.)

Rodriguez (left) is pictured with her friend, Elvira Peralta in Santa Catalina Island in 1951. Rodriguez changed her name to Gloria Gutierrez after marrying Octavio di La Paz Gutierrez. (Courtesy of Gloria Gutierrez.)

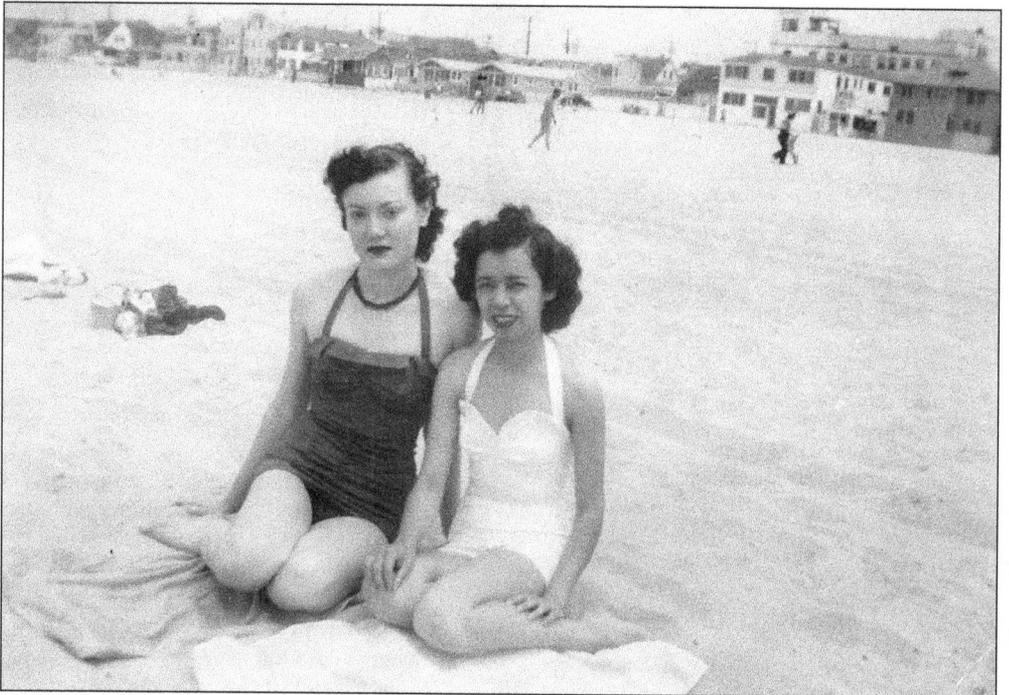

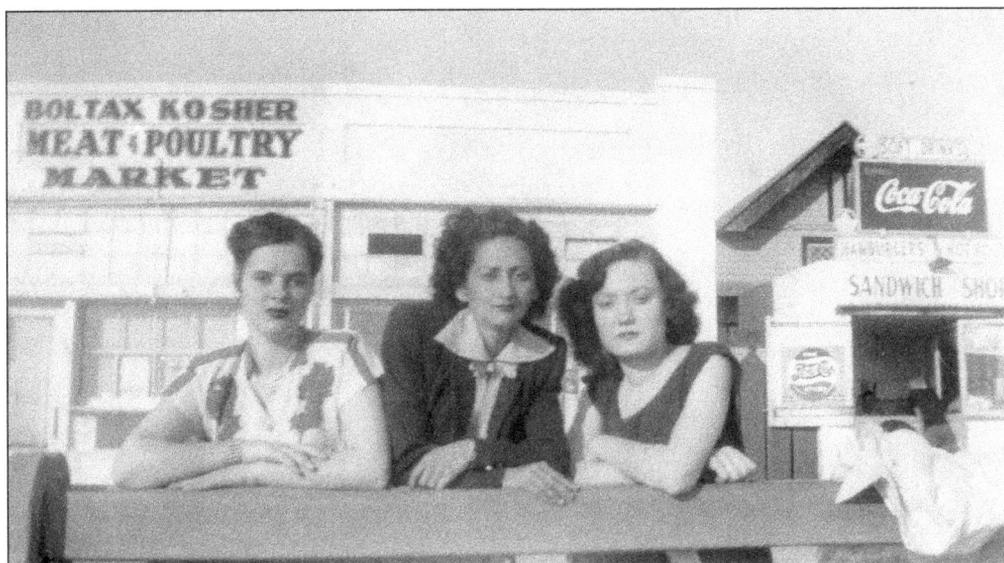

The Santa Monica Boardwalk has been a popular promenade for Central American immigrants because of its proximity to downtown Los Angeles and the accessibility of public transportation. Pictured in the 1950s from left to right are Lilian Rodriguez Simo, Arminta Alvarenga, and Gloria Rodriguez Simo, all immigrants from El Salvador since the late 1940s. Alvarenga worked for the Southern Pacific Railroad, and Gloria worked in the garment industry. (Courtesy of Gloria Gutierrez.)

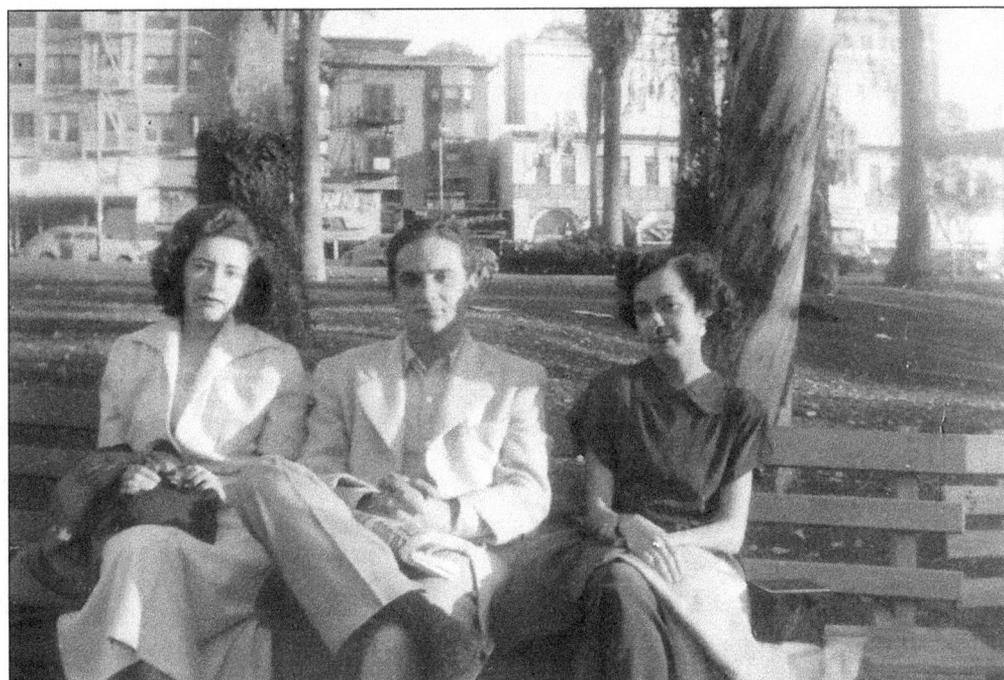

This 1950s photograph was taken in Santa Monica and shows a group of Salvadorans enjoying a day off from work. From left to right are Juaquina Peralta, who worked in the garment industry, and Antonio Huezo and Elvira Peralta, who worked for an insurance company. (Courtesy of Gloria Gutierrez.)

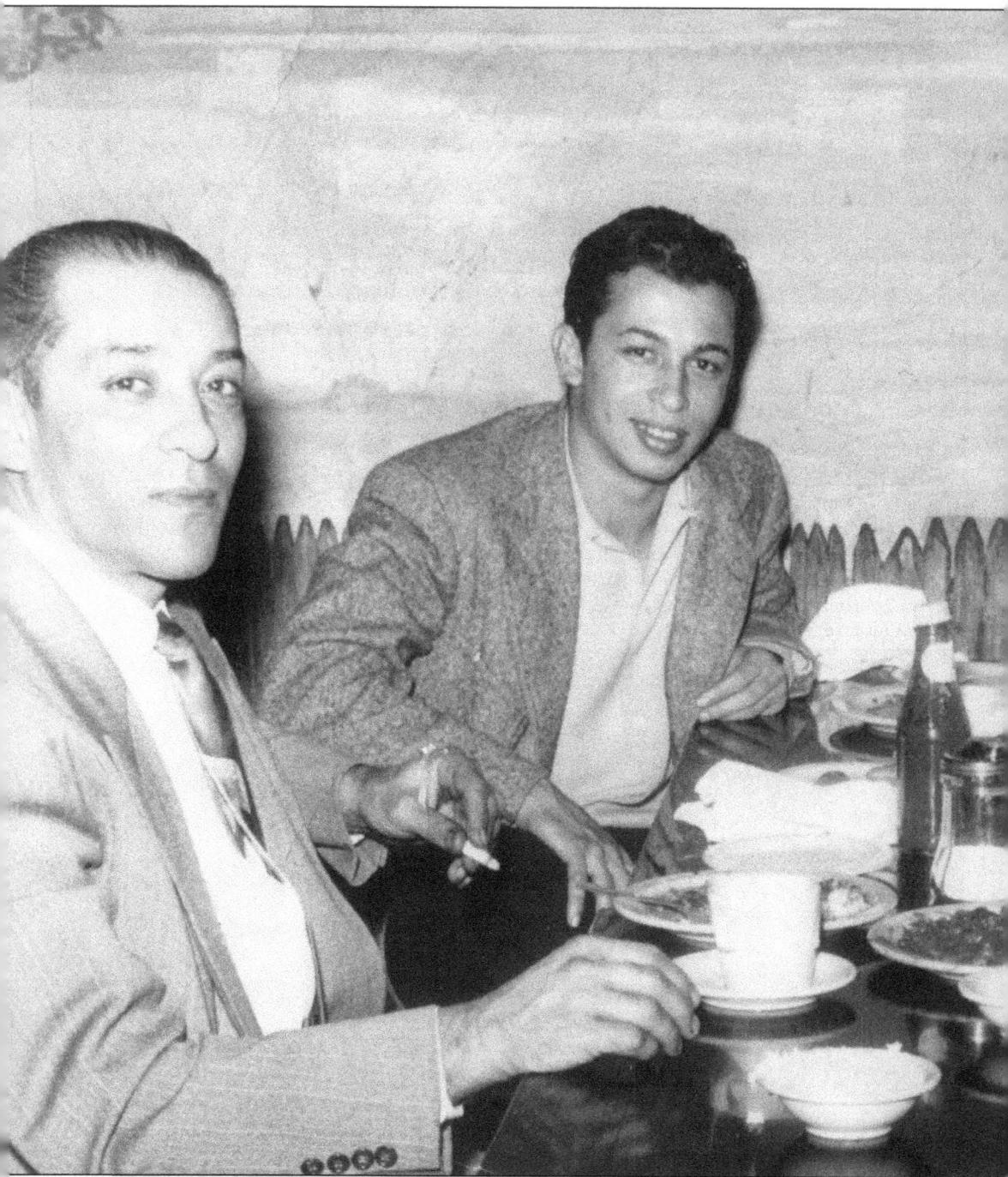

The Ochoa family is pictured here. From left to right are Erasmo, Henry, William, Hilda, and María Julia. Originally from Estelí, Nicaragua, they immigrated to Los Angeles in the 1950s. Erasmo and Hilda migrated after life under the dictatorship of Anastasio Somoza Garcia became unbearable; they came searching for a better future for their children. Their first residence was near Pico-Union. Ten years later, they moved to La Puente, a working-class suburb of Los Angeles. Erasmo and Hilda worked in different factories in the furniture and garment industries. William

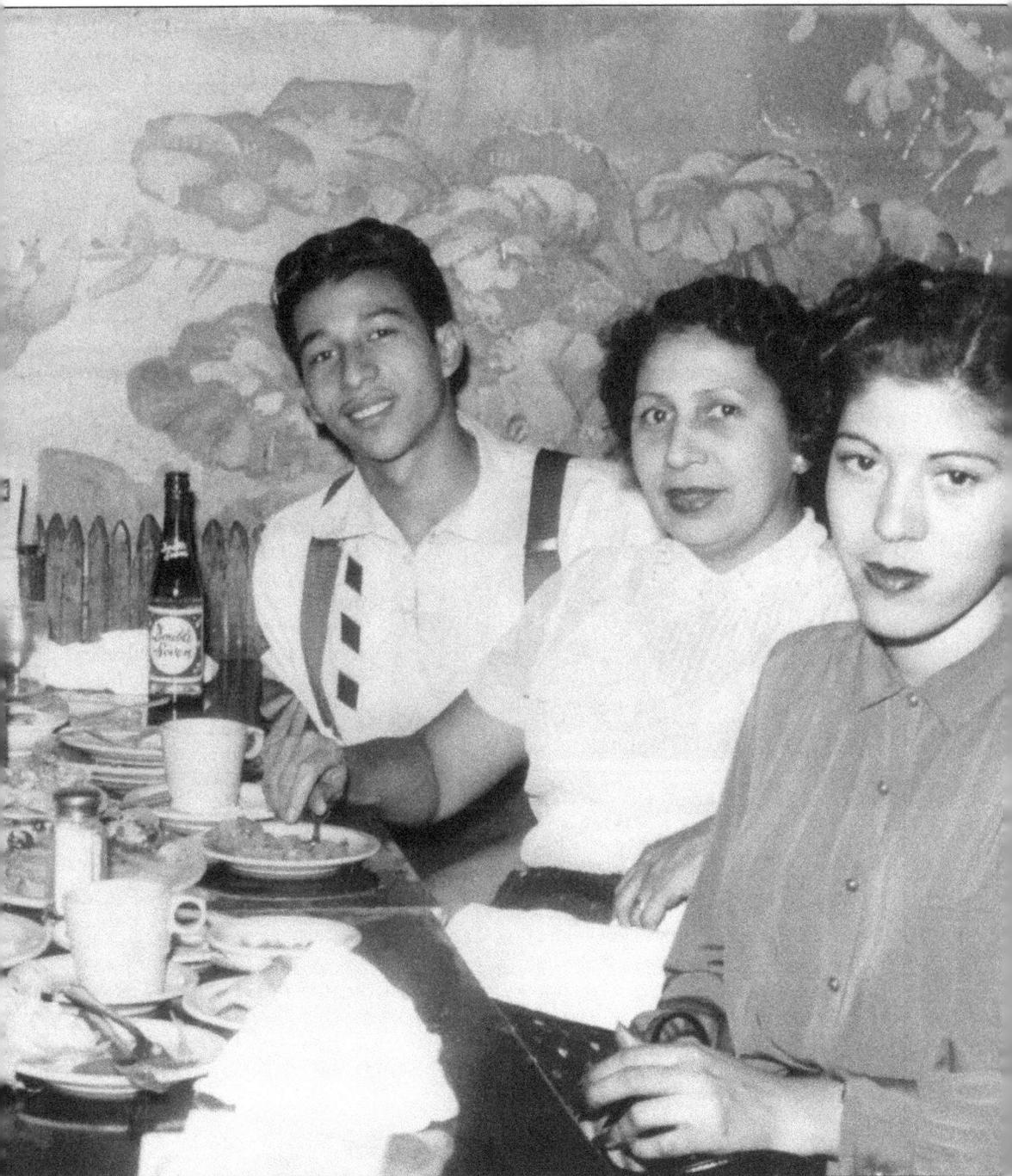

worked in the metal industry until his retirement in the 1990s. Henry attended school until starting a teaching career; he taught middle school in Hacienda Heights until his death in 1989. This 1950s portrait was taken at the Clifton's Cafeteria, located in the heart of downtown Los Angeles. The restaurant has been a common gathering place for immigrant families. (Courtesy of the Ochoa family.)

While living in Los Angeles, Trinidad Simo-Aleman sent this photograph to her mother, Matilde Simo, who was living in El Salvador. The picture was taken during a visit to relatives in Mexico. On the back of the image, Trinidad wrote an emblematic note of an immigrant sharing feelings and thoughts. She describes to her mother the trip to Mexico; she also gives an update of day-to-day life in Los Angeles, and then she asks after the well-being of those left behind in El Salvador. She says goodbye, sending her love with all her heart. The note was signed May 1, 1944. (Both courtesy of Gloria Gutierrez.)

The first Salvadoran woman to become a general counsel of Los Angeles was Simo-Aleman (center). In this 1963 photograph, she is meeting Princess Margaret of England. (Courtesy of Gloria Gutierrez.)

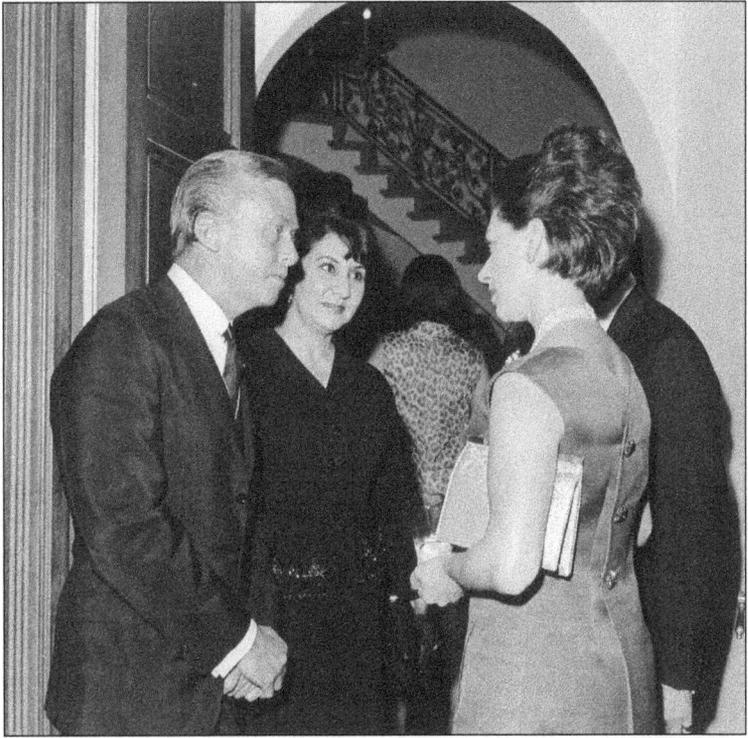

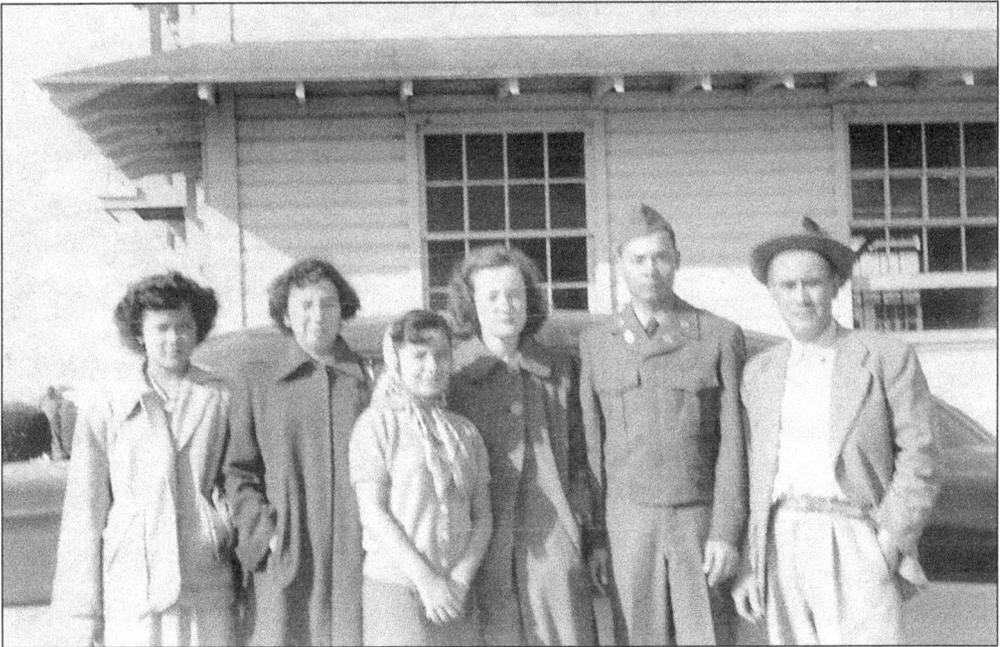

Los Angeles–based Salvadoran immigrants are visiting a friend and relatives in Fort Ord in Monterey. From left to right are Luz Dheming, from La Union, El Salvador; unidentified; Teresa Gutierrez, from La Union, El Salvador; Gloria Rodriguez from Sonsonate El Salvador; Bob Panganilian from Guam; Miguel Angel Gutierrez from San Miguel, El Salvador. (Courtesy of Gloria Gutierrez.)

A second generation of Salvadoran children, born in Los Angeles, are playing in front of their home on Valencia Street in the Pico-Union neighborhood on a Sunday afternoon in June 1958. From left to right are Hilda Valenzuela, Beto Valenzuela, unidentified, and Mario Castañeda. (Courtesy of Gloria Gutierrez.)

A birthday celebration of Sandra Gutierrez, who was born of Salvadoran immigrants, is pictured here. The photograph was taken in December 1957 at their home at 1361 Valencia Street in the Pico-Union area. From left to right are the following: unidentified; Sandra Elena Gutierrez, who became the first Salvadoran to serve on the state commission; Mario Castañeda; unidentified; and (sitting) Sandra Gutierrez. (Courtesy of Gloria Gutierrez.)

Roberto Alfaro, a Salvadoran immigrant, was studying in Mexico, and when his visa expired, he came to the United States to renew it. During that visit, he was drawn to Los Angeles, eventually settling in 1963. While continuing his studies at California State University, Los Angeles, he was recruited in the 1970s by other Salvadorans to work on behalf of the newly arriving Salvadoran refugees. He became a cofounder of the first committee in solidarity with the Salvadoran people in Los Angeles. He is photographed in front of MacArthur Park Lake. (Courtesy of Roberto Alfaro.)

Isabel Paiz Argueta emigrated from El Salvador at the age of nine. She later married Roberto Cardenas, a Mexican American, and worked in the entertainment industry until her retirement. She has been an active member of the Salvadoran community, working to help recent immigrants, as well as the Central American community abroad. The family was photographed in their home in Baldwin Hills. From left to right are Cardenas (first row) Isabel, Ricardo, and Roberto S.; (second row) Rosalie and Roberto. (Courtesy of Isabel Paiz Contreras.)

Mercedes Huezo de Garcia came to Los Angeles from Sonsonate, El Salvador, as a tourist in the mid-1960s, and was attracted by the glamour of the big city. Finding that she enjoyed life in Los Angeles, she decided to stay and settled in the Pico-Union area. She is pictured (left) with an unidentified friend in December 1968. (Courtesy of Danilo Huezo.)

Maria Marta Marroquin migrated to Los Angeles in the early 1970s. She left El Salvador in search of economic opportunities to better support her son, whom she left behind. From her arrival until her retirement, she worked as a caregiver for the elderly. She resided near MacArthur Park, sharing an apartment with friends to minimize the cost of rent. She is pictured in her apartment in the MacArthur Park area with an unidentified friend in 1973. (Courtesy of Joaquin Romero collection.)

Danilo Huezo came to Los Angeles for a short visit with his relatives. The visit became permanent, and he eventually married Juanita Mena, a native of Costa Rica. The couple lived on Albany Street in the Pico-Union area. Although Huezo ultimately returned to El Salvador, he remains connected to Los Angeles, where his children live. Pictured from left to right in this 1970s photograph are Derling Flores Huezo, Juanita Mena, and Danilo Huezo. (Courtesy of Danilo Huezo.)

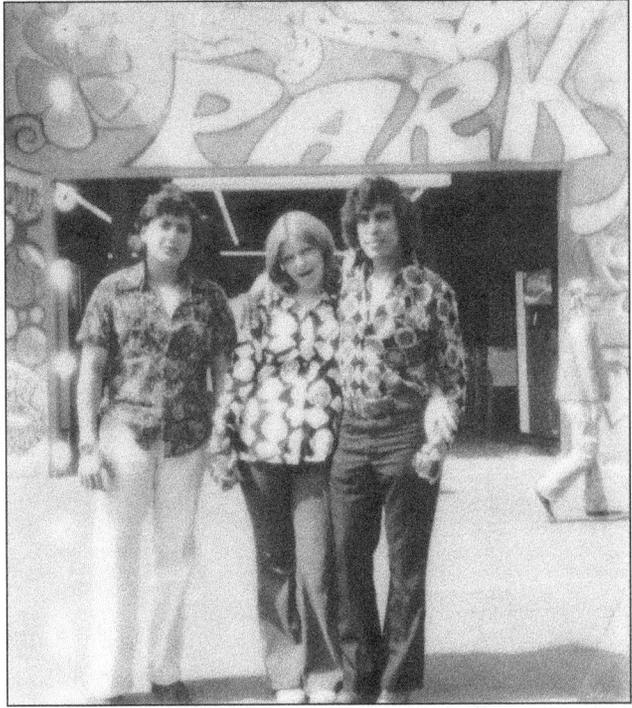

Like many others, Carlota Rivera immigrated in hopes of changing her economic and social circumstances. Through her sister, who had come to Los Angeles years before, Rivera was able to travel with a plane ticket and a visa. Since her arrival in the early 1970s until retiring in 1994, she worked as a babysitter, caring for children of the upper-class neighborhoods of West Los Angeles. Pershing Square (seen here), Teatro Blanquita, and Plaza Olvera in downtown Los Angeles were some of her favorite visiting sites on weekends. (Courtesy of Oscar Lopez.)

The specific factors that ignited the Central American migration during the late period of the 1970s are complex, as it is often difficult to distinguish who becomes a political refugee, a labor immigrant, or an adventurous traveler. The people in these images represent the mosaic of immigrants living in Los Angeles during that era. The group of women above was photographed after church services at the Angelus Temple in Echo Park. Maria Marroquin, left, described her new friends as hardworking maids and nannies that came from Honduras, Nicaragua, and Guatemala to earn a living to raise their children. The three men sitting on the car (left) immigrated for different reasons. Pictured from left to right, Herbert Segura was lured to the life of Los Angeles by images portrayed on television, Arturo Lopez came following a sweetheart, and Baltazar Montes moved to Los Angeles as the military repression increased in El Salvador. (Both courtesy of Joaquin Romero collection.)

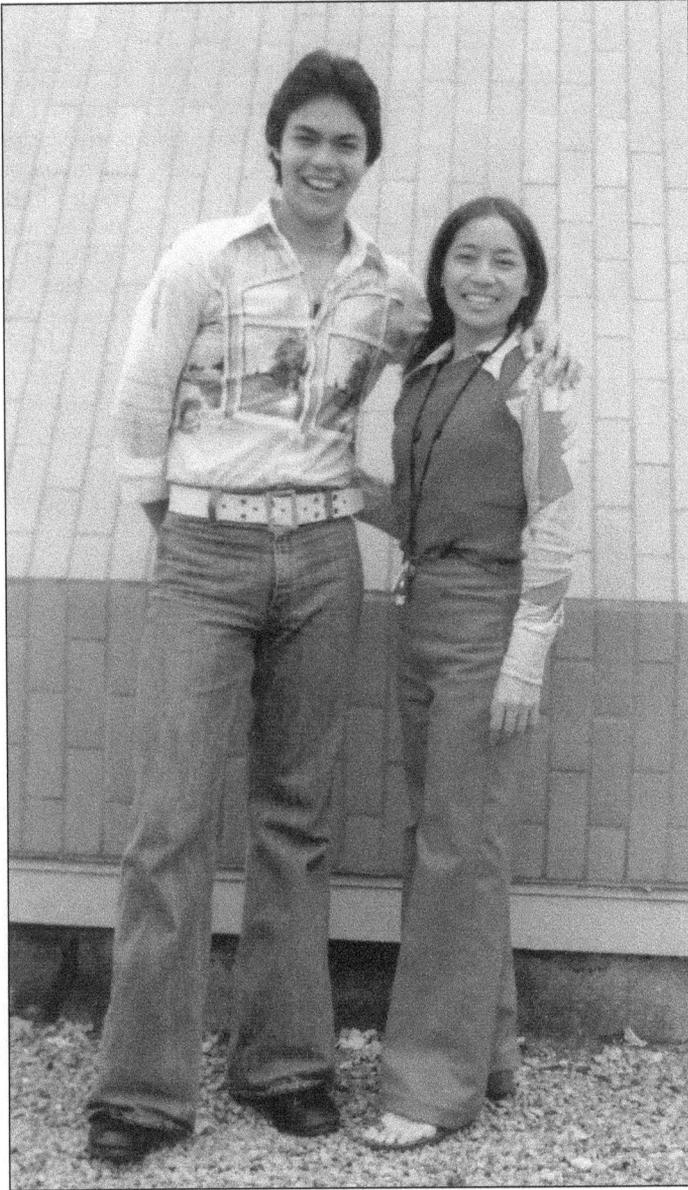

By the mid-1970s, hundreds of Guatemalans left their native land, escaping from Carlos Arana Osorio's military regime. This was the case of Roland Palencia and his family, who were forced to emigrate after paramilitary forces assassinated his father. Upon his arrival, Palencia became a dedicated student and later graduated from the University of California, Los Angeles. In this 1975 picture, Palencia, left, is with his Los Angeles High School biology teacher. The late-1970s era was a period of political repression by Central American governments who were being supported by the United States. During this time, most of the Central American economies were tilting towards a handful of wealthy individuals, while many others suffered poverty and unemployment. Despite efforts to resist the oligarchies and demands to improve social conditions, those in power successfully intimidated the population. Many of the opposition were persecuted, and some were tortured and killed. During the next decades, these conditions resulted in an increase in the numbers of emigrants traveling to North America. (Courtesy of Roland Palencia.)

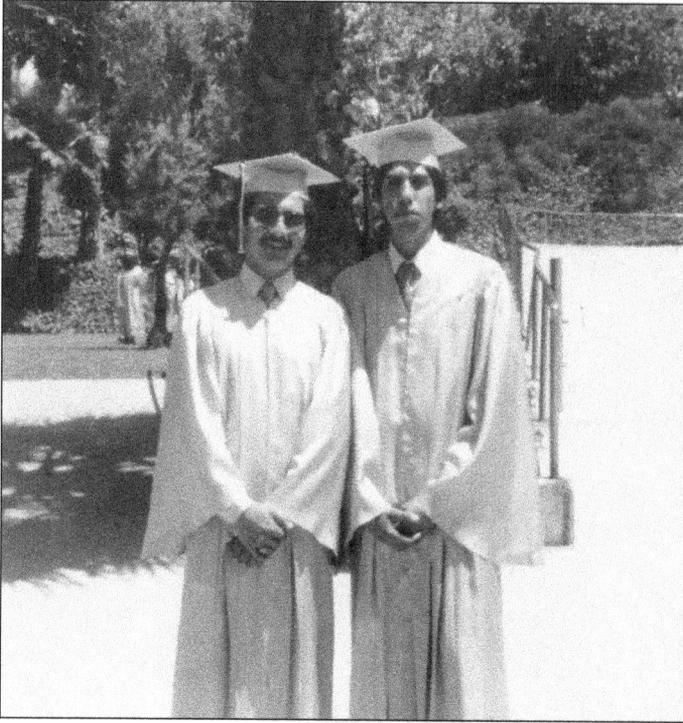

Nicaraguan Francisco Ramirez, left, immigrated in the late 1970s. He came to Los Angeles with Mario ?, a childhood friend (pictured). They resided in the Hollywood area but attended school in South Central Los Angeles. They are photographed at their high school graduation from Manual Arts High School. (Courtesy of Mauricio Miranda.)

Some Central Americans during the late 1970s had begun to exhibit the pride of their cultural heritage. In this image, the Garifuna community participated in the Latin American parade celebrated in 1979 on the streets of downtown Los Angeles. (Courtesy of Garifuna American Heritage Foundation Archives.)

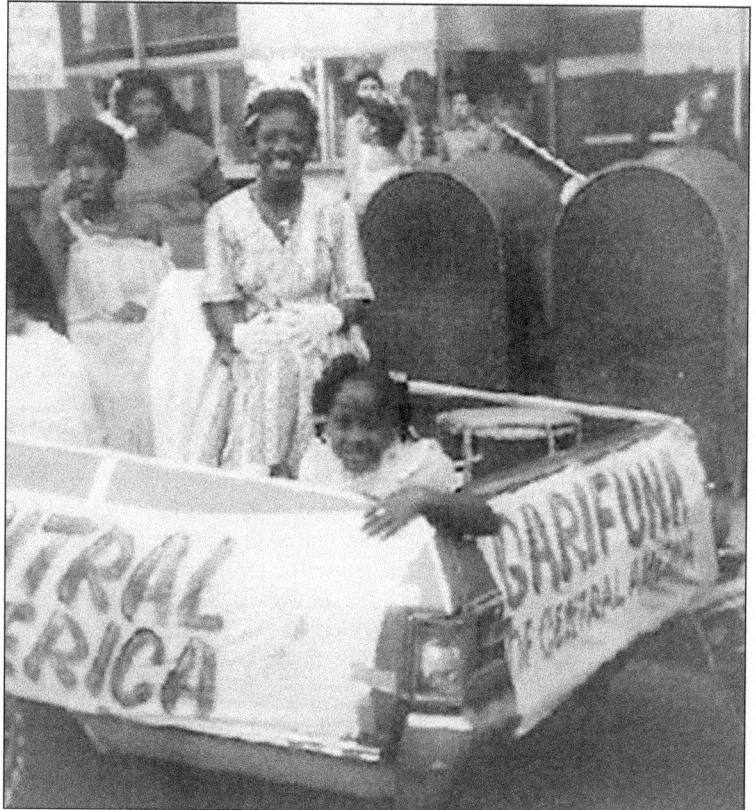

Two

THE GREAT MIGRATION OF CENTRAL AMERICANS TO LOS ANGELES

The large-scale migration of Central Americans to the United States during the 1980s was rooted in a combination of regional and social factors that included population growth, poverty, lack of agricultural land, geographic proximity, and wars. The insurgency movements in El Salvador, Guatemala, and Nicaragua and the military interventions by the United States had devastated the region's economies. That, coupled with the increasing greed of the landowners, led to more and more Central Americans being dispossessed and ultimately joining the exodus to the United States. Due to the proximity of Southern California and other local economic factors, Los Angeles attracted a substantial number of those Central Americans. During the 1980s when the new immigrants arrived, several local economic changes were occurring. Downtown Los Angeles was going through a revitalization process. New multistory hotels and buildings were being constructed to accommodate the new high-tech electronic jobs, as well as the financial and trade industries that required additional office space. At the same time, old downtown warehouses once occupied by manufacturing businesses were being taken over by the garment industry. And so, since the new hotels, office spaces, and industries needed workers, many Central Americans living in the Pico-Union area filled the service jobs needed.

By the late 1980s, Central Americans had spread to other neighborhoods of Los Angeles, such as Hollywood, Van Nuys, North Hollywood, or South Central. Newly arrived Central Americans continued to be attracted to the Pico-Union neighborhood, however, because of lower housing costs and accessibility to public transportation and nearby jobs in addition to the existing Latino cultural environment.

Many of the immigrants during this era came to Los Angeles, planning to stay for a short time, but as civil wars wore on, returning became less likely. In the meantime, Central Americans in Pico-Union, along with a wide range of local supporters from church leaders to Hollywood celebrities, took to the streets to denounce U.S. intervention in Central America. Furthermore, several local and immigrant activists became engaged in establishing nonprofit organizations dedicated to humanitarian efforts, assisting new immigrants in meeting basic needs, such as health, food, work, shelter, and other necessities. MacArthur Park on Alvarado Avenue has been the niche for most of the Central Americans' civic and social engagements.

Central American Population, Los Angeles Region, 1970-2000

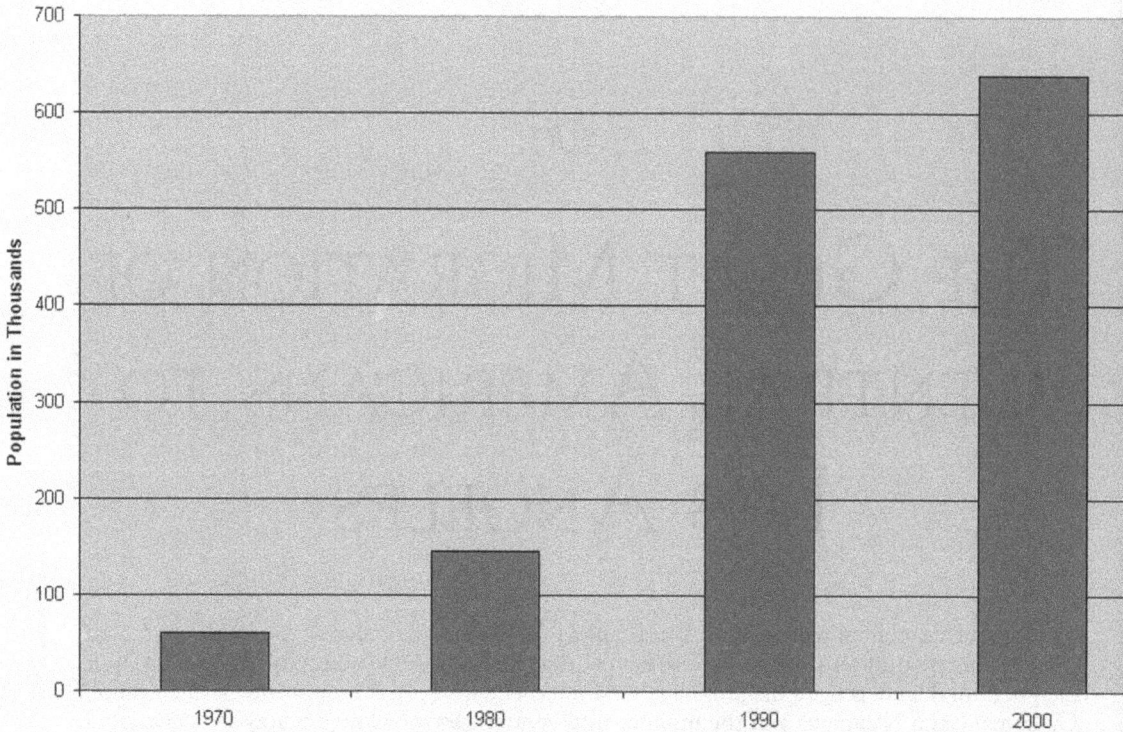

For the most part, the number of Central Americans who immigrated to the United States between the 1940s and 1960s was relatively small. Many of the first immigrants of the 1940s were either involved with coffee or banana trading, or they were affluent Central Americans who traveled for vacations. In general, immigrants involved with banana production traveled to the East Coast, and those who came from the coffee production zones traveled to West Coast of the United States. Many Hondurans, for example, traveled to New Orleans, which was a main port for banana imports, and many Salvadorans traveled to San Francisco, a port entrance for coffee. From the 1960s through the mid-1970s, Central Americans immigrants came to Los Angeles, attracted by employment opportunities; however, by the later years of the 1970s, political immigrants began to arrive in Los Angeles County. The percentage increased in the 1980s, as the political turmoil in the region escalated. The violence of the wars and the economic devastation of the region forced more civilians to flee their countries, and the percentage of immigrants in Los Angeles increased, as illustrated on this graph. (Courtesy of Angie Saldivar.)

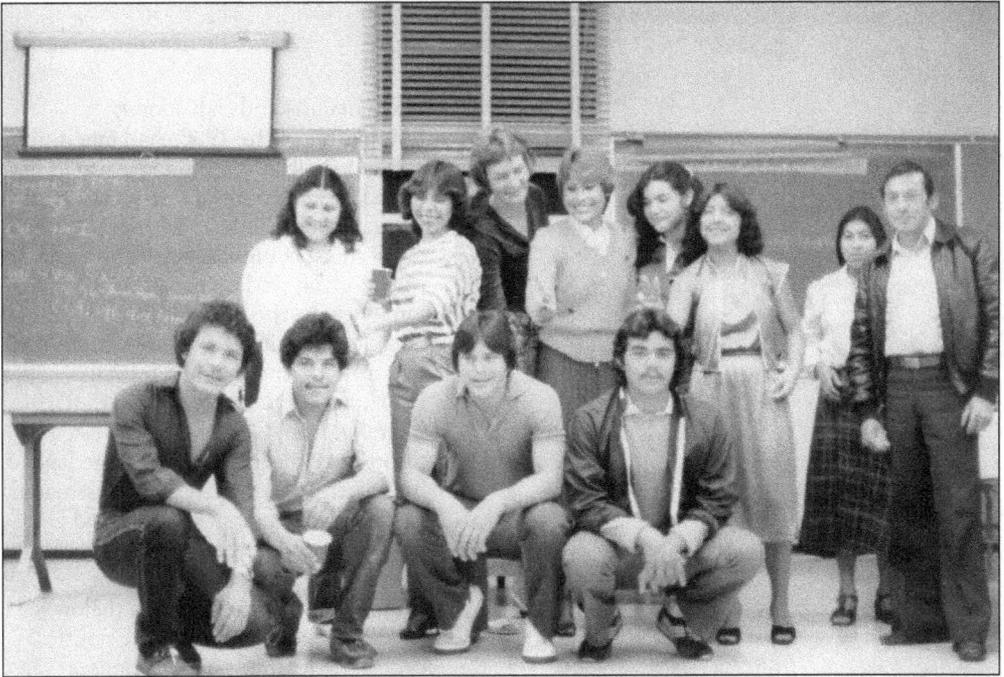

Evans Community Adult School on Sunset Boulevard has been a prime center for recent immigrants who seek to learn English or obtain a high school equivalency certificate. This was the case for Manuel Araujo, third person from the left in the first row; however, he explains that often it was impossible to attend classes on a regular basis because he had to work long hours. (Courtesy of Francisco Carias.)

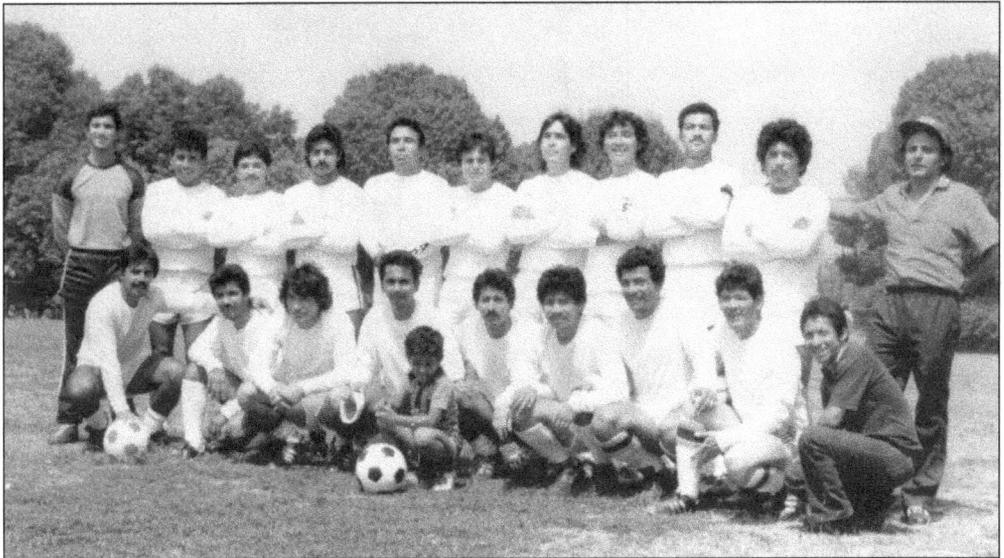

The scale of migration from some regions of Central America, particularly Guatemala and El Salvador, had been so great and rapid that, in many cases, immigrants from tiny towns became reunited in Los Angeles and formed soccer teams. In this photograph is a soccer club formed in 1980 by immigrants from Armenia, El Salvador, a town with a population of less than 15,000. (Courtesy of Herbert Segura.)

29

Guatemalans and Salvadoran immigrants of the 1980s had much in common, including the experiences of forced exodus, political persecution and fleeing from countries with devastated economies, being smuggled through Mexico, and finding themselves foreigners in the immense city of Los Angeles. In spite of this, they often had ways to find comfort together. For example, Nestor Villatoro (left), migrated from Guatemala as a last resort after his life was threatened and his father was tortured and assassinated in 1985. In Los Angeles, he found an avocation competing as a cyclist, wining bicycle races throughout California. Francisco Carias (below) left El Salvador following the political unrest; he learned to use a camera and became an amateur photographer. (Left, courtesy of Nestor Villatoro; below, courtesy of Francisco Carias.)

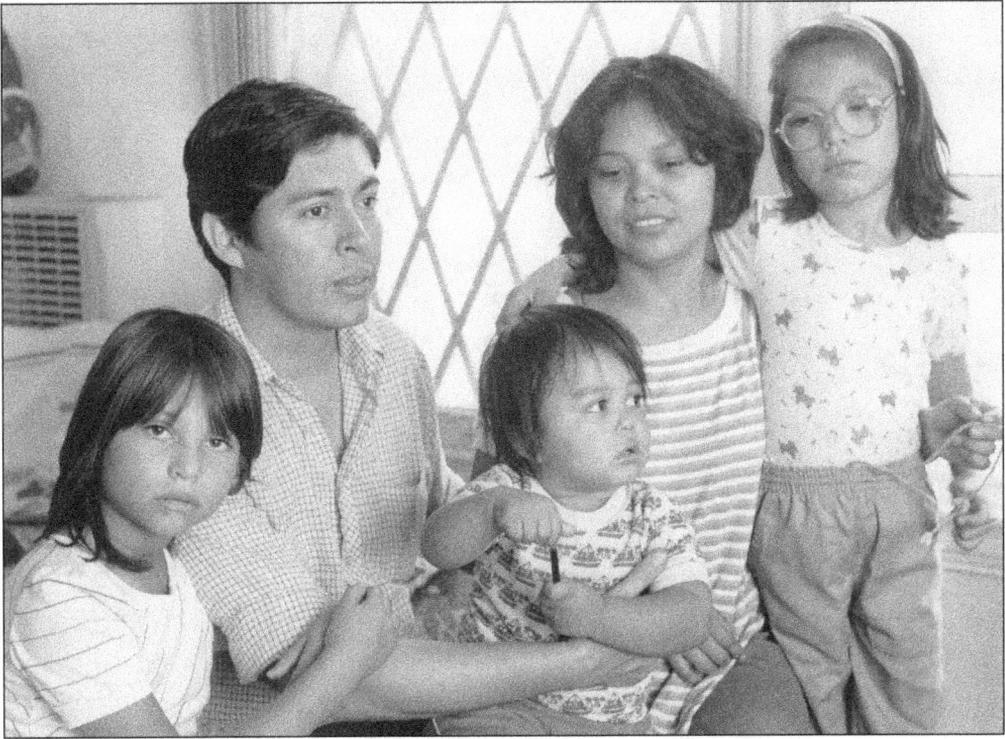

Joaquin Romero, second from left, came with a temporary visa in 1981 to obtain medical treatment for a bullet wound he had received from the Salvadoran army while working as a photographer for a Catholic human rights agency. He did not want to leave his country, but because he had taken photographs of people being abused by government officials, he risked persecution and death to himself and his family if he had stayed. In 1982, he brought his family to live in a tiny apartment in Pico-Union. Unable to work as a photographer and with a family to care for, Romero took a low-paying job as a janitor. Despite their sorrow at being so far from their homeland and the difficult economic circumstances of their lives, the family maintained their faith and hoped for a better future. (Courtesy of Joaquin Romero collection.)

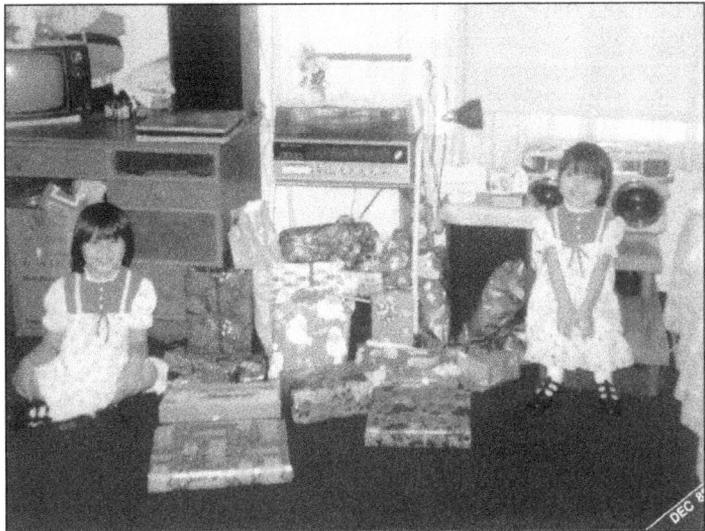

Anna Romero, left, and Marta Romero are celebrating their first Christmas in Los Angeles. (Courtesy of Joaquin Romero collection.)

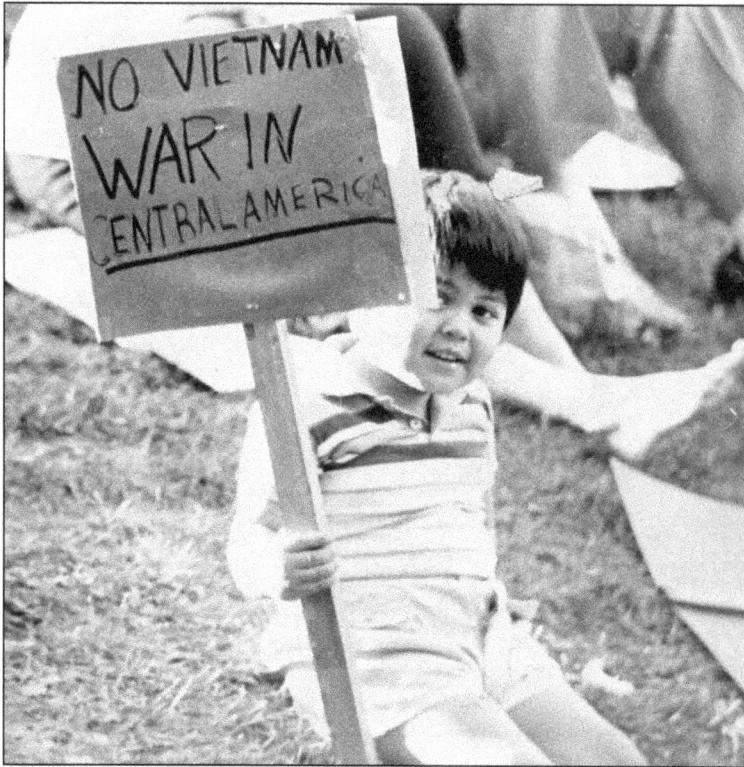

During the 1980s, as the wars against the insurgencies in Guatemala and El Salvador intensified, thousands of innocent civilians were killed, and the exodus of Central Americans began to take place. Nicaraguans were also fleeing their country's bloodshed due to a war ignited by the United States, who backed the Contra War against the Sandinista government. Central Americans living in the United States, as well as other sympathizers, began to voice their opposition to the United States's intervention. Little Arnulfo Romero is holding a picket sign during a 1983 demonstration in MacArthur Park (above). The park was an epicenter for Central Americans' rallies. Others, like Roland Palencia, pictured in front of the 1983 Gay Pride parade in West Hollywood (right), supported local causes and protested against the Central American genocide. (Above, courtesy of Joaquin Romero collection; right, courtesy of Roland Palencia.)

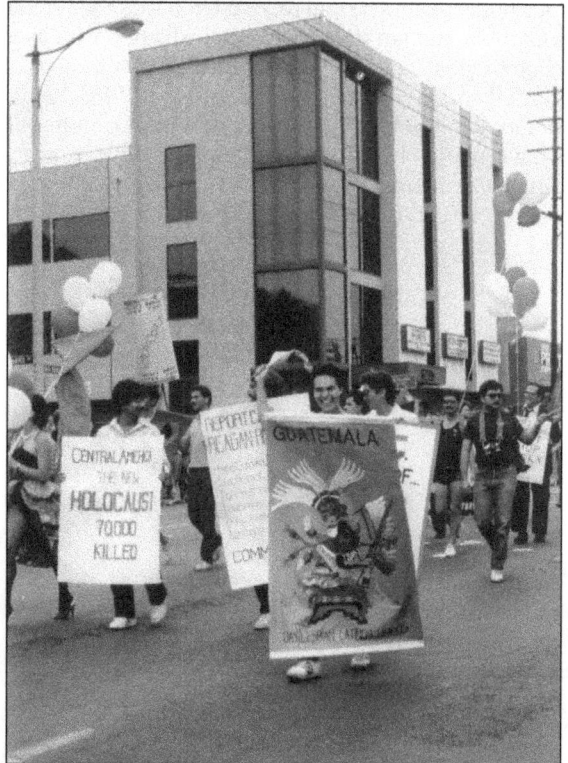

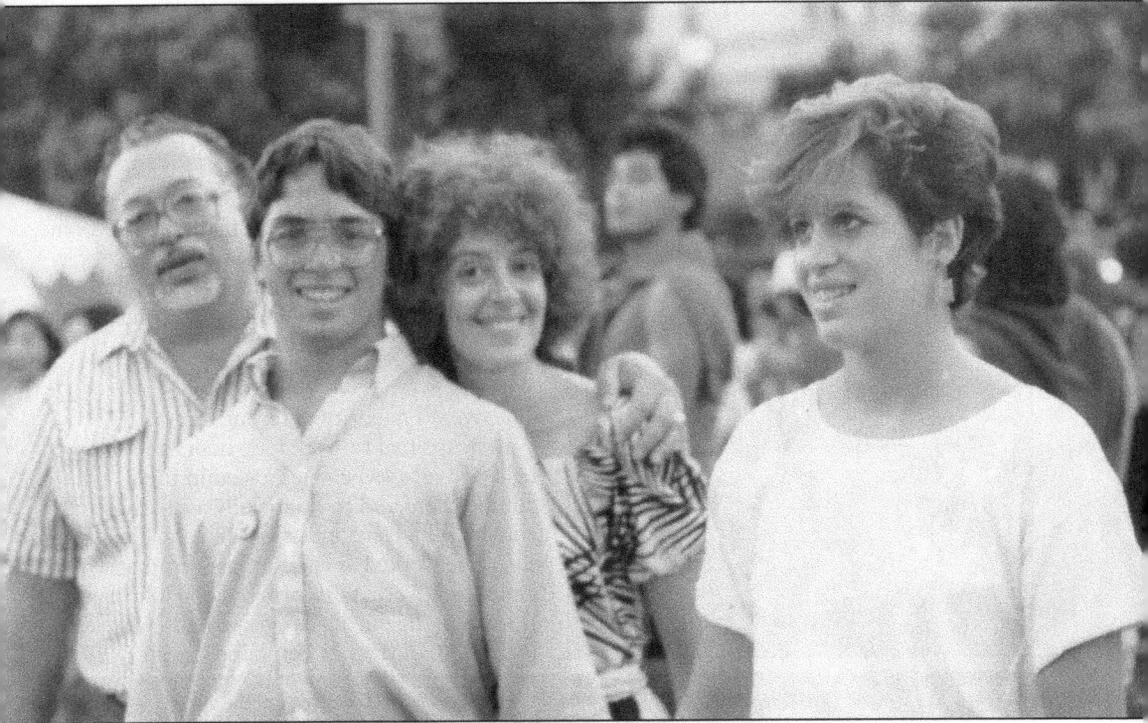

The roots of the first immigrant generations were emerging as the new Central American Angelenos. Henry Ochoa, a member of the first immigrant generation from Estelí, Nicaragua, arrived in Los Angeles in 1950, fleeing the terror-ridden dictatorship of Somoza García. Once established, he attended East Los Angeles City College and California State University, Los Angeles. In the 1960s, he married Francesca, a native New Yorker of Italian heritage. Their children were raised conscious of the injustices in Central America and in their local communities. The Ochoa family is pictured at a 1985 Los Angeles street festival. From left to right are Henry Ochoa, Enrique C. Ochoa, Francesca Ochoa, and Gilda L. Ochoa. In this photograph, Enrique is wearing a "U.S. out of Central America" button. In 2005, Enrique and Gilda co-edited the book Latino Los Angeles: Transformations, Communities, and Activism. In 2009, Enrique is the director of Latin American Studies and a professor of history at California State University-Los Angeles. Gilda is now an associate professor of Chicano-Latino Studies and sociology at Pomona College. She has also written books on Mexican American-Mexican immigrant relationships in La Puente and on Latino teachers. (Courtesy of the Ochoa family.)

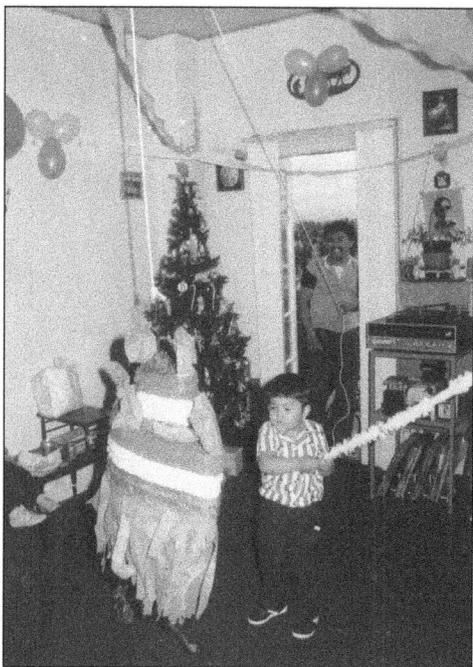

Newer immigrants did their best to maintain family traditions although often it was a challenge given the crowded conditions in which they lived. Despite the hardships, the Romero family, like many others, tried to create a cheerful environment. This 1985 picture shows a birthday celebration; the family breaks a piñata inside their small one-bedroom apartment, which is being shared by 10 people. Their home lacked an outdoor recreational area. (Courtesy of Joaquin Romero collection.)

The overall majority of recent Central Americans had to work long hours and often held two jobs to be able to sustain their families here and to financially assist those abroad. Elba Hernandez was an example of this. She worked at the Raffles L'Ermitage Hotel in Beverly Hills, where Pope John Paul II was staying during his visit to Los Angeles in 1987. (Courtesy of Francisco Carias.)

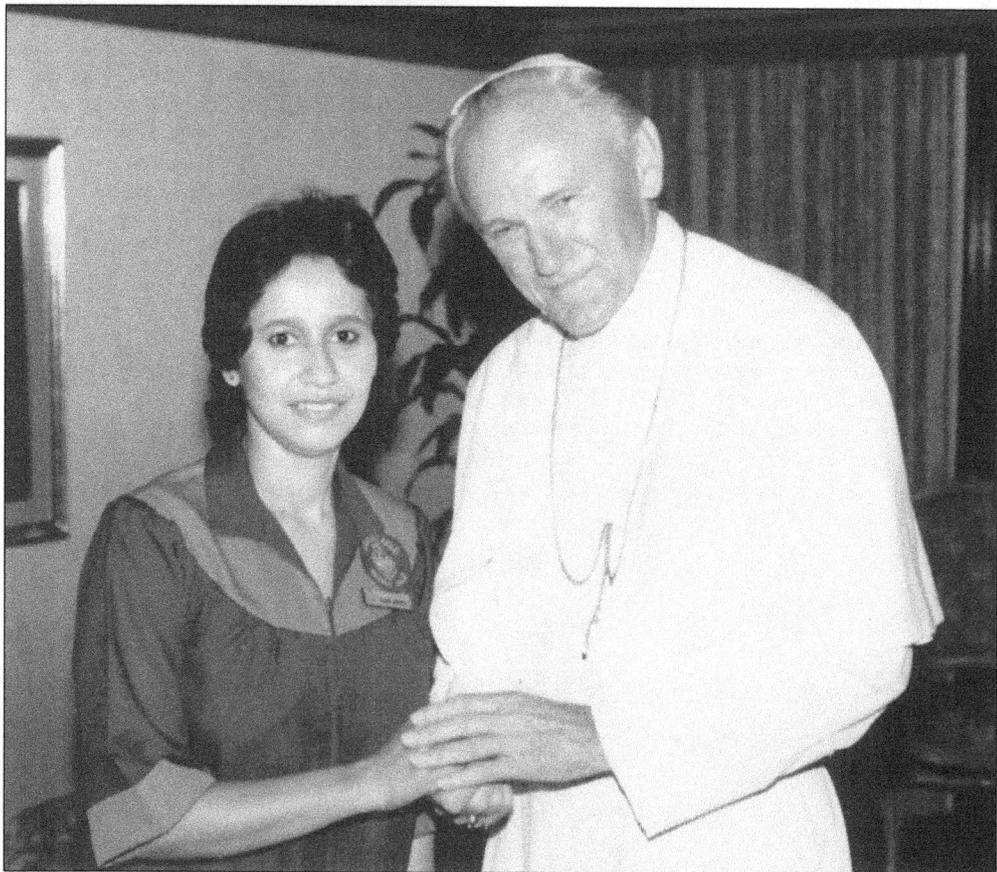

Throughout the 1980s, human rights organizations across the country voiced their support for thousands of Guatemalan and Salvadoran detainees held in immigration detention centers across the states. The federal government did not grant refugee status to those who had flown from the autocratic regimes. However, through the courts, advocates were able to slow down deportations, and by the end of the decade, some Central Americans had won partial U.S. court victories, which led to a new policy that granted temporary protective refugee status and work permits for some Central American immigrants. In the above picture is a Guatemalan refugee, photographed by Ulli Steltzer. At left, Salvadoran children are being released from a detention center. As in many other cases, the children in this picture were separated from parents who were left behind waiting for hearings. (Both courtesy of Joaquin Romero collection.)

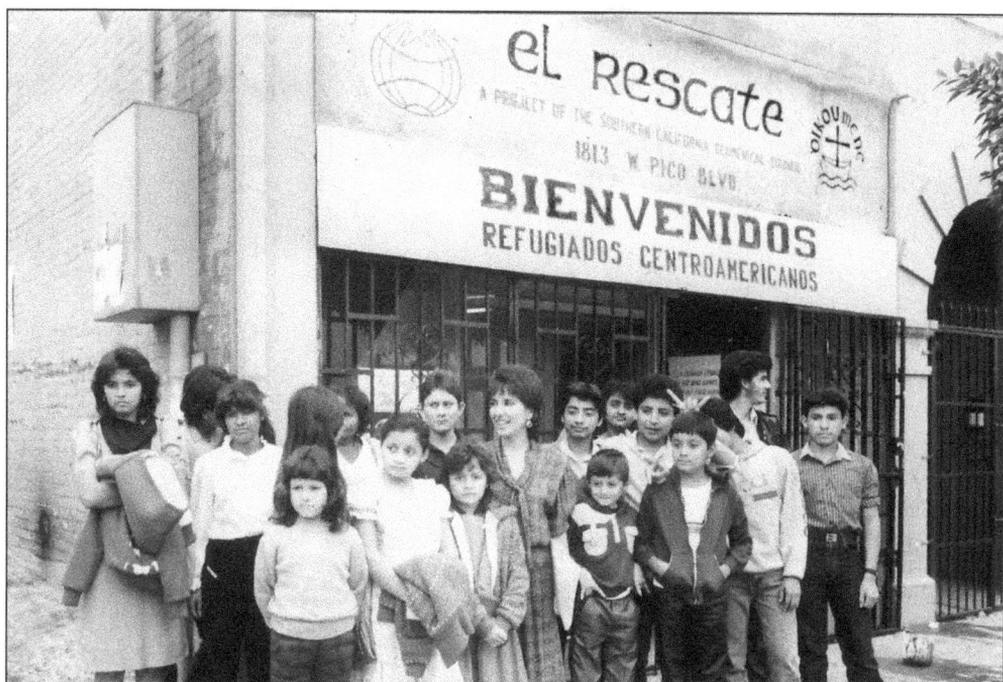

While the population of those forced to flee their embattled countries increased, Central American activists, along with the support of other sympathizers, established several nonprofit agencies dedicated to assist the burgeoning refugee community. El Rescate (the Rescue) was founded in 1981 by members of the Santa Chirino Amaya Refugee Committee and the Southern California Ecumenical Council. The agency, above, became the first one in the United States to offer free legal and social services for the immigrant community. Later, El Rescate funded a shelter for the refugees called El Refugio (the Refuge), located at 1565 West Fourteenth Street in Los Angeles in a building that once served as a home for retired Swedish missionaries (below). Volunteers donated beds, blankets, toys, and necessities needed to run the shelter. (Above, courtesy of El Rescate Archives, photograph by Joaquin Romero; below, courtesy of Joaquin Romero collection, photograph by Joaquin Romero.)

Immigration policies applied across the board to Salvadoran and Guatemalan refugees, and were enforced regardless of age or gender. Detention centers were filled with youths separated from their parents waiting to be deported. In this picture, an unidentified woman holding an infant smiles after being released with the help of one of the humanitarian agencies. (Courtesy of El Rescate Archives.)

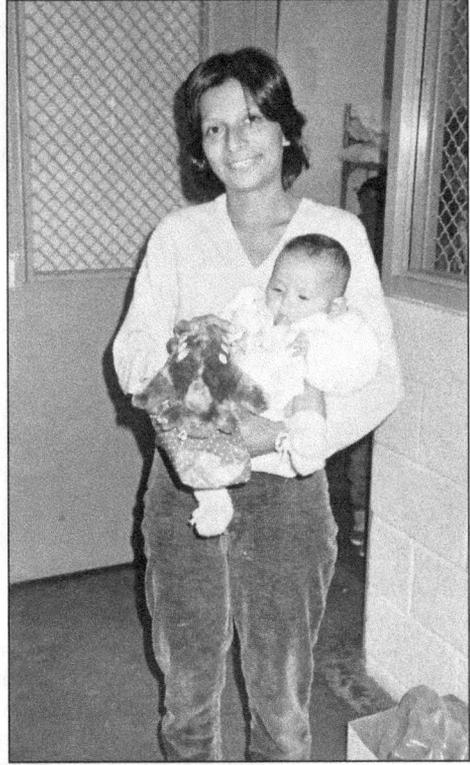

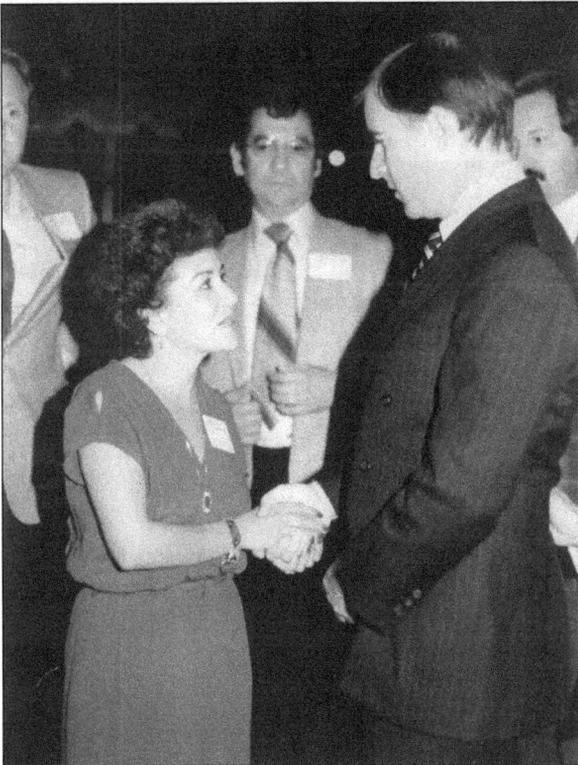

Isabel Cardenas was one of the concerned citizens advocating for Guatemalan and Salvadoran refugees during the early 1980s. She lobbied California governor Jerry Brown to grant special refugee status for the civilians affected by the wars. Pictured in the center are Cardenas (left) and Brown. (Courtesy of Isabel Cardenas.)

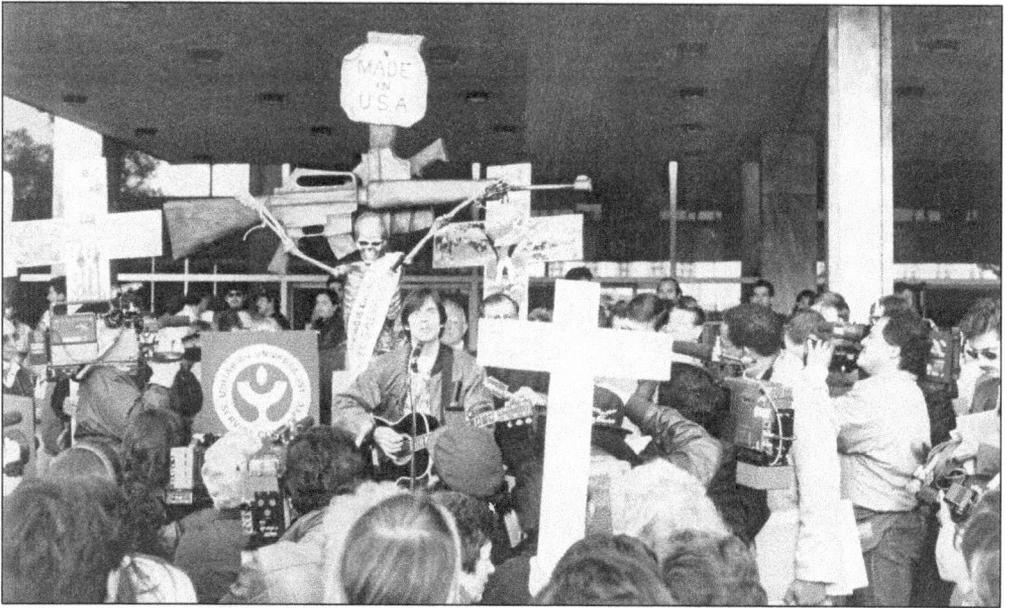

Concern was growing about flagrant abuses by governments in Central America and the refusal of U.S. agencies to recognize the increasing numbers of immigrants who were in need. A variety of human rights activist groups began to protest and advocate for the new arrivals. As Central Americans continued to flee from the civil wars, Los Angeles's many Hollywood celebrities and clergy became active, participating in and organizing a range of activities to show their support for the Central American community and to state their discontent with U.S. intervention and financial support of the wars. Throughout the 1980s, volunteer musicians and movie stars offered concerts, dinners, and theatricals to raise awareness of the conditions in Guatemala, El Salvador, and Nicaragua, and to protest the unjust immigration policies. Singer Jackson Browne, above, and actor Martin Sheen, below in the first row at left, are pictured in a rally in front of the Los Angeles office of Immigration and Naturalization Services. (Both courtesy of El Rescate Archives.)

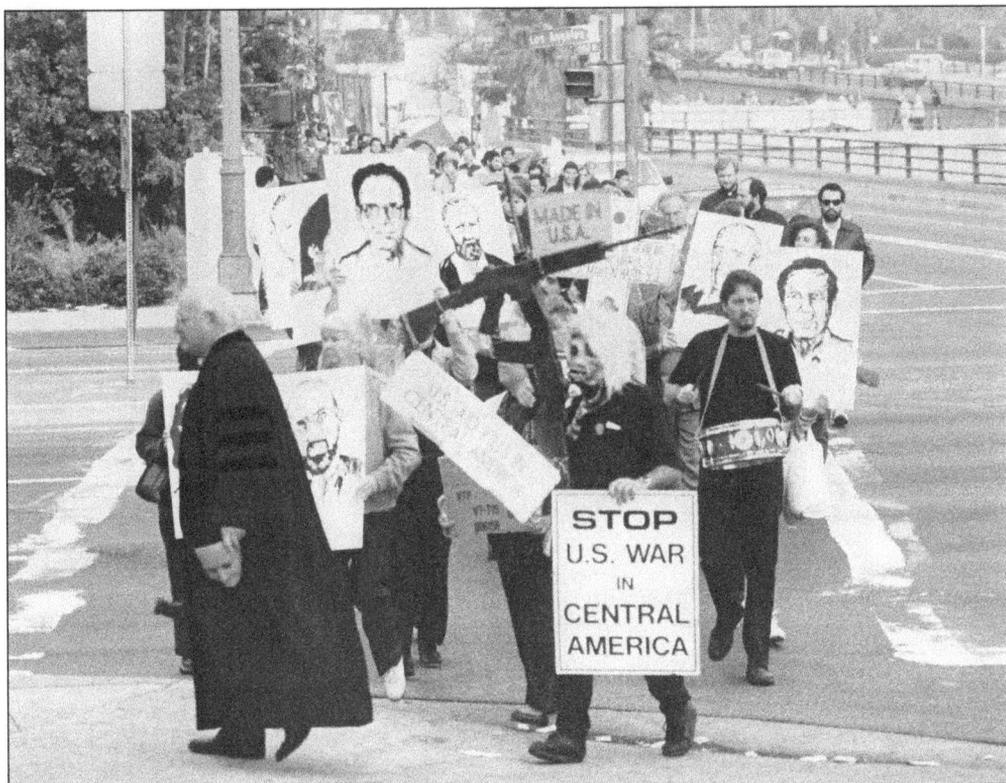

Demonstrations and marches from MacArthur Park through downtown Los Angeles were common while the bloodshed in Central America continued. In the picture above, Blase Bonpane, director of the Office of the Americas in Los Angeles, leads a group of peace advocates (below), marching through downtown and ending at Los Angeles's federal building where the group formed a human wall protesting the United States's policies in Central America. Bonpane has been an active campaigner for peace, monitoring human rights issues in Central America. In 1984, he was awarded a certificate of commendation by the City of Los Angeles for his dedication to the Central American regions. (Both courtesy of El Rescate Archives.)

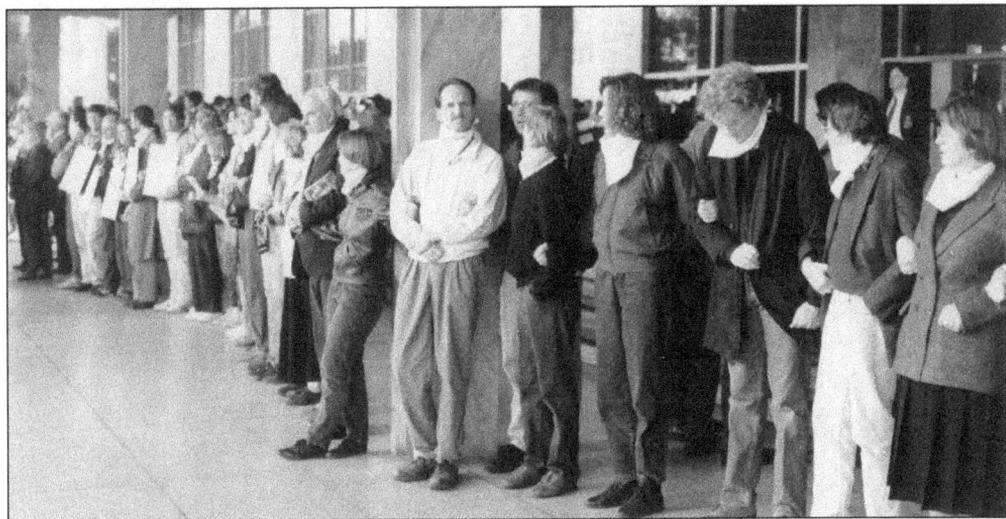

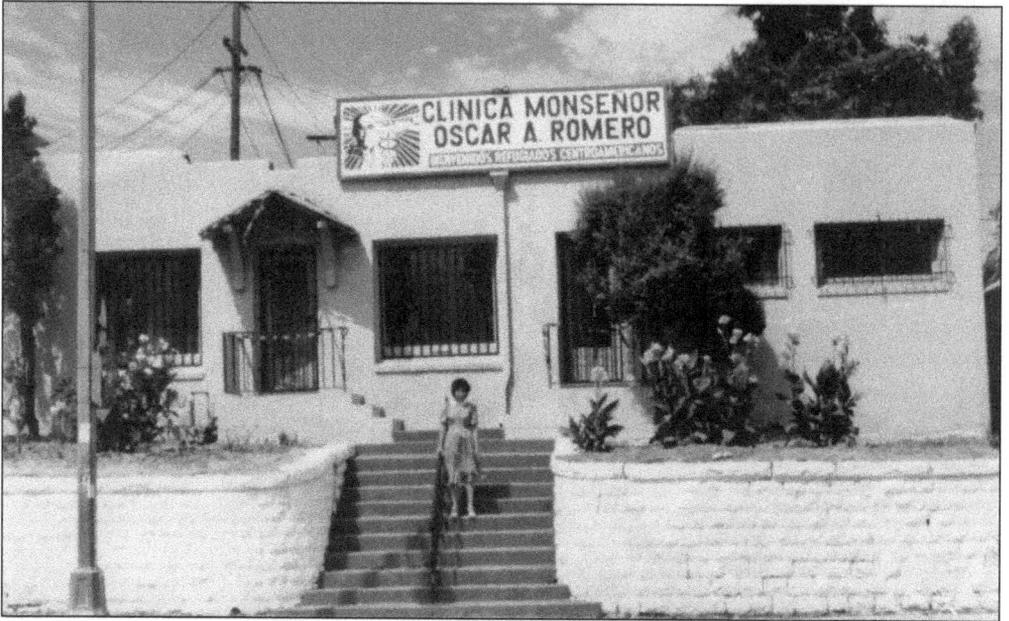

Clinica Romero was established in 1983 with the efforts of refugees and other volunteers. The medical clinic opened its doors in a small house in the Pico-Union area. It was run with private contributions, donated medications, volunteer medical professionals, and other workers who assisted the Central American refugees. The name of the clinic was inspired by the life of martyr Monsignor Oscar Romero, the archbishop of San Salvador, assassinated in 1980 by a Salvadoran right-wing group. Since its opening, this free clinic has maintained an exemplary country-wide reputation, attracting political figures, such as presidential nominee John Kerry, who visited Clinica Romero in June 2006. The above image shows Clinica Romero's first location on 1833 West Pico Boulevard; below, Mayor Tom Bradley visits Clinica Romero during its opening. (Both courtesy of Clinica Romero.)

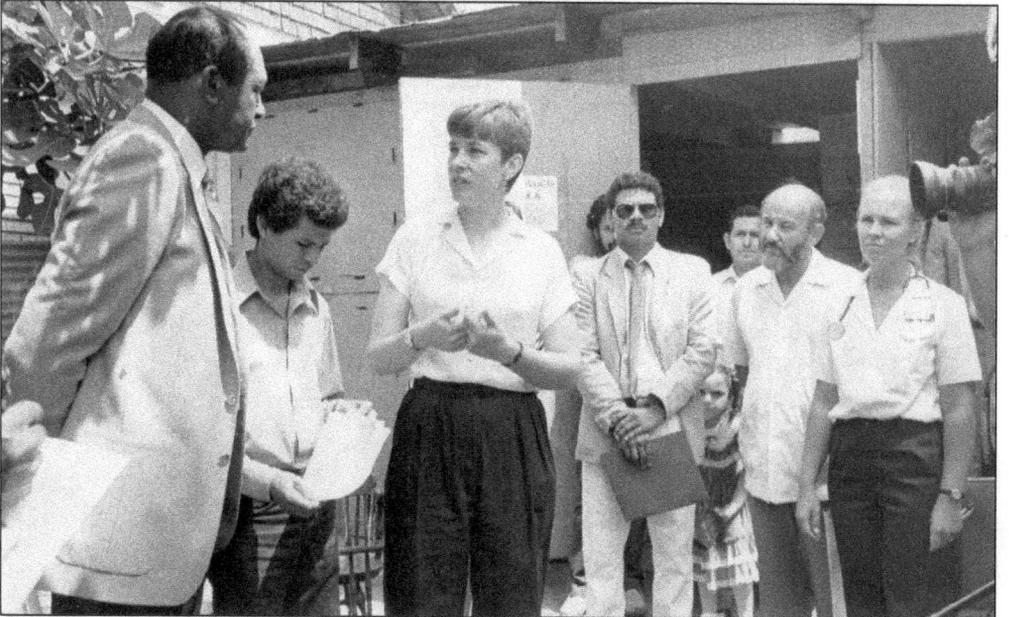

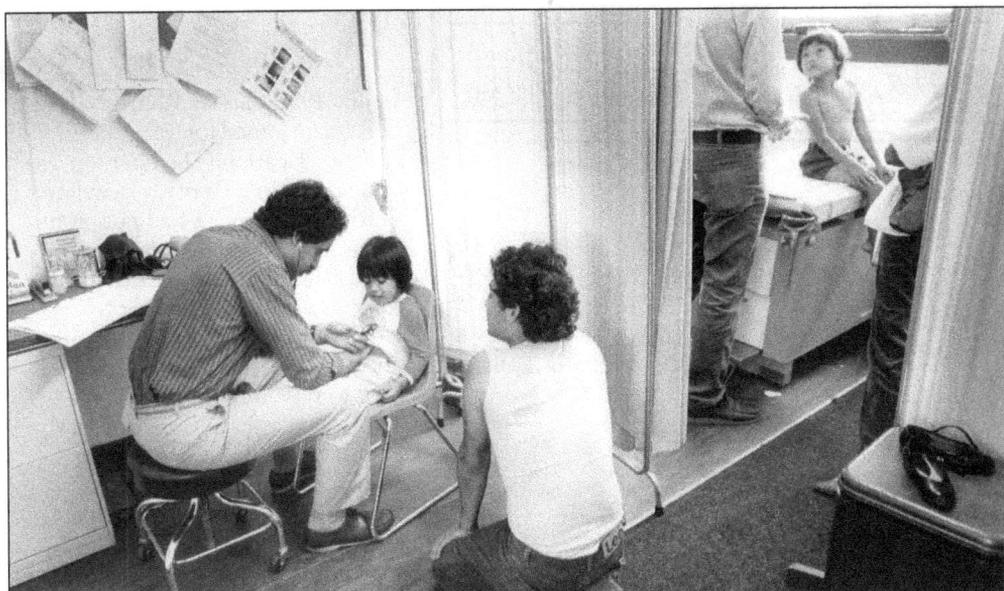

The house where Clinica Romero began its services was so small that doctors used portable partitions to make examining rooms. The resources to manage the agency were very scarce, but volunteer medical providers and others were always eager to help. Clinica Romero's initial mission was to assist the Central American refugee community, but it has always been available all indigent patients because the Pico-Union neighborhood was, and remains, deficient in adequate social services, and the needs of the community have always exceeded its resources. As Clinica Romero developed, its offerings also expanded, adding dental services and health education with outreach workers who went out to the community. Today Clinica Romero continues to provide free health care services in the Pico-Union area and has added another facility in the Boyle Heights neighborhood. (Both courtesy of Clinica Romero.)

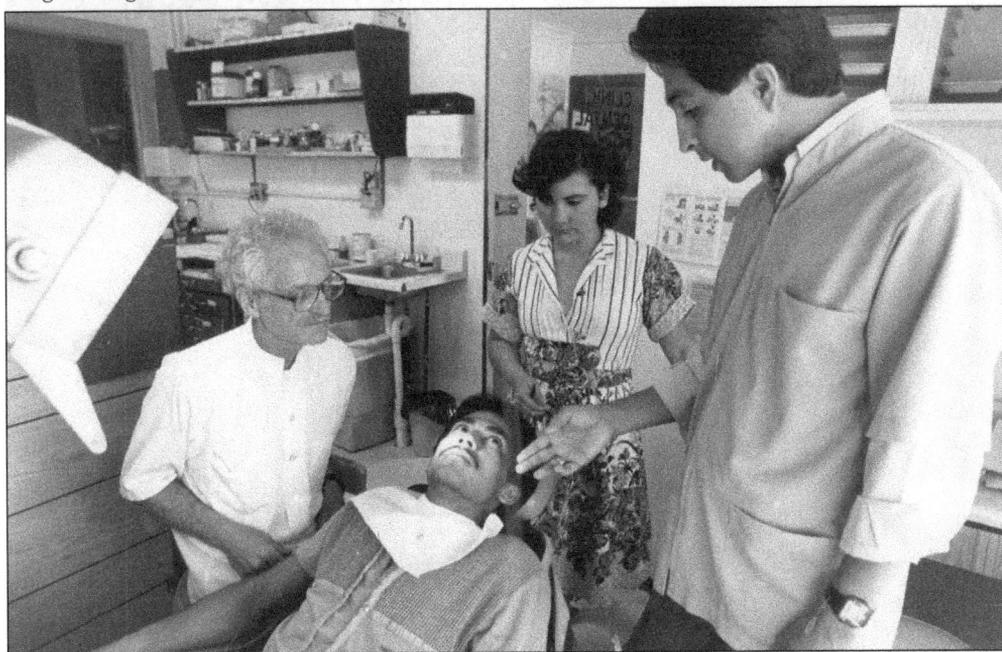

In July 1987, Clinica Romero and El Rescate joined forces and moved to a new location. The opening was announced in a monthly newsletter (left). Both agencies had nonprofit status and were able to receive grants that they used to expand their services, reaching out to a larger number of people. Concerts and social gatherings were also used to raise funds. For example, actors such as Esai Morales, Daryl Hannah, Rob Lowe, and others attended a 1988 benefit dinner for El Rescate, after they went to the Oscar awards. In the same year, another benefit event for El Rescate was held at the II Giardino Restaurant; attendees included Jane Fonda, Kris Kristofferson, and Faye Dunaway. Other smaller fund-raising events were held on Clinica Romero's patio (below). From left to right are Ciro Hurtado, Will Echegoyen, and unidentified. (Both courtesy of Clinica Romero.)

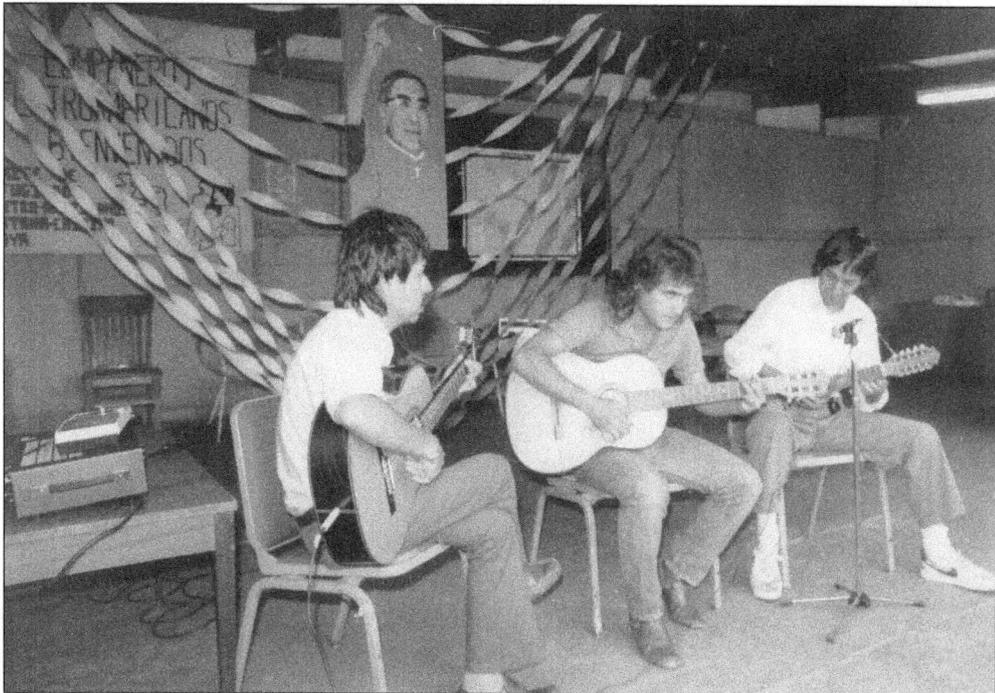

El Rescate

A PROJECT OF THE SOUTHERN CALIFORNIA ECUMENICAL COUNCIL

Clínica Msr. Romero

Volume 5 Issue 2 — 2675 WEST OLYMPIC BOULEVARD, LOS ANGELES, CA 90006 — September, 1987

The Prospect for Peace in Central America

Edificio Romero Opens

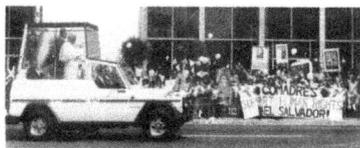

42

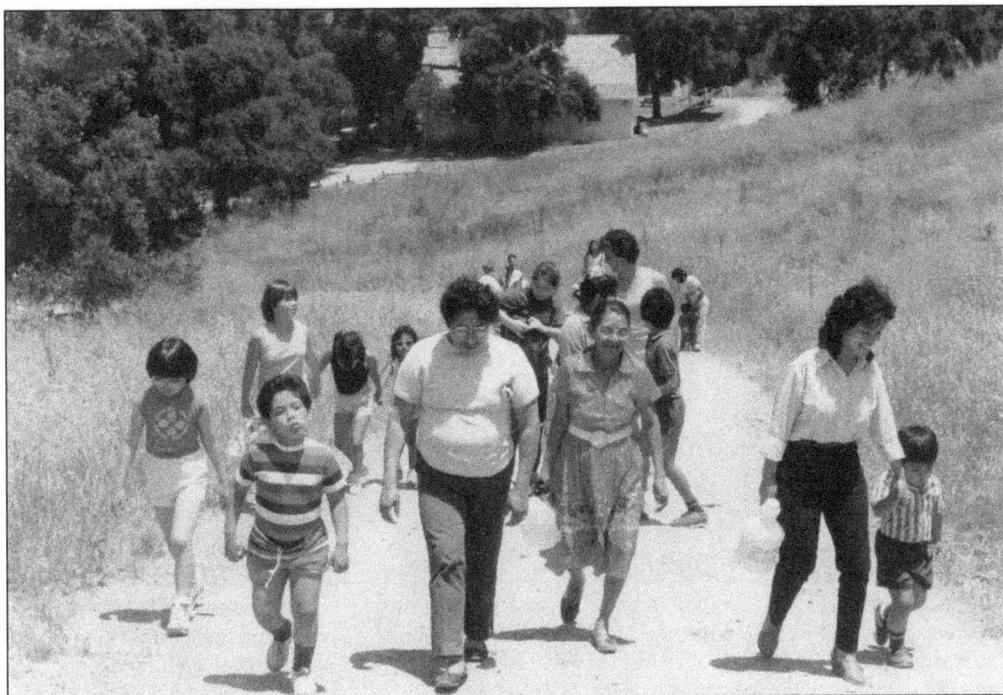

With the help of El Rescate volunteers, refugees got together and planned activities that brought families and neighbors together. Some of the activities included family trips to the beach, parks, and entertainment for the children. At other times, families got together on a weekend to do street cleaning. The staff of El Rescate searched for donated cleaning supplies, transportation, and food. Above, parents and children are enjoying a hiking trip in Malibu Creek State Park. These gatherings also served to inform people about local and international issues. In 1986, Mayor Tom Bradley wrote a letter (at right) to El Rescate, recognizing the important role of the agency in the community. (Above, courtesy of Joaquin Romero collection; right, courtesy of El Rescate Archives.)

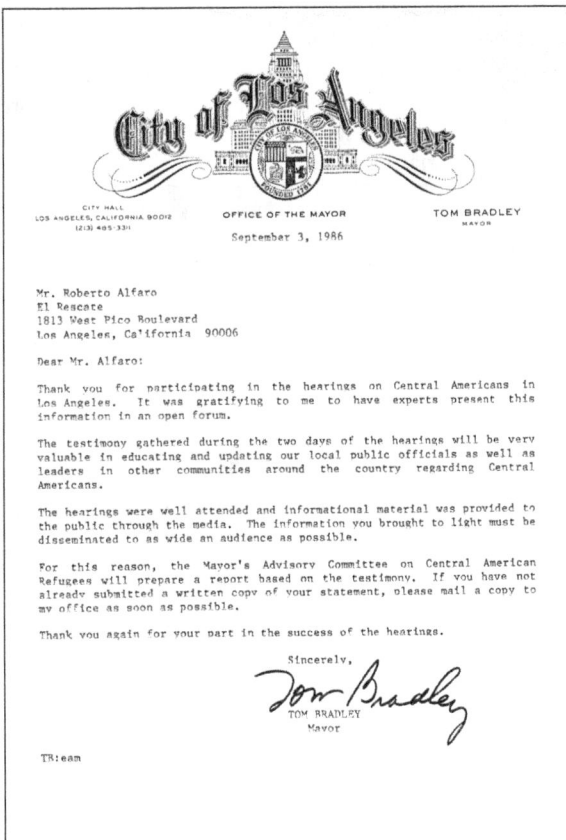

City of Los Angeles

CITY HALL
LOS ANGELES, CALIFORNIA 90012
(213) 485-3311

OFFICE OF THE MAYOR

TOM BRADLEY
MAYOR

September 3, 1986

Mr. Roberto Alfaro
El Rescate
1813 West Pico Boulevard
Los Angeles, California 90006

Dear Mr. Alfaro:

Thank you for participating in the hearings on Central Americans in Los Angeles. It was gratifying to me to have experts present this information in an open forum.

The testimony gathered during the two days of the hearings will be very valuable in educating and updating our local public officials as well as leaders in other communities around the country regarding Central Americans.

The hearings were well attended and informational material was provided to the public through the media. The information you brought to light must be disseminated to as wide an audience as possible.

For this reason, the Mayor's Advisory Committee on Central American Refugees will prepare a report based on the testimony. If you have not already submitted a written copy of your statement, please mail a copy to my office as soon as possible.

Thank you again for your part in the success of the hearings.

Sincerely,

Tom Bradley

TOM BRADLEY
Mayor

TB:eam

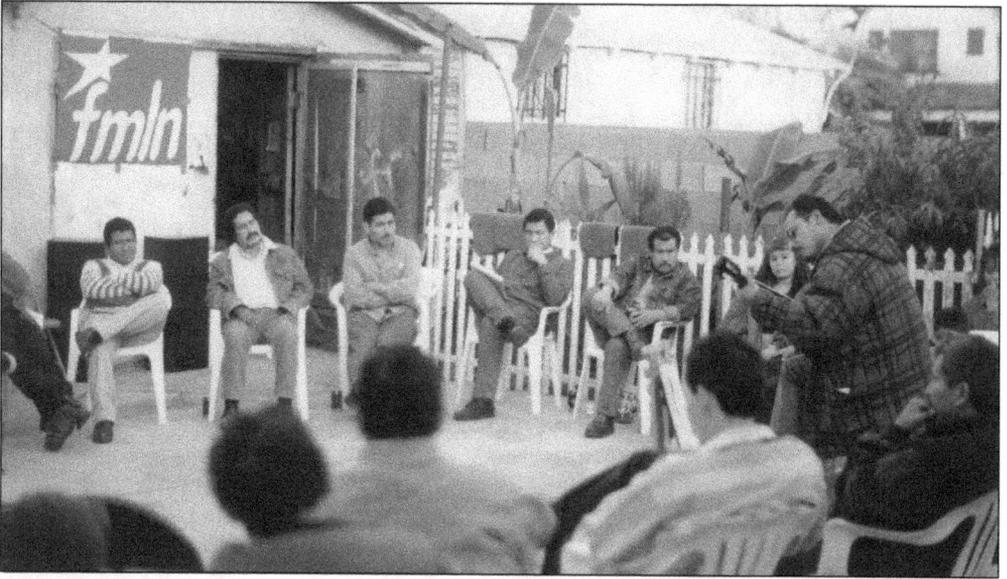

In Los Angeles, a group of Salvadoran refugees and local supporters formed in solidarity with the Frente Farabundo Martí de Libración Nacional (FMLN)—in English, the Farabundo Martí National Liberation Front—a leftist political party of El Salvador. Above, a group of FMLN members is meeting in the backyard of a house. From left to right are Julio Cristales, Rafael Escamilla, Hector Rivera, unidentified, Magin Parada, unidentified, and Manuel Olmos. The FMLN presence in Los Angeles has been palpable in the area surrounding MacArthur Park, where supporters often meet for celebrations, rallies, fund-raising events, or general information meetings. Below, a group of musicians gets ready for a concert in the historic band shell in MacArthur Park on an afternoon in August 1984. (Above, courtesy of Joaquin Romero collection; below, courtesy of Francisco Carias.)

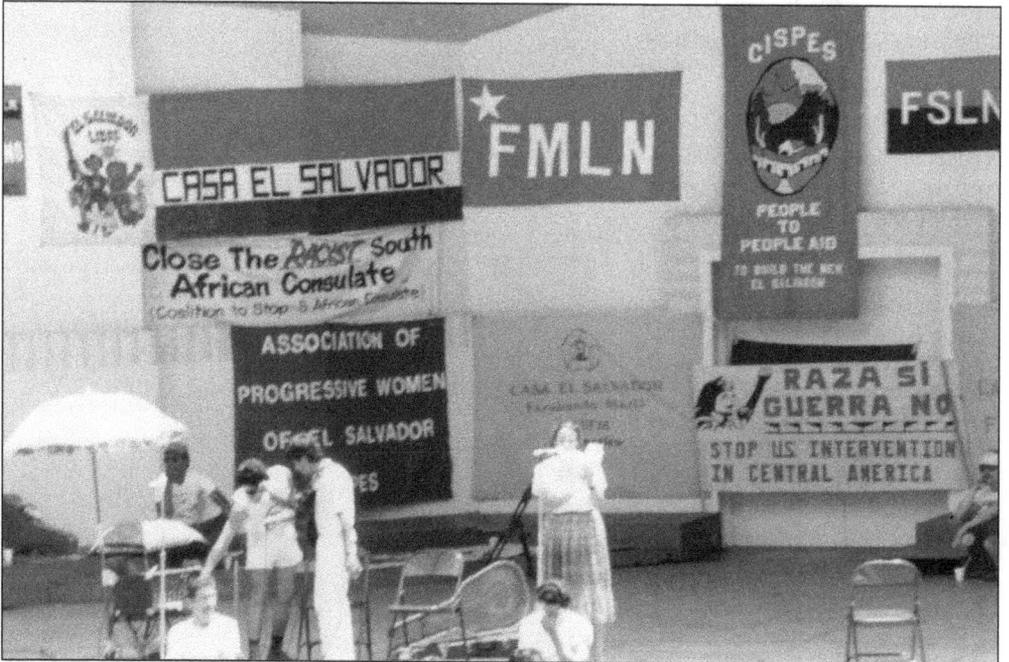

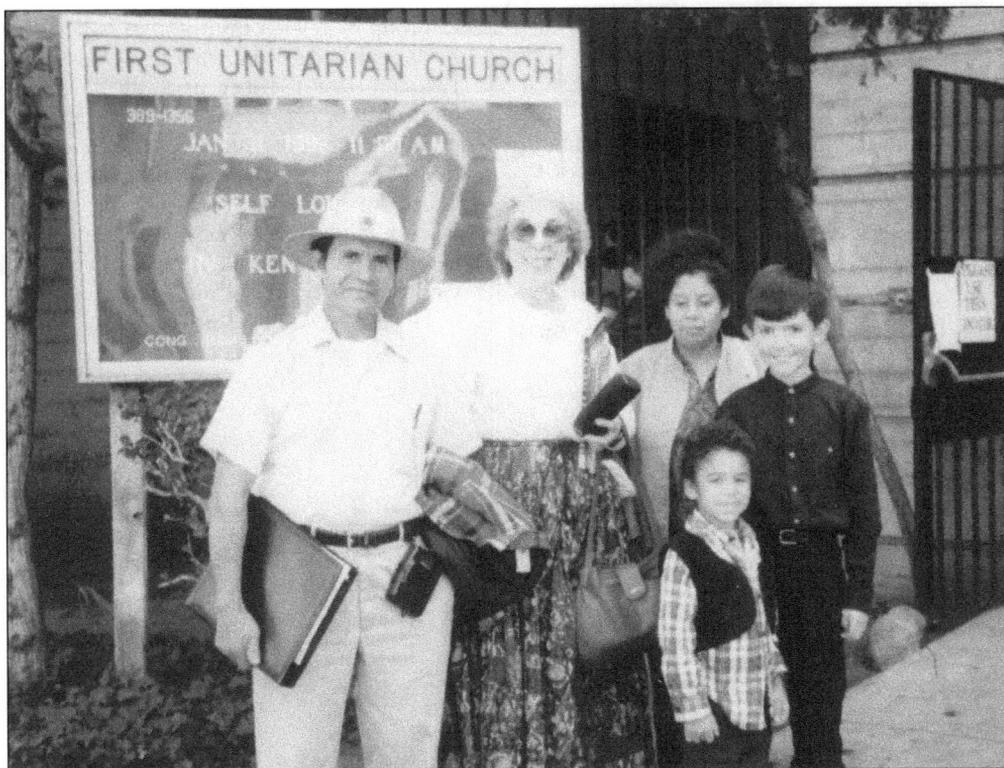

Throughout the nation, different groups concerned about the United States's intervention in Central America and about the human rights of refugees were formed. Religious groups came together to form coalitions. For example, in New York, a group was formed and named Inter-Religious Task Force on Central America. In Los Angeles, the Southern California Ecumenical Council Interfaith Taskforce on Central America (SCITCA) and the Unitarian Universalist Service Committee were some of the activist groups educating and mobilizing the local religious communities. Pictured above from left to right are unidentified; Rochelle McAdam, an activist of the sanctuary committee; and Noemy Zelada and two unidentified child, who were a part of a group of refugees protected by the sanctuary community. At right is an illustration from the February 1983 *la Opinion* newspaper of the sanctuary movement. (Above, courtesy of Rochelle McAdam; right, courtesy of la Opinion/Impremedia.)

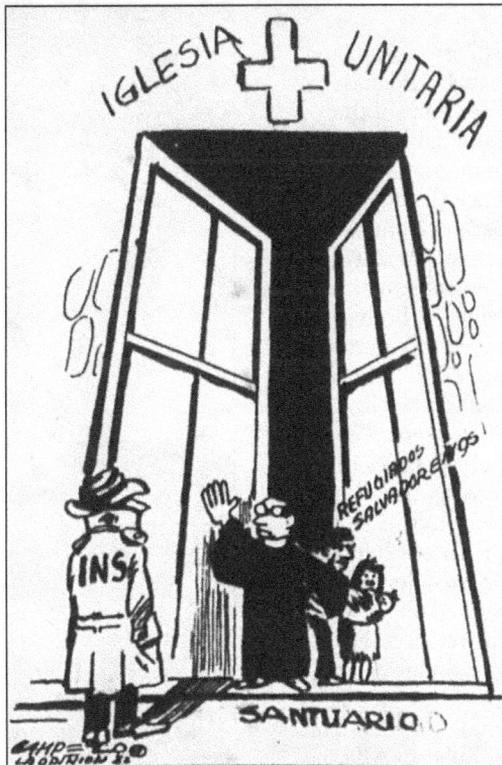

New Jewish Agenda, Guatemala Information Center, Comité El Salvador
PRESENT/A

de/from **ELLIS ISLAND**
a/to **EL NORTE**

fronteras diferentes tierra común
different borders common ground

Ed Asner

Ellis Island Band Sabiá

Domingo, 20 Abril, 1986
Sunday, April 20, 1986
3:00 P.M.

Fairfax High School

These school premises have been licensed pursuant to the provisions of Section 39379 of the Education Code of the State of California by NEW JEWISH AGENDA from the board of Education of the City of Los Angeles. The Board of Education does not sponsor or take responsibility, nor does it necessarily endorse any of the activities, statements, or opinions which may be expressed at this meeting or activity.

A group of Jewish immigrants called the New Jewish Agenda, with the Guatemala Information Center and El Salvador Committee, organized a musical theater production to raise funds for the sanctuary movement. The play, *From Ellis Island to El Norte*, was presented on April 20, 1986, at Fairfax High School; performers included actor Ed Asner, as well as other Jewish and Central American cast members. (Courtesy of El Rescate Archives.)

Roberto Alfaro and Isabel Cardenas were some of the early Salvadoran immigrants, who, since the late 1970s, became politically active, advocating for Central American refugees. Both of them were supporters of the work of El Rescate and Clinica Romero. Alfaro served as El Rescate's executive director from 1985 to 1987. In this picture, they are accompanied by Salvadorans who worked on behalf of the refugees. From left to right are Alfaro, Camilo, Cardenas, and unidentified. (Courtesy of Roberto Alfaro.)

As Pres. Ronald Reagan's administration tightened its policy towards the Nicaraguan Sandinista government and continued supporting the anti-Sandinista group (Contras), many of the Los Angeles–based Nicaraguans campaigned throughout the nation to expose the intervention, funding, and military aid of the United States against the legitimate Nicaraguan government. Different coalitions were formed, and several newsletters were distributed to update and inform the public. At right is an image of a 1987 bulletin. The Los Angeles Nicaraguan community was supported by U.S. citizens, as well as other immigrants. In the picture below, a group of supporters that included Hondurans, Mexicans, Salvadorans, and Nicaraguans met in Los Angeles Casa Nicaragua. (Right, courtesy of El Rescate Archives; below, courtesy of Pedro Arias.)

Nicaragua
NETWORK NEWS
A Bimonthly Bulletin of the Nicaragua Network
April 1987 Vol. 1, No. 2

Ronald Reagan's
Foreign Policy Crisis
by David Reed

Ronald Reagan's foreign policy, designed to "let America Stand Tall Again," is in crisis. The policy collapse is not due to his oft-touted "poor management style," but is the consequence of more fundamental flaws in overall policy design. These flaws were merely exacerbated by the Iran/contra scandal.

The past six years have seen the largest military build-up in our nation's history. The purpose: to reestablish U.S. military supremacy around the world. The US has tried to reestablish nuclear superiority over the Soviet Union through the production of an array of "first strike" weapons. And, through the Reagan Doctrine, the Administration has attempted to halt the gains of progressive movements in the Third World and to overthrow progressive Third World governments that have come to power in the past decade such as Nicaragua, Angola and Grenada.

But the Reagan foreign policy has failed miserably. Despite large injections of aid to the governments of El Salvador, Guatemala and South Africa, liberation struggles in those and other Third World countries continue to advance. U.S. patronage of the Nicaraguan contras and the UNITA forces has failed to topple those progressive popular governments.

NON-ALTERNATIVES

This failure has provoked deepened debate among policy makers. Unfortunately, this debate has concentrated on *means*. The *ends*-- containing a phantom threat of international communism and reestablishing US military supremacy--are never questioned. Democrats and Republicans alike fundamentally agree on those objectives. At issue is merely how to achieve the goals.

Currently, this foreign policy debate focuses most sharply on providing military aid to the Nicaraguan contras. On the one hand, the administration opts to use military force to overthrow the Nicaraguan government. The liberals prefer promoting the internal opposition forces in Nicaragua, and using international, financial, commercial and diplomatic pressure to "contain" the Nicaraguan revolution. Meanwhile, they advocate massive aid to the other Central American governments and do nothing to address the overwhelming US military presence in Honduras. This is hardly an alternative.

IRAN/CONTRA SCANDAL DEEPENS CRISIS

The Iran/Contra Scandal has focused public attention on this debate and intensified it as well. The scandal has damaged Reagan's public acceptance at home and weakened the US's relationship with allies. Totally absent, however, is a more fundamental challenge to the principles guiding our government's foreign policy. No critique is heard from policy makers as to the viability of the containment policy underlying our government's present intervention in Central America and South Africa. Our government's failure to respect and respond to the legitimate rights of all peoples in the Middle East is not questioned. Both the scandal itself and the fundamental crisis in our foreign policy are being reduced to the level of "mismanagement." There is no questioning the basic assumption that the U.S. has the right to intervene around the globe and to violate international and domestic law and order in the pursuit of global powers cloaked in the guise of "national security."

Dr. Martin Luther King understood the pervasiveness of this assumption as the basis for all US foreign policy, no matter what the decade, no matter what the administration. In his speech, entitled "Beyond Vietnam," Dr. King said,
(Continued on page 13)

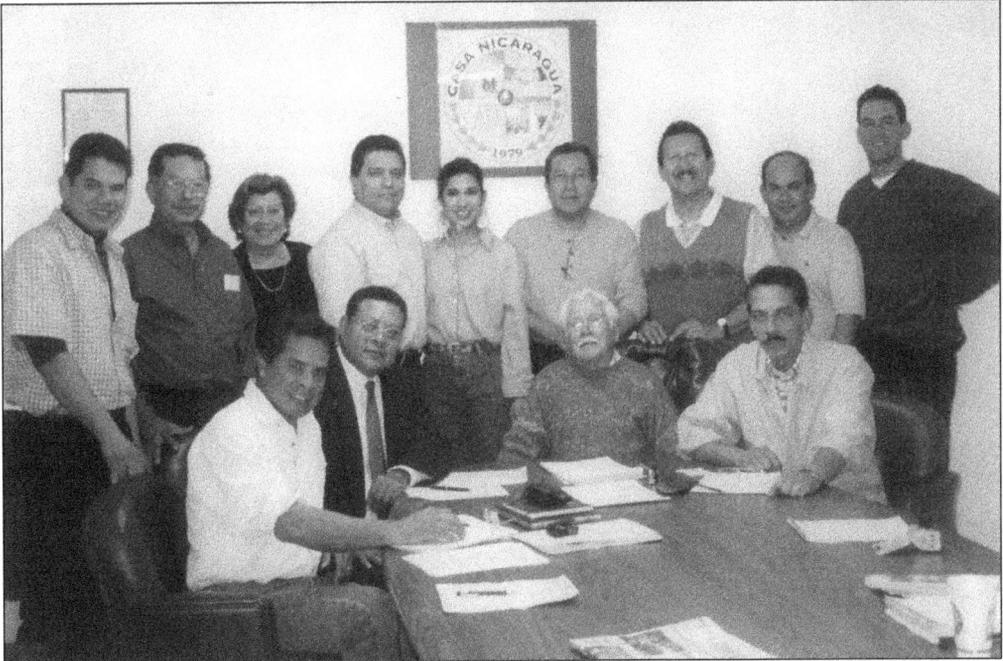

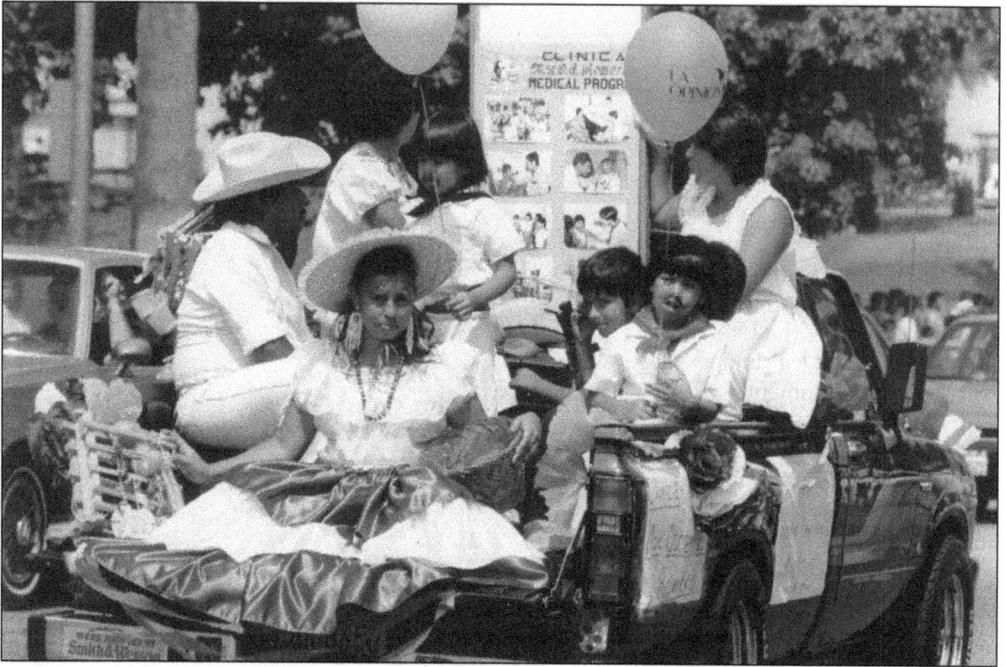

In 1983, a group of Central Americans started a Central American Independence Day parade, where various floats with Central American music paraded around Pico-Union, representing local organizations and businesses. In the above picture, a float represents Clinica Romero's sixth anniversary of providing services to the community. Sitting in the center is Clinica Romero employee Edith Hernandez; the others are unidentified. Below, the crowd in 1983 occupies half of Alvarado Street; today the parade has become so popular that it takes up the entire boulevard. (Both courtesy of Francisco Carias.)

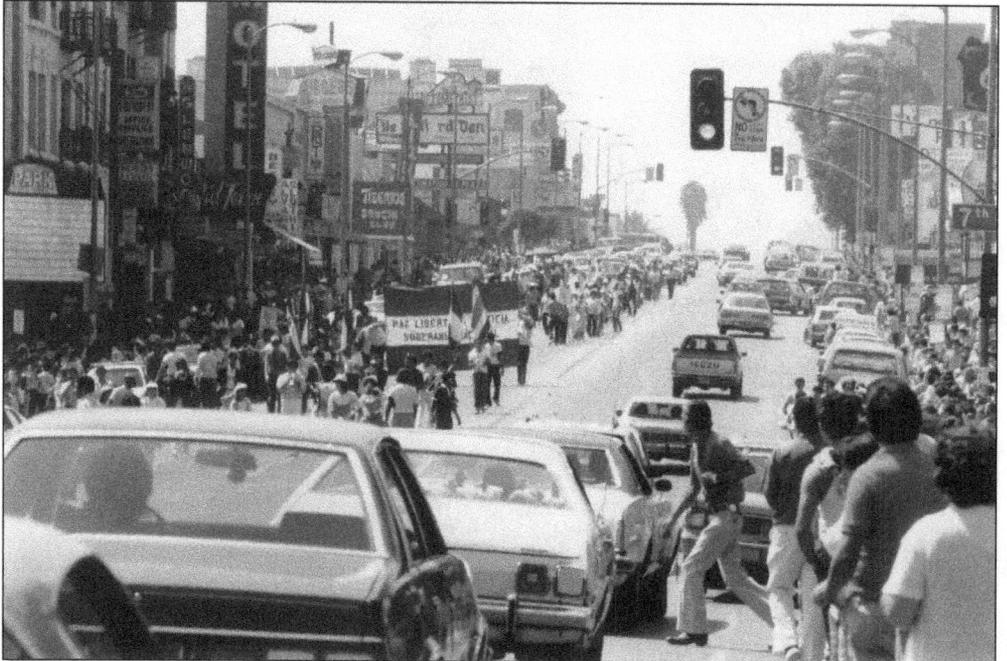

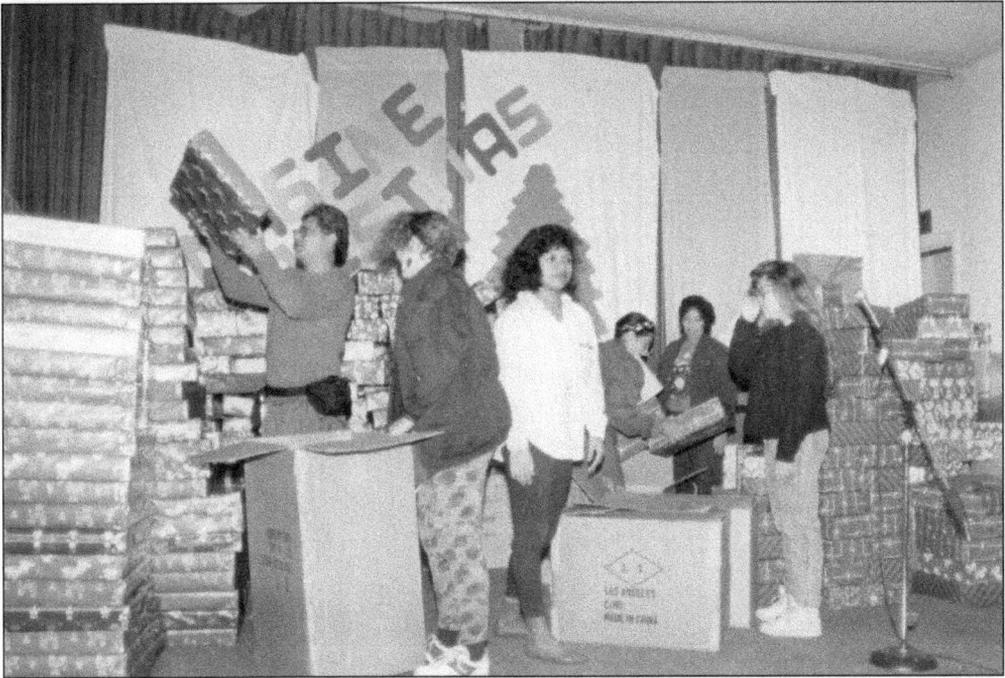

Clinica Romero made Christmas celebrations traditional occasions by collecting donated toys to give to the local families in Pico-Union. During the 1989 Christmas season, Clinica Romero collected over 1,000 donated gifts for neighborhood children. In addition, it gathered more gifts that were delivered to 200 refugee children held in detention centers by Immigration and Naturalization Services. Above, on December 21, 1989, Clinica Romero's employees and volunteers helped to organize the presents. From left to right are Oscar Lopez, Edith Hernandez, Alba Escobar, Sara Martinez, and two unidentified. Below, a group of Pico-Union community children is ready to collect surprises, as a Santa Claus piñata is about to spill some goodies. (Both courtesy of Clinica Romero.)

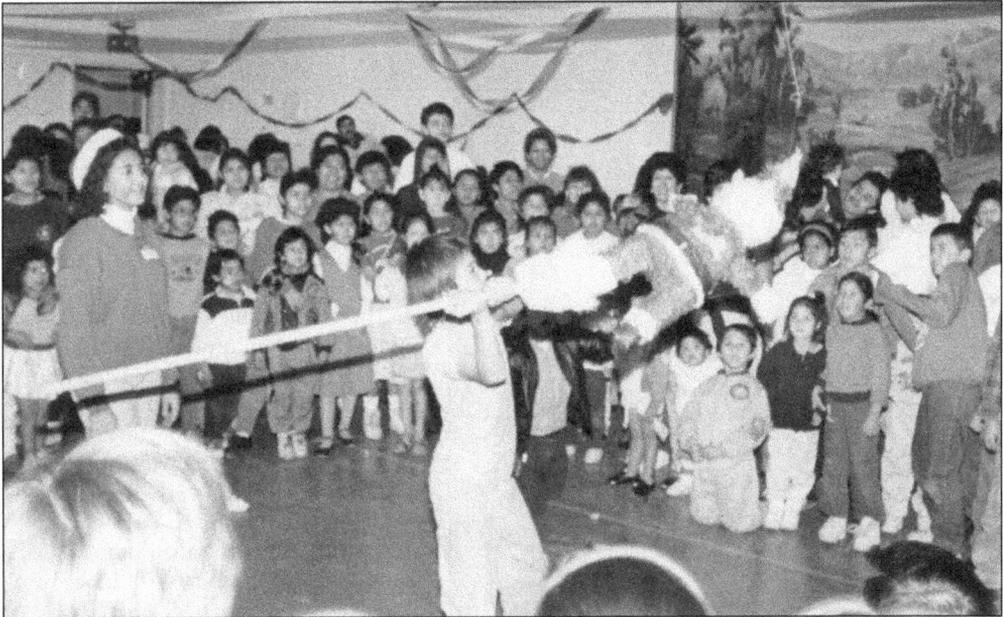

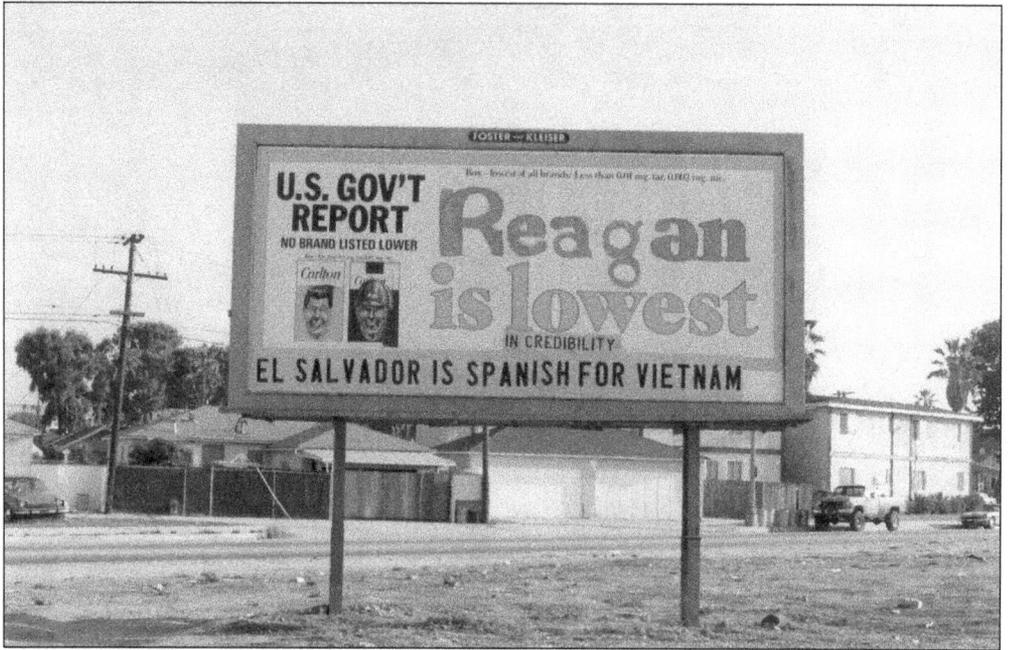

During Pres. Ronald Reagan's administration, Central Americans in Los Angeles organized a series of demonstrations to protest the United States's involvement in the bloodshed. A group of Los Angeles activists used their graphic skills to redesign this billboard, sending messages to Reagan. (Courtesy of Roberto Alfaro.)

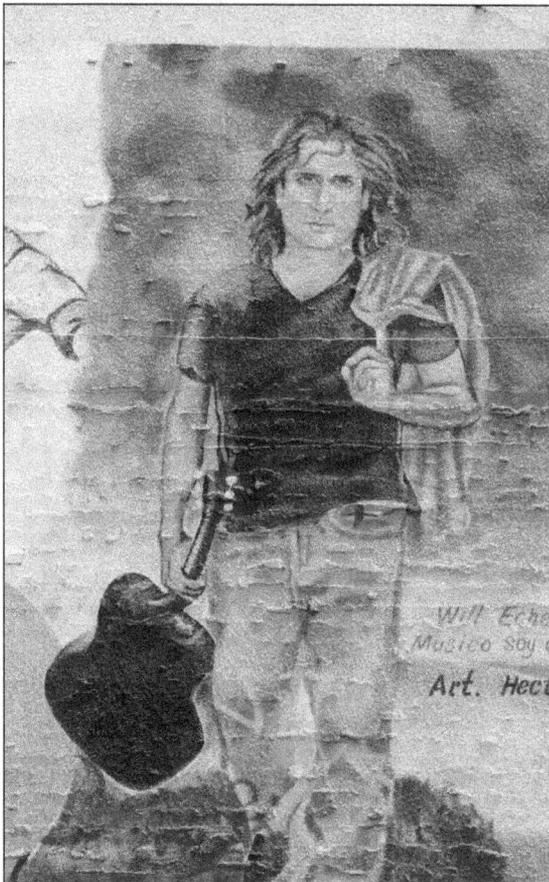

As the burgeoning Central American immigrant community settled in the MacArthur Park area, they tried to establish their presence in different ways. Today on Alvarado Street north of Seventh Street across from MacArthur Park Lake, there is a symbolic mural that was painted in the late 1980s of Salvadoran immigrant troubadour Will Echegoyen. (Courtesy of Remberto Diaz.)

Three

A CULTURE OF TRANSNATIONALISM AND BELONGING

As the political turmoil in some Central American nations was prolonged and the economies of most of the countries deteriorated, many of the immigrants had already put down roots in the streets of Los Angeles. Faced with the possibility of returning to their native lands, they chose not to go back because they had established new lives in this city. Many had married and had children with spouses of other nationalities, making the dream of return unlikely and, in some cases, impossible. Others had established businesses in Los Angeles neighborhoods, such as restaurants, grocery stores, and bakeries, which catered to the yearning for native tastes. At the same time, there was the launching of international courier services for local and international needs. Hence, many began a new transnational life, maintaining cultural, economic, and family ties with their countries of origin. During the period, community leaders of the 1990s shifted their efforts to campaigning to obtain work permits and to seek permanent residency status for the many undocumented immigrants.

Several of the already established nonprofit organizations, as well as newer ones, began to address chronic social problems that were affecting local residents of the Los Angeles area. For example, El Rescate engaged in economic development programs, and the Association of Salvadorans in Los Angeles (ASOSAL) began working on immigration legal issues, as well as getting licenses for street vendors. The Central American Refugee Committee addressed legal needs, the Guatemala Unity Information Agency (GUIA) provided computer training and GED courses to help immigrants get their high school diplomas, and after school programs and a newer organization named the Salvadoran-American Leadership and Education Fund (SALEF) focused on scholarship funds and on promoting naturalization and voting participation. There were also grassroots efforts oriented toward youth and family support services. Many Central American families have raised their children in neighborhoods that suffer from inner-city problems, such as gangs, drugs, poverty, overcrowding, and lack of social services. These conditions have led to a generation with increased rates of high school dropouts, gang affiliations, and other problems plaguing inner-city dwellers. Nevertheless, the Central American community and its friends have continued to work together to build healthier communities.

During the 1990s, more Central American nonprofit organizations were born and dedicated themselves to the immigrant communities. One of them is ASOSAL, founded in 1991 by a group of Salvadorans who were seeking to legalize and defend immigrant rights. Today, as with previous organizations, some of ASOSAL's goals include political advocacy and social services. However, the organization has also focused attention on disseminating the richness of the Salvadorans and other Central American culture and identity. ASOSAL, located in the heart of the Pico-Union neighborhood, offers free classes of Central American folk dances for children and marching band music lessons, among other courses. The organization also maintains a strong connection with El Salvador through a program designed to send financial aid to needy communities. In these pictures, a group of unidentified children, students of ASOSAL, is displaying traditional costume. (Both courtesy of Association of Salvadorans in Los Angeles collection.)

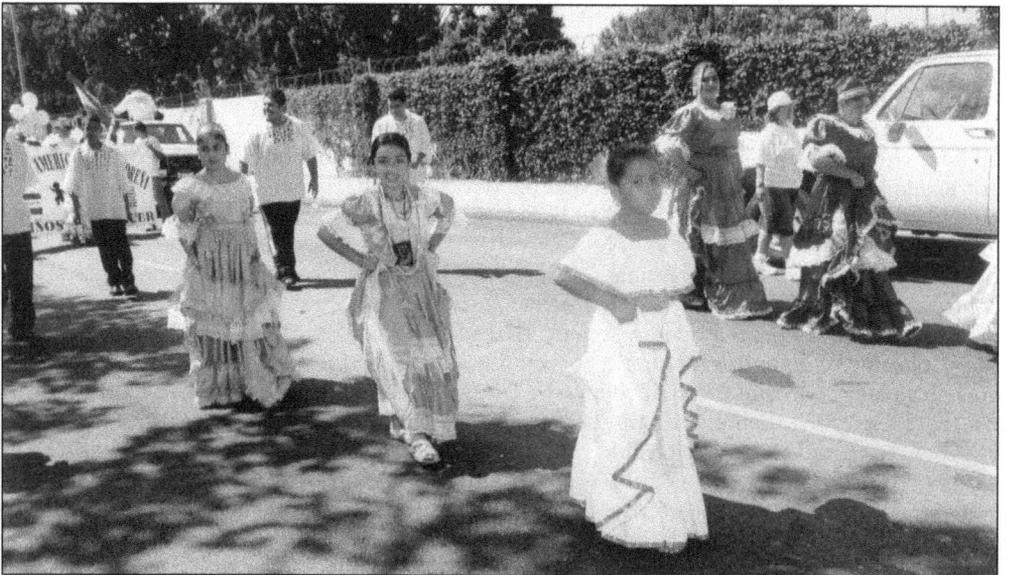

ASOSAL places emphasis on building children's self-esteem. It also appreciates the importance of immigrant children adapting to the new culture. For this reason, the organization includes in their curriculum ballet and cheerleading classes. The Pico-Union neighborhood, where ASOSAL is located, has a high-density population, mostly low income, and is underserved in afterschool recreational activities. Hence, the children benefit greatly from all the available free classes, as is apparent in this image of the joyful faces of these unidentified children, who are pupils of ASOSAL. (Both courtesy of Association of Salvadorans in Los Angeles collection.)

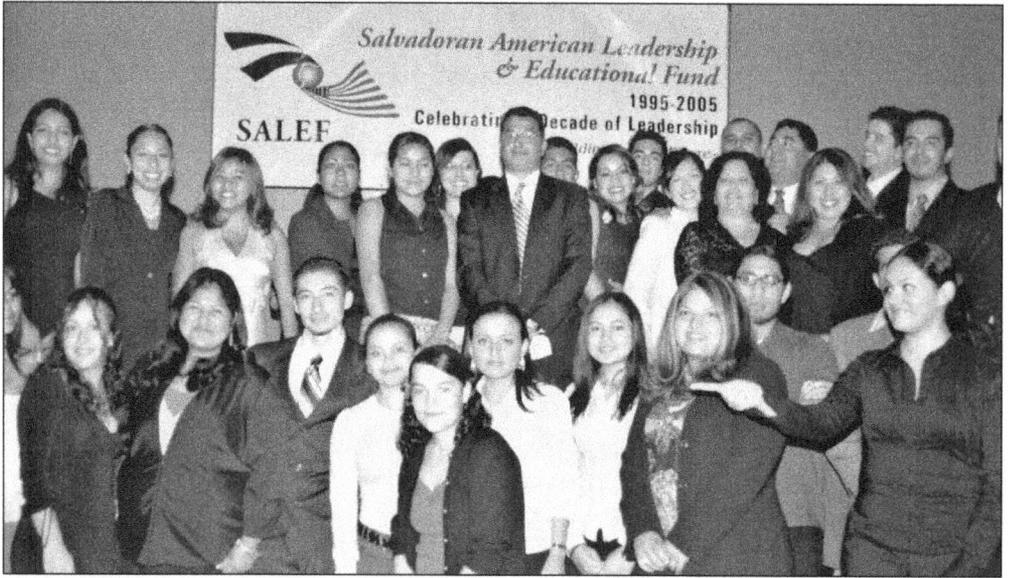

SALEF is another organization formed in 1995 by a group of Salvadoran immigrants and other activists. It has been dedicated to promoting civic participation, including voter registration, U.S. citizenship, leadership development, and one of its most prominent goals, which is to provide educational financial assistance for higher education to Central American and other Latino college students. Additionally, the organization works with entities from El Salvador to promote the country's economic and political progress. In this picture, SALEF executive director Carlos Vaquerano (center, second row) is with a group of unidentified recipients of scholarship awards. (Courtesy of Joaquin Romero collection.)

The presence and influence of the Central American community in Los Angeles has been well recognized nationwide, attracting a variety of political figures. Luis Gutierrez, representative of Illinois's fourth district, made a trip to Los Angeles and met with some of the members of a Central American coalition. (Courtesy of United Hondurans of Los Angeles collection.)

A group of Honduran immigrants began meeting in 1997 in the offices of the Central American Resource Center (CARECEN) to understand current immigration rights. Three months after the first meeting, the group had organized a delegation and traveled to Washington, D.C., meeting other Honduran immigrants from across the United States, to express their concerns. By 1998, with the help of CARECEN, a new organization was founded, called United Hondurans of Los Angeles (HULA). The organization offers social services in Los Angeles, and it also assists needy communities in Honduras. CARECEN is an organization founded by a group of Salvadoran refugees who sought to legalize the immigrant status of those fleeing the bloodshed affecting Central America during the 1980s. In the picture above, Hondurans celebrate the first anniversary of HULA. Below, Hondurans proudly display the name of the new organization. (Both courtesy of United Hondurans of Los Angeles collection.)

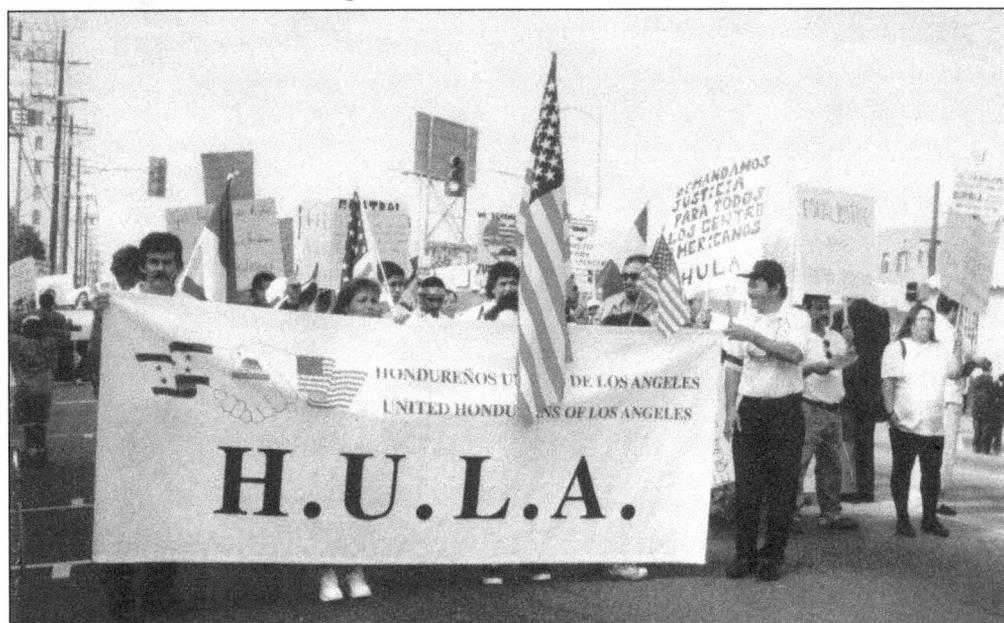

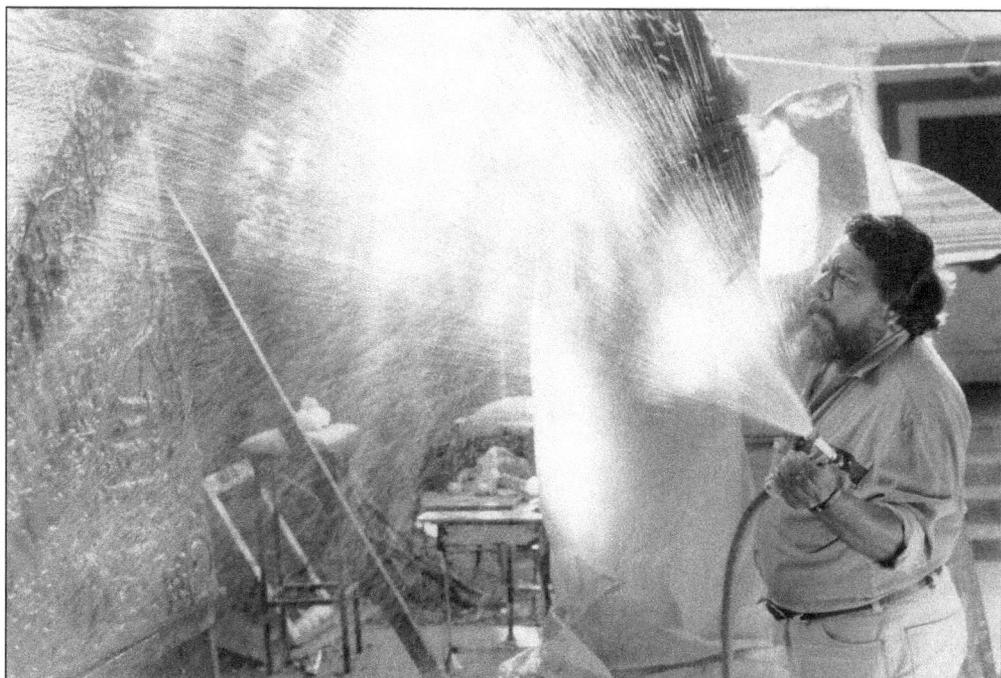

A group of Salvadorans, with the help of the organization El Rescate, attempted to preserve their history in a time capsule that was buried in MacArthur Park in 1993; it will be opened in 2093. Among the items contained in the capsule are letters, pictures, cassettes, and videotapes gathered from different immigrants. Salvadoran artist Dagoberto Reyes (above) did the sculpture that lies on the ground over the spot where the capsule was buried. The sculpture (below) commemorates the journey of Central American immigrants. (Both courtesy of Dagoberto Reyes.)

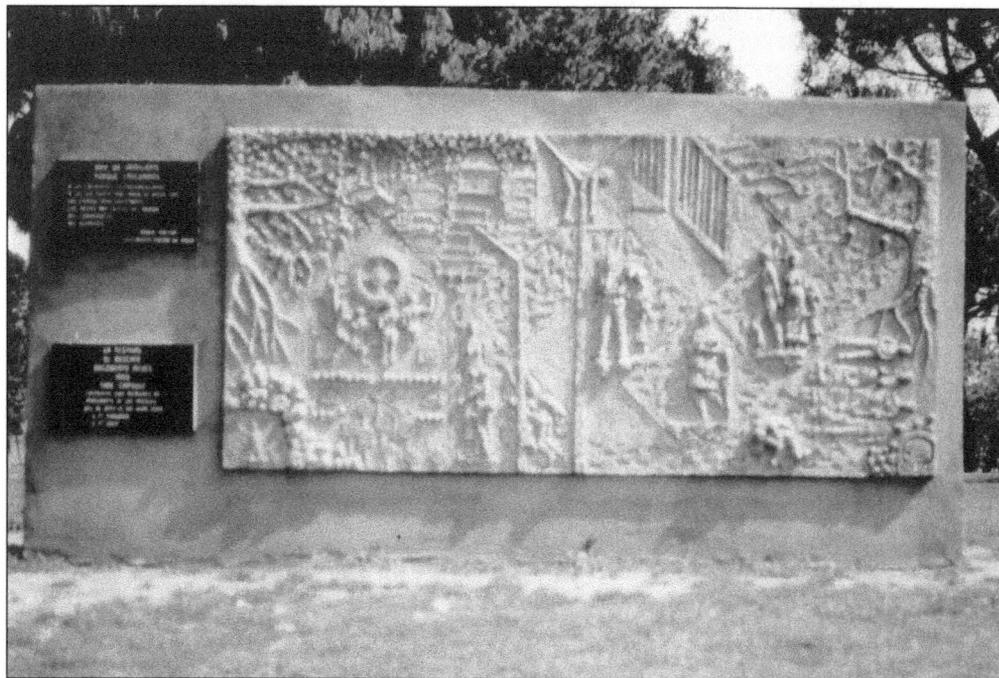

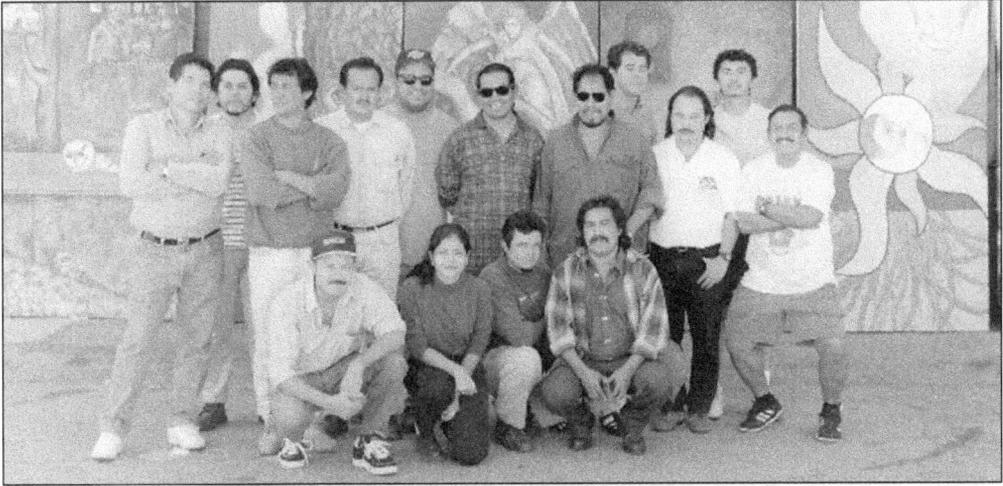

Salvadoran Group of Artists (GAS) was formed in 1996 by those who were interested in bringing together immigrant Salvadoran artists to using their talent to demonstrate their culture and to illustrate the impact that the war had on their fellow citizens. The members from left to right are (first row) Tony Leiva, Neifa Cosenza, Pehdro Kruhz, and Rafael Escamilla; (second row) Alvaro Rosado, Carlos Novoa, Vicente Palacios, Francisco Mejia, Werner Pastran, Edgar Aparicio, Eduardo Alfaro, Ricardo O'Meany, Jesus Salvador Reyes, Francisco Sevillano, and Edgar Turish. (Both courtesy of Pehdro Kruhz.)

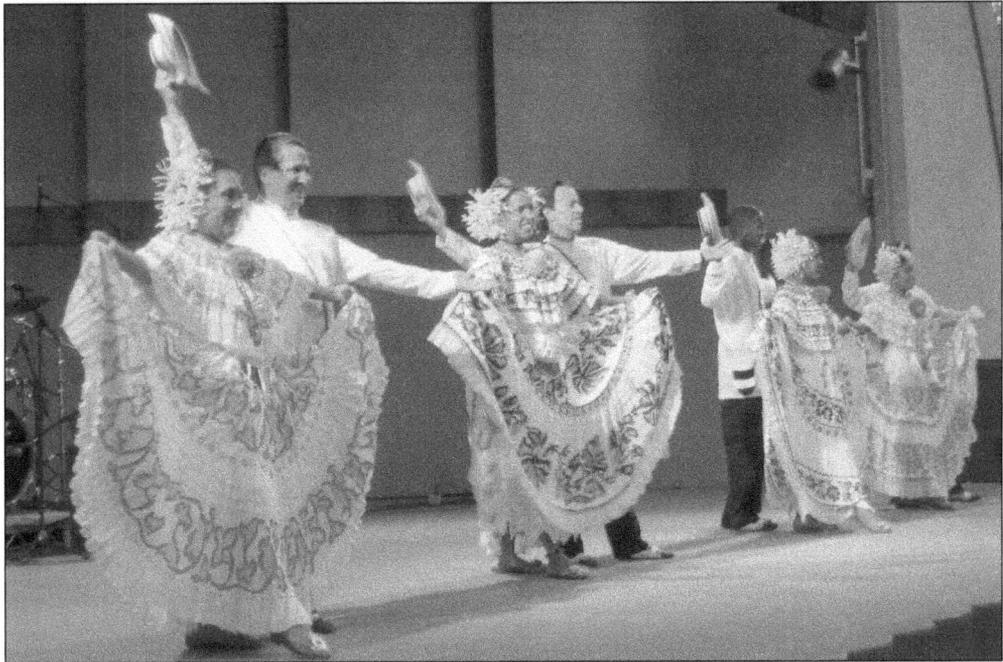

The renowned Ballet Floklórico Viva Panama was started in 1991 by Victor Grimaldo, who wanted to pass on to his children the Panamanian folkloric heritage. The family formed the first dance group for a presentation in one of the children's school. Today the dance company includes Panamanians, as well as other Central Americans. They have performed internationally and locally. In this picture, the group is performing at the John Anson Ford Amphitheatre. (Courtesy of Victor Grimaldo.)

Andres Montoya, a native of Tegucigalpa, Honduras, immigrated to Los Angeles in 1970 to join his family, who had established themselves in the late 1960s. He graduated from Los Angeles City College with degrees in graphic design and fine arts. Today he is the art director of a public television channel and dedicates his spare time to painting. His work has been exhibited in several national galleries in Spain and France. At right, Montoya's artwork was selected for inclusion by the city of Santa Clarita's Art Stop Project. The posters are presently displayed at Santa Clarita's public transportation stops; he was the first selected Latino artist for such a project. (Both courtesy of Andres Montoya.)

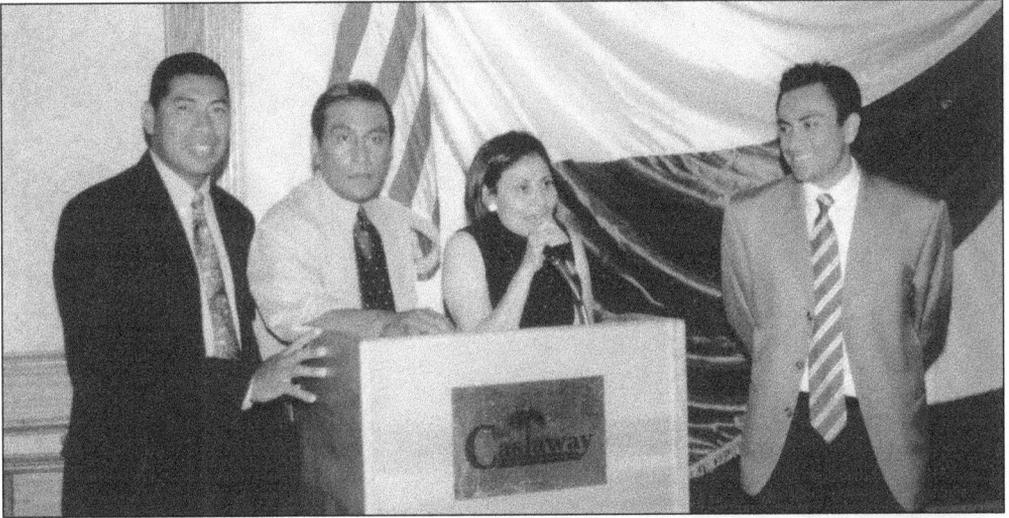

The ASOSAL promotes beauty pageant contests for girls of Central American ethnicity. The group organizes annual contests, where participants wear traditional costumes of every Central American region. The main goal is to help young girls connect with their cultural heritage. The event takes place at different locations; in the above picture, it is at the Castaway Restaurant in Burbank. From left to right are Nelson Canizales, Antonio Minero, Teresa Tejada, and Salvador Duran. Below is a group of unidentified Central American girls at the Hollywood Park Casino. (Both courtesy of Association of Salvadorans in Los Angeles collection.)

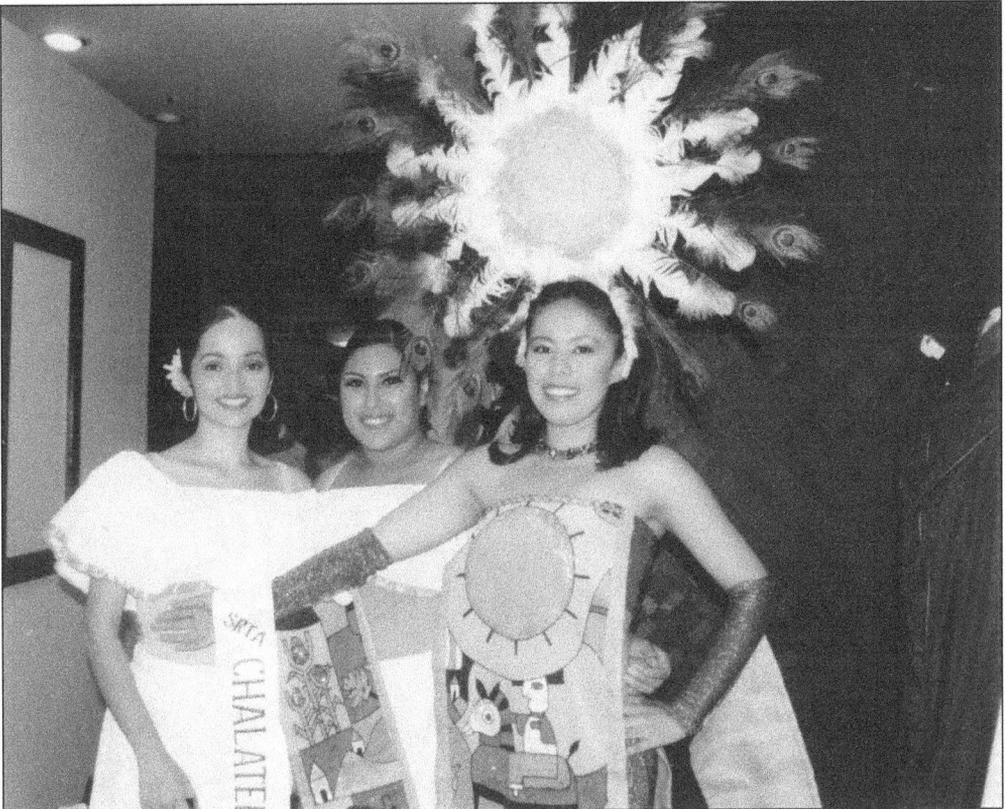

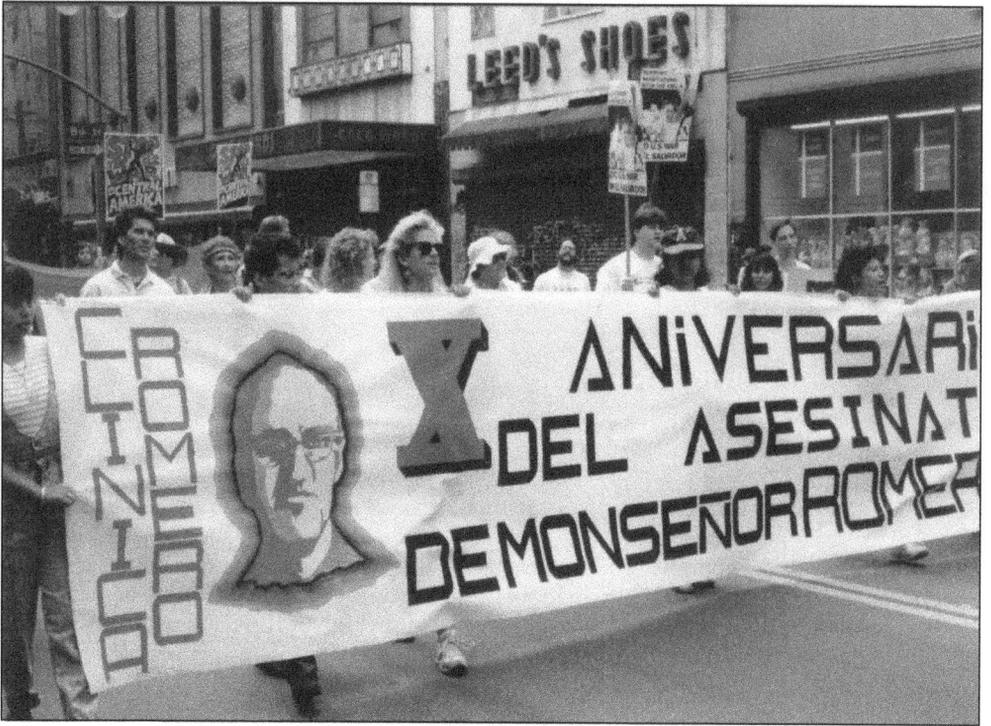

On March 24, 1980, while celebrating mass, Msgr. Oscar Romero was killed in El Salvador with a shot to the heart while holding up the Eucharist. The day before his assassination, Romero had called on the soldiers to obey God's higher order and to stop carrying out the government's repression and killings of its own people. Since that date, Salvadorans in Los Angeles use every opportunity to honor his memory. Both images were taken during a march down several blocks in downtown Los Angeles during the 10th anniversary of Romero's death. (Both courtesy of Joaquin Romero collection.)

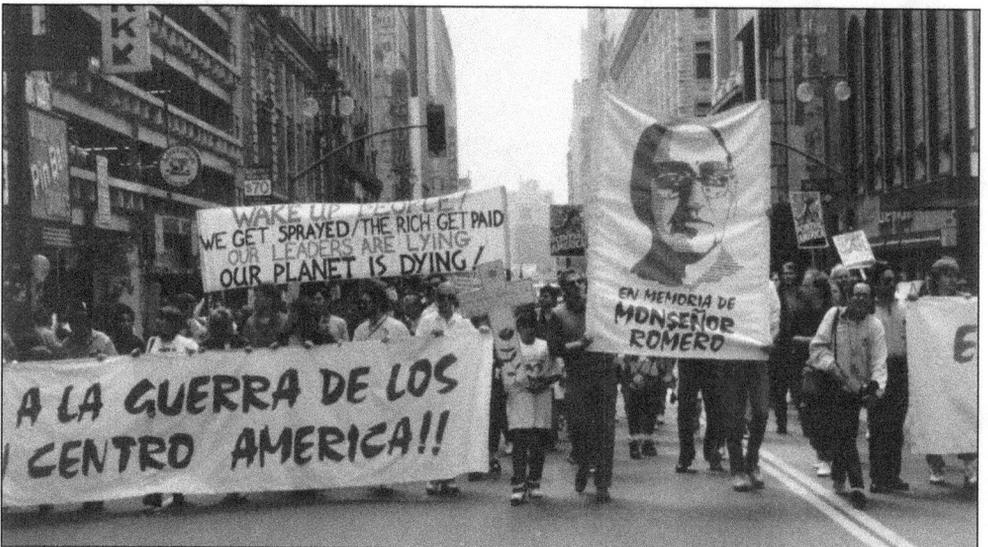

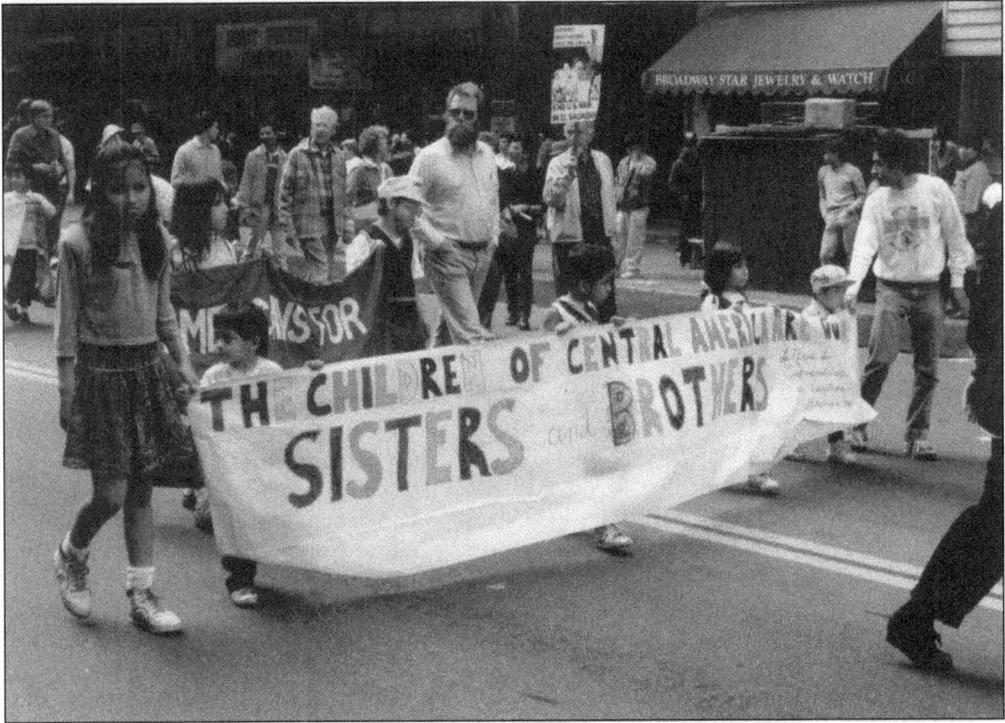

For thousands of Central Americans, particularly Guatemalans and Salvadorans, the 1980s was a period filled with hopes of returning home, but as the wars were prolonged, many lost interest in going back. Some had already established family ties in Los Angeles, and for others, it was less attractive to return because their closest family members had also migrated to different parts of the world. However, the majority had immigrated to the United States, particularly to Los Angeles. Hence, the 1990s and the first decade of the 21st century turned into a quest for seeking permanent legal residency. The struggle was noticeable in several street marches. (Both courtesy of El Rescate Archives.)

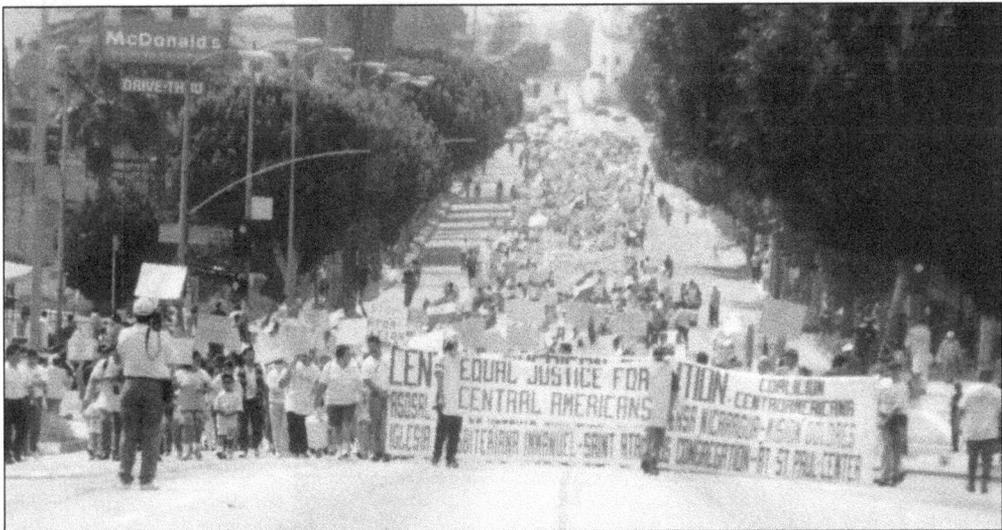

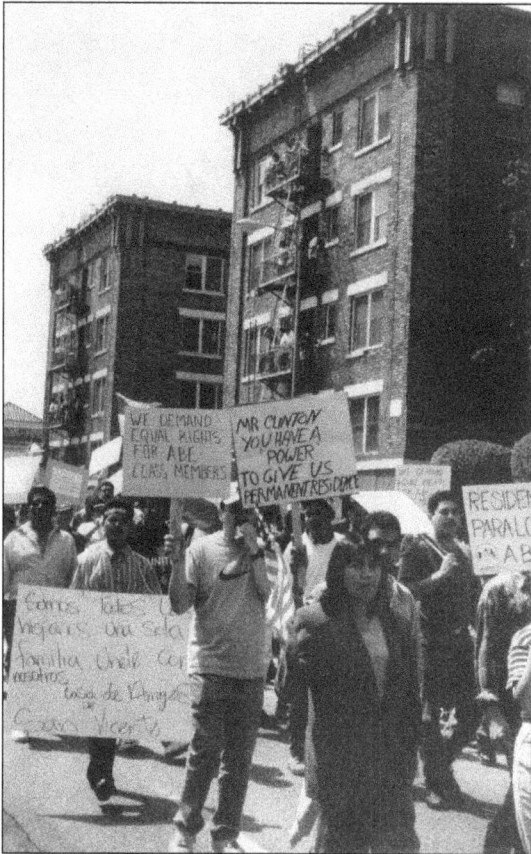

At left, a marching group on Alvarado Street north of Eighth Street is passing in front of an apartment building that has been home to hundreds of Central American immigrants. The signs had messages for Pres. Bill Clinton concerning the American Baptist Church (ABC) ruling. The ABC was a program based on a class-action suit won by the church and other activists who provided asylum to some Salvadoran and Guatemalan refugees. Clinton's administration implemented policies that restricted the possibilities for those refugees to legalize their permanent residency. Below, an unidentified woman, left, is holding a sign demanding equal treatment for Central Americans, referring to the United States's policies favoring Cuban and Nicaraguan immigrants over other Central American immigrants. Luis Hernandez, center, is holding a sign demanding amnesty for all refugees, and an unidentified women is holding a sign demanding identification cards. (Left, courtesy of Joaquin Romero collection; below, courtesy of Association of Salvadorans in Los Angeles collection.)

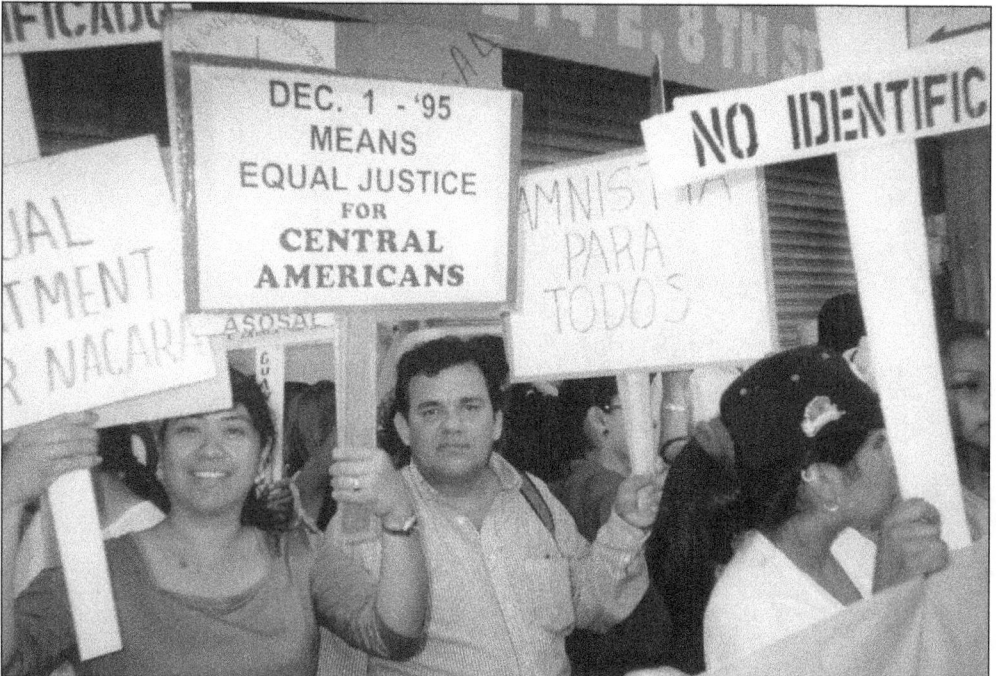

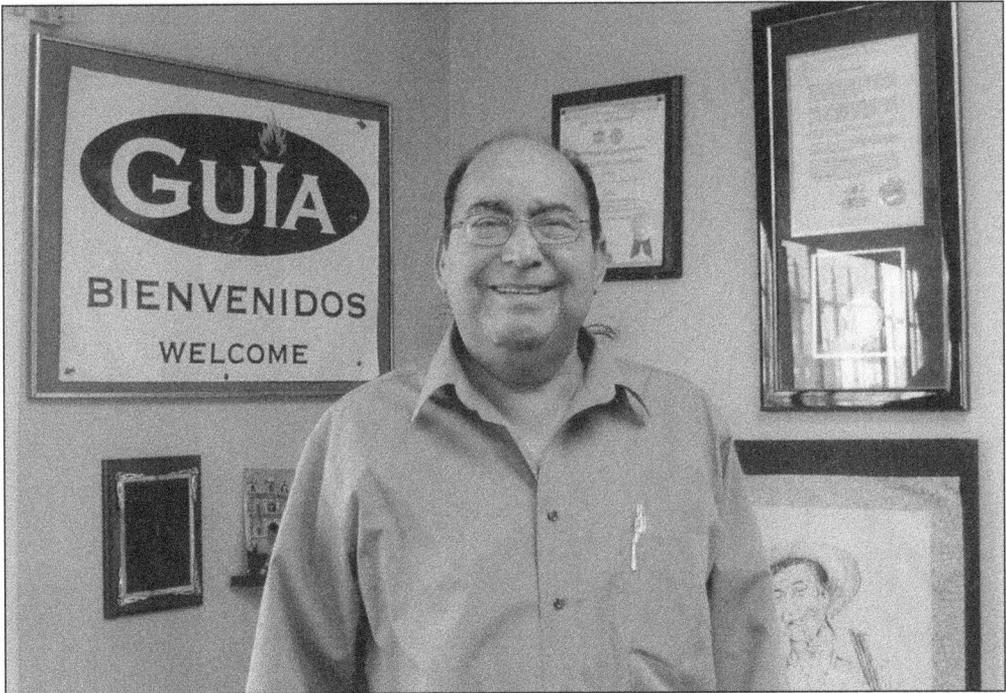

The GUIA, a nonprofit organization, was formed by a Guatemalan immigrant group in 1997. The agency, located in Los Angeles, offers GED courses, computer training, and adult literacy classes. The services are free and available to anyone in need. Additionally, the organization sponsors an annual week during the month of August to celebrate Guatemalan culture in Los Angeles. GUIA has also cofounded a similar organization in Miami. Rafael Garcia, above, is a native of Guatemala who immigrated in 1964. He is a cofounder and current executive director of GUIA. A group of unidentified students, below, in GUIA's offices receives citizenship and immigration information. (Both courtesy of Guatemala Unity Information Agency collection.)

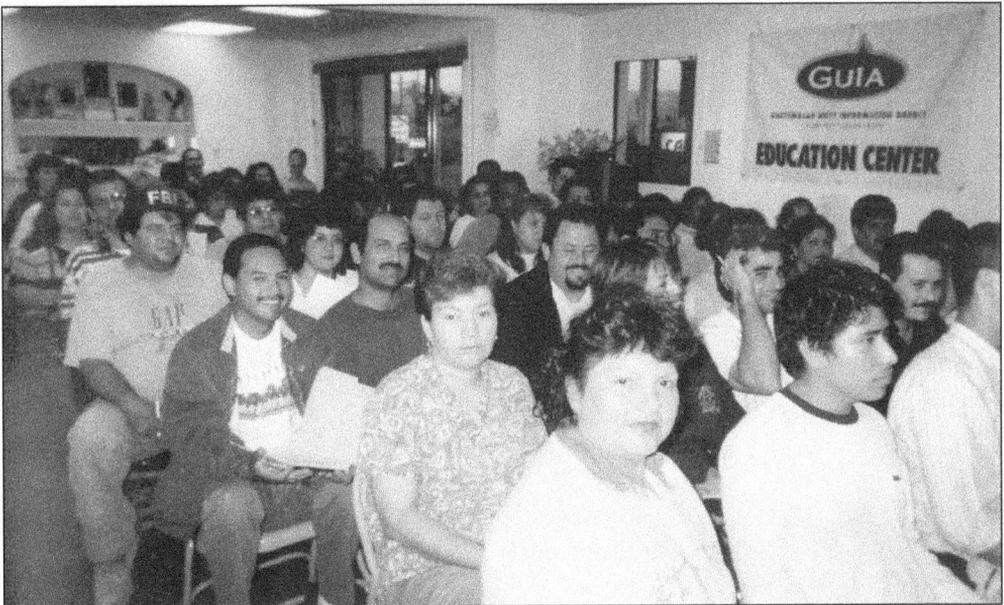

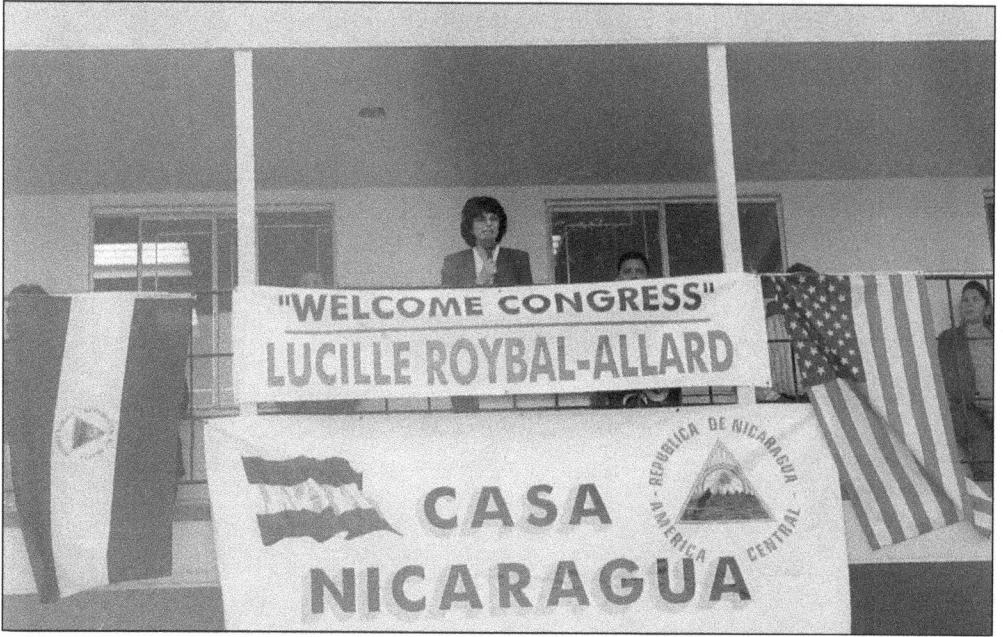

Casa Nicaragua is another organization that has been lobbing for just immigrant policies, as well as promoting Nicaraguans' culture. Congresswoman Lucille Roybal-Allard, above, is one of the many political figures who has addressed the community at Casa Nicaragua. Moreover, the City of Los Angles has also recognized the contribution of this agency. Below, from left to right are councilman Ed Reyes, Julio Cardoza, and two unidentified. (Both courtesy of Casa Nicaragua.)

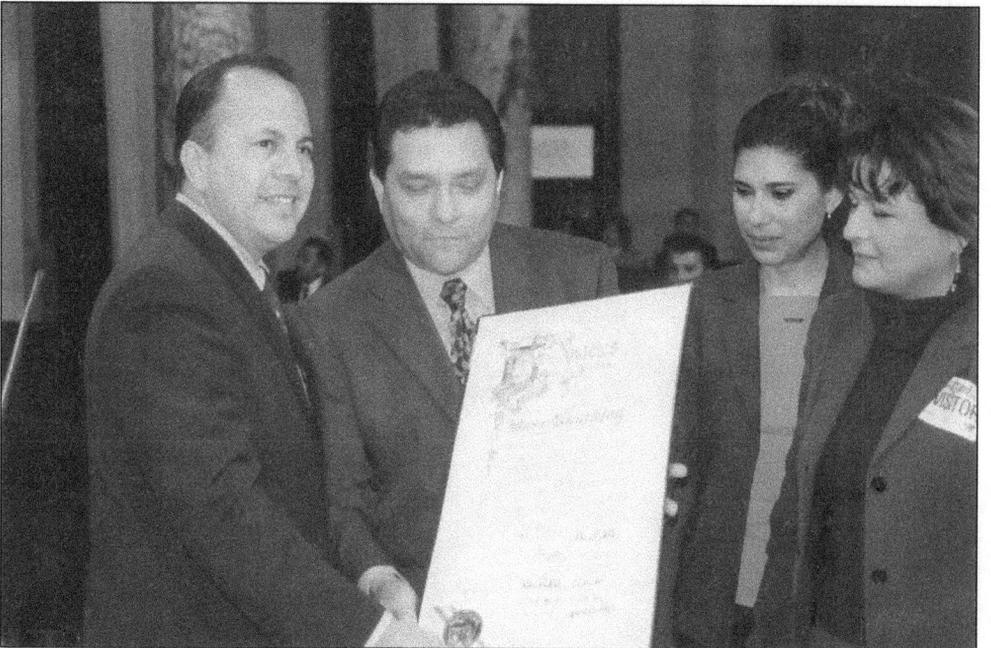

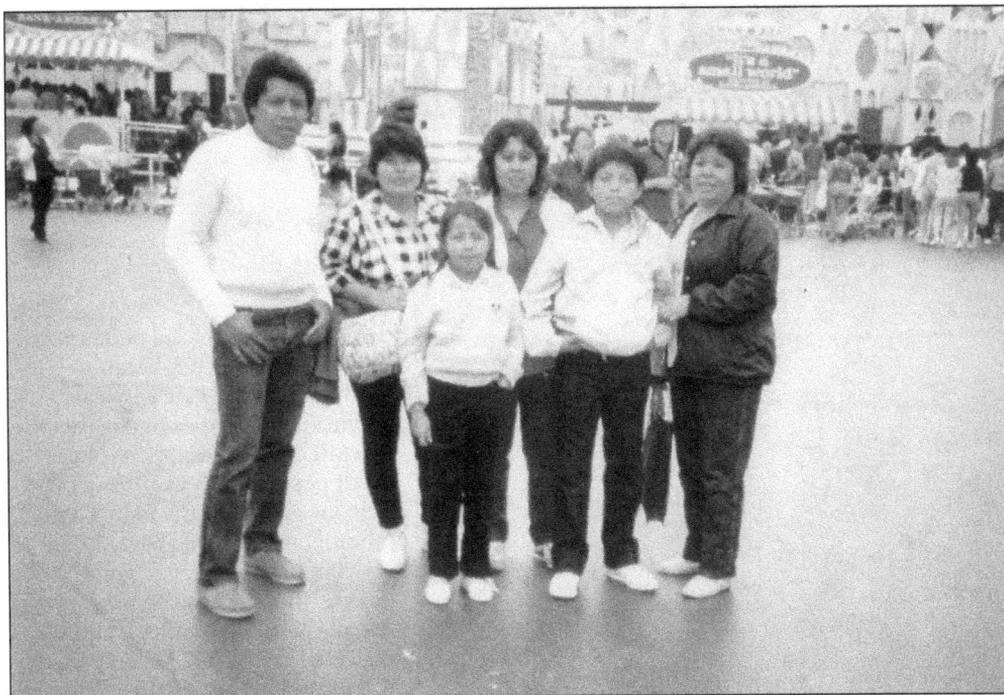

The Cruz family, immigrants from Guatemala, similar to many other Southern California families, enjoyed their visits to Disneyland whenever they could afford it. Pictured here from left to right are Oscar Rafael Cruz, Sandra Maite Cruz, Heidi Noemi Cruz, Irma Patricia Delgado, Oscar Ernesto Cruz, and Yolanda Delgado. Below, the Carias children are enjoying a family weekend at the San Diego Zoo. (Above, courtesy Oscar Ernesto Cruz; below, courtesy of Francisco Carias.)

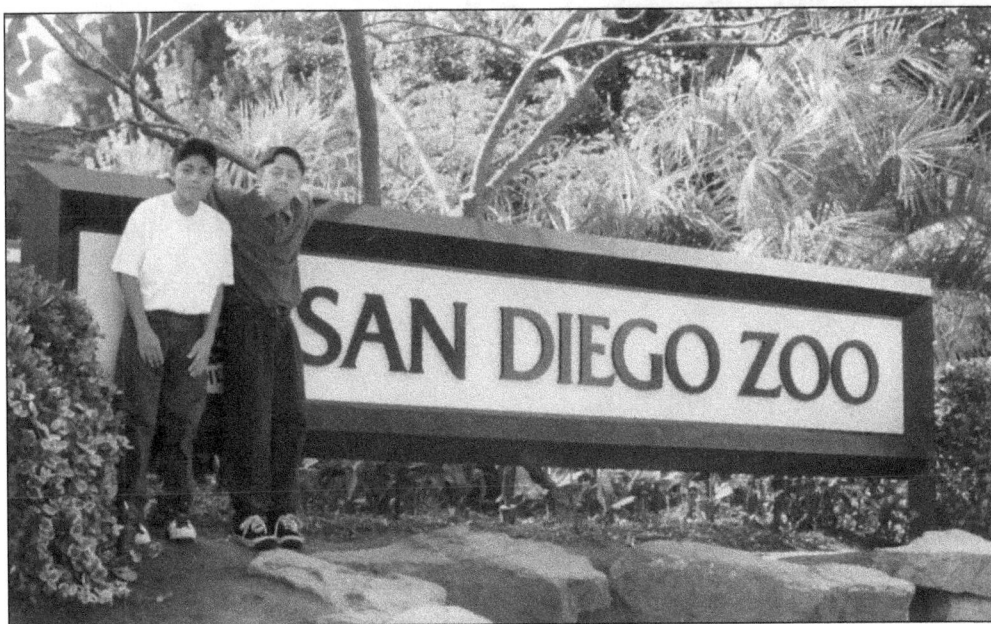

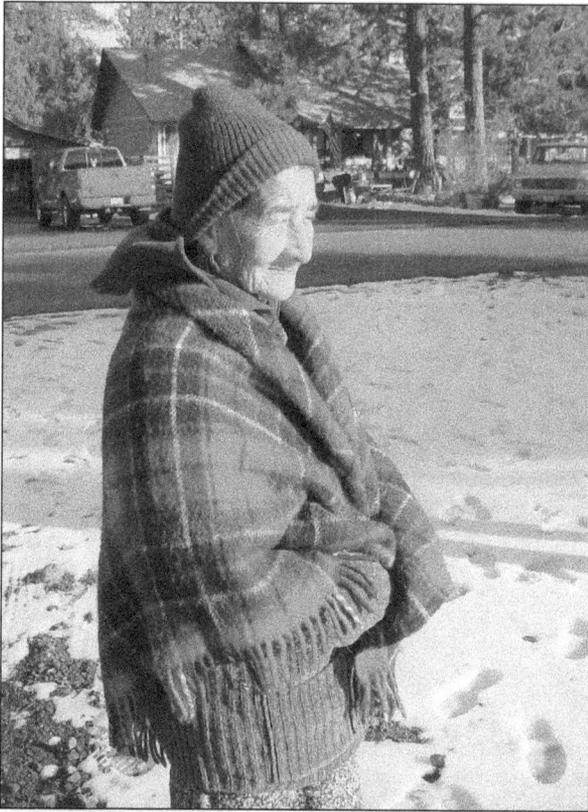

As immigrants settled permanently in Los Angeles, they began to acclimate to the new physical environment. For example, the overall climate conditions of the most populated Central American regions are hot and humid. In the photograph at left, a Salvadoran woman experiences the snow for the first time in the San Bernardino Mountains. Others, pictured below, like Wildebrando Mejia and his Nicaraguan wife, Veronica Rojas, prefer the warm temperatures of the Kern River and to rest in a Salvadoran hammock. (Both courtesy of Pehdro Kruhz.)

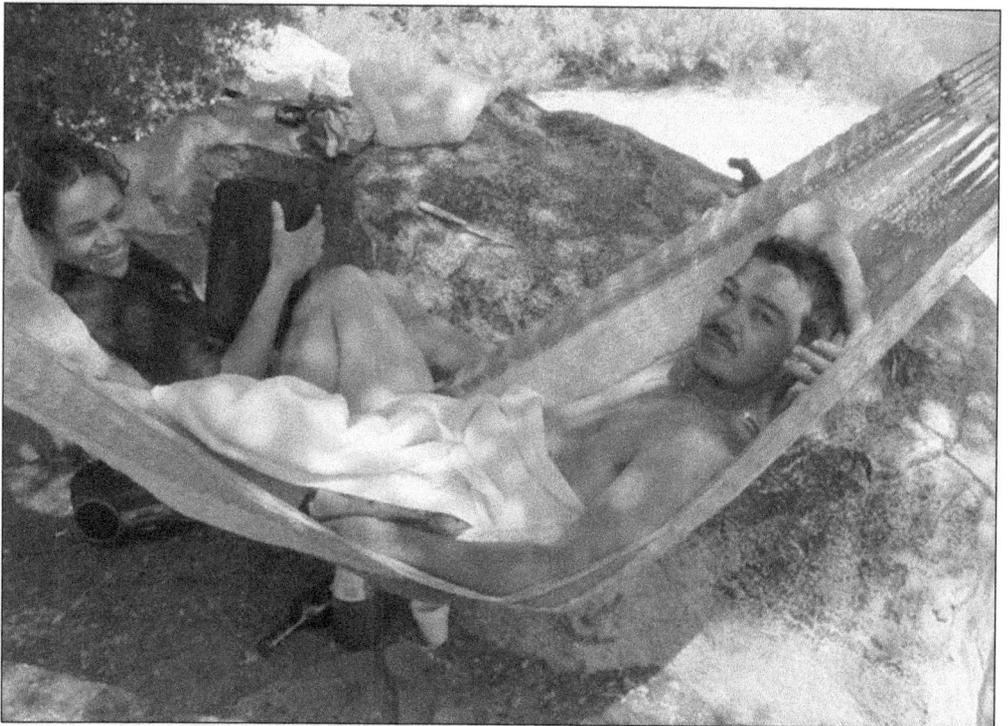

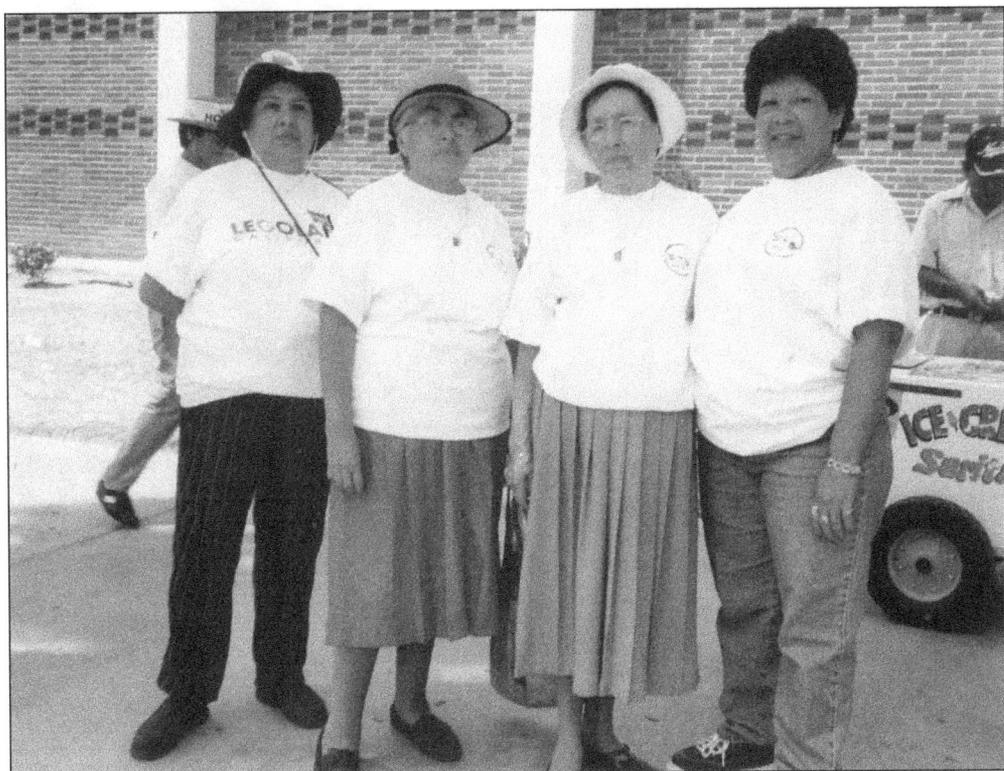

Enjoying the warm weather of Los Angeles and buying ice cream from the street vendor, like the group of unidentified Honduran women, above, might be attractive to almost anybody, but earning a living on the streets has been viewed as a crime by some authorities. Below, a group of Guatemalan musicians playing their marimbas was not allowed to continue giving a concert on a Sunday afternoon in Echo Park by the Los Angeles police, who claimed that the music would disturb the park goers. (Above, courtesy of United Hondurans of Los Angeles collection; below, courtesy of Segura collection.)

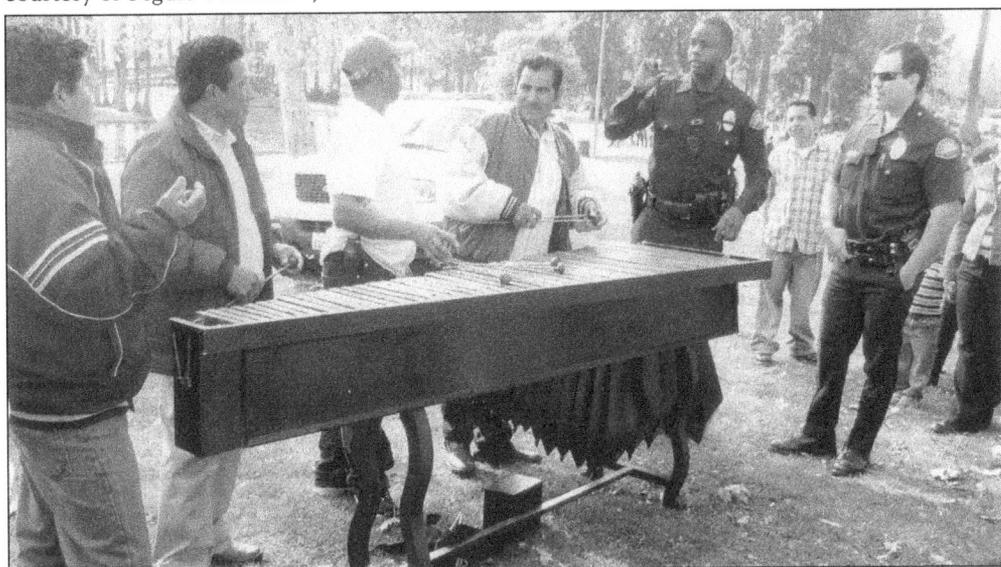

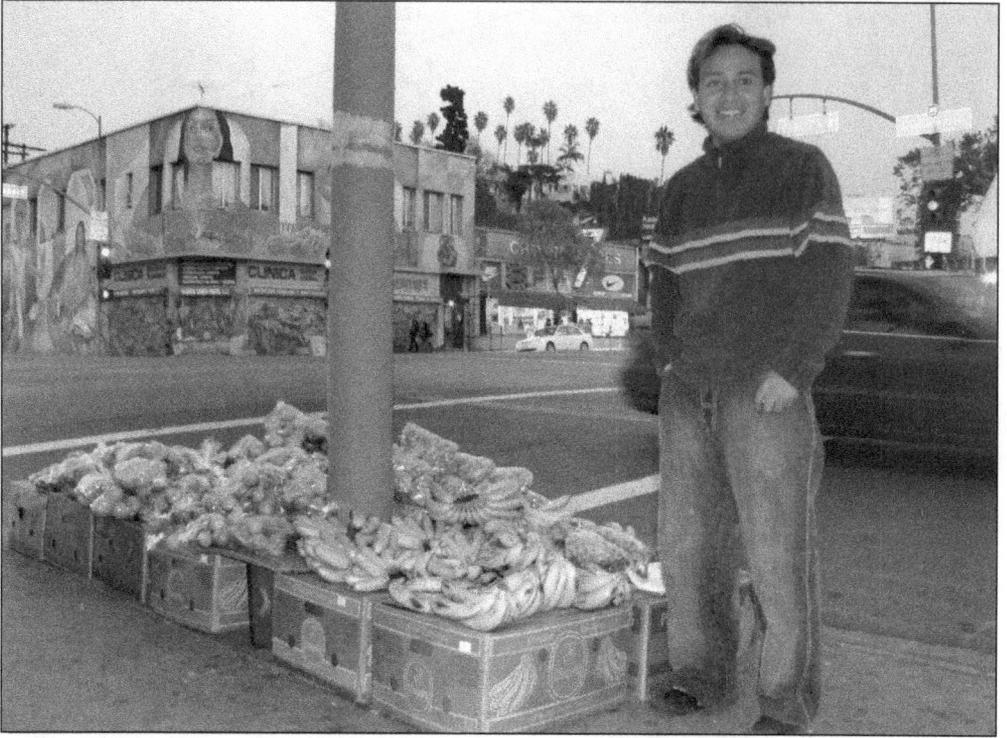

Several agencies have sought to legalize street vending, such as ASOSAL and CARECEN, among several others, but their efforts have not been successful, and many street vendors experience harassments, expensive fines, and sometimes incarceration. Nonetheless, the demand for their goods is abundant, and many of them are seen around the city. Above, Alex ? is selling fruit on the corners of Echo Park Street and Sunset Boulevard. Since this picture was taken, he has returned to his native Guatemala, and his cousin has taken his place in that corner. Below, on the same corner, Irma ? from El Salvador sells tamales every Friday afternoon. (Both courtesy of Segura collection.)

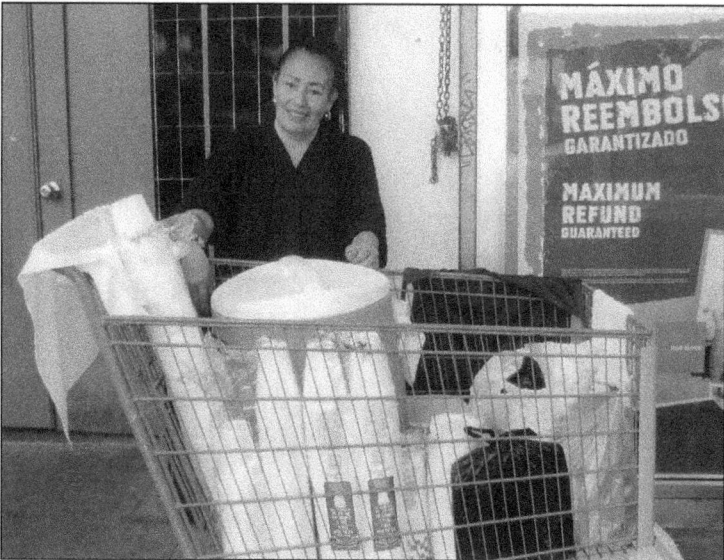

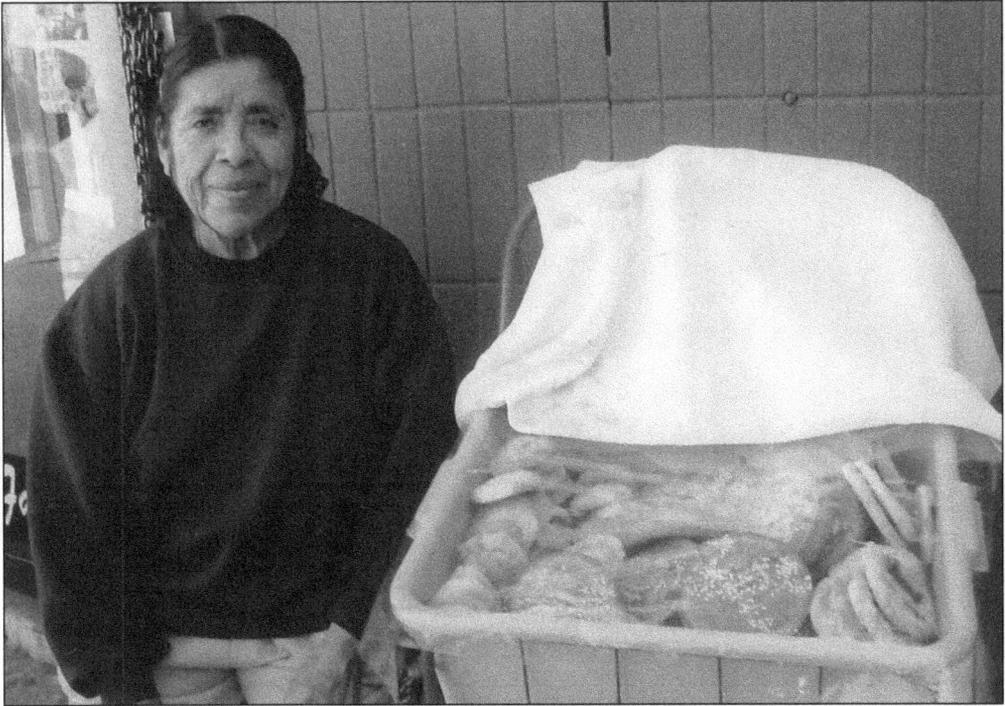

Street vendors from other nationalities also cater to the Central American consumers, for example, on Sunset Boulevard, this Mexican woman (above) sells Salvadoran pastries every afternoon in front of the bus stop. Below, on the north side of Sunset Boulevard, another woman named Odilia ?, a native of El Salvador, sells *pupusas*, a thick tortilla filled with beans, cheese, or meat. (Both courtesy of Segura collection.)

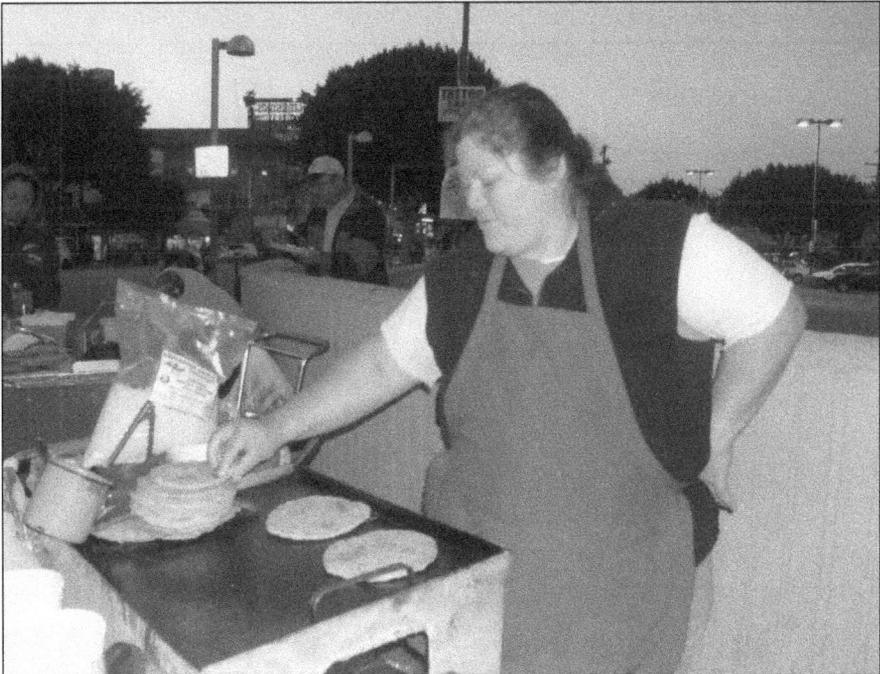

Other Central Americans have been successful entrepreneurs. Above, Tony Alvarez emigrated from Costa Rica in February 1989, and seven months later he opened his first travel agency on Alvarado Boulevard and Sunset Boulevard. He started his business with only $500, and put his last savings into renting a tiny office space. After becoming number one in sales to Costa Rica, he moved to a larger office in the Silverlake area. Below, Oscar Benitez, who arrived from El Salvador in 1978, opened a book store in the San Fernando Valley is 2001. He has authored several books and poems, among them *When the Night Falls* and *Thirty Poems for Maria*. (Both courtesy of Segura collection.)

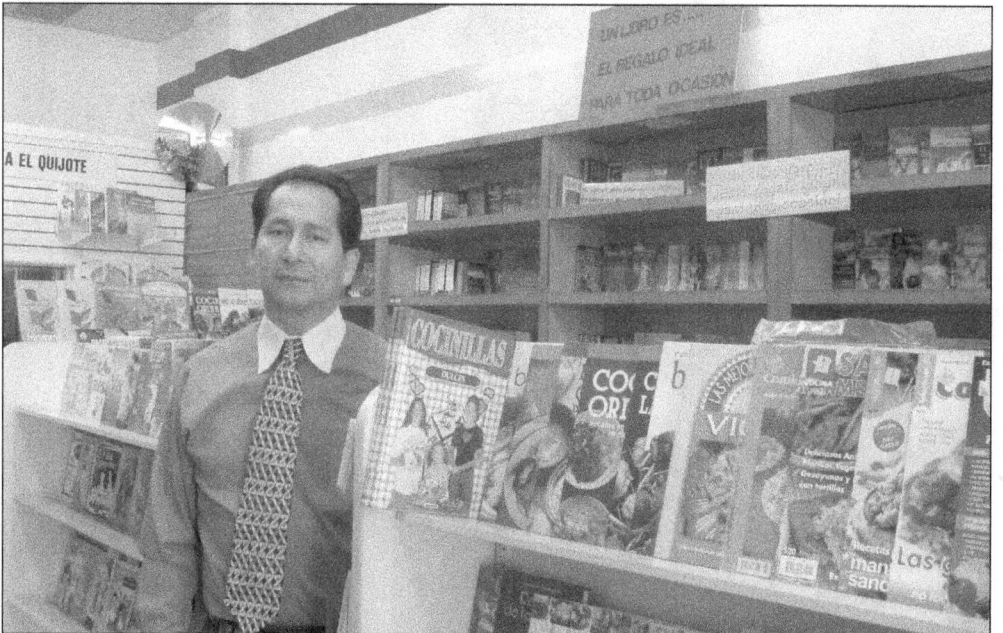

Throughout Los Angeles, Central American businesses have flourished, from bakeries to courier agencies, with restaurants being the most common. Although beans, rice, corn, banana plantains, and yucca roots are common staples used in almost every Central American nation, each country cooks them differently, and each has a unique style and its own diversity of food. Each county has been influenced pre-Colombian indigenous, Spanish, Afro-Caribbean, and Creole cultures. In Los Angeles, the first Salvadoran restaurant (above) opened downtown and is currently in a new location and under new management. On Santa Monica Boulevard (below) is a recently opened Guatemalan bakery and coffee shop. (Above, courtesy of Segura collection; below, courtesy of Jose Leonardo.)

Silvano Torres (left), a Garifuna native of Belize, came to visit some relatives but was attracted by the area because he liked the diversity of the city. He owns and manages a trucking company from his south Los Angeles home. Committed to exhibiting the richness of his culture in Los Angeles, he cofounded the Belize Cultural Foundation, and for several years, he has been a director of Central American Festivities Committee (COFECA). Additionally, Torres has maintained ties with Belize, helping its community with different social services and working as the vice president of the Justice for Peace organization. Wildebrando Mejia, from El Salvador (below), owns a truck and works transporting merchandise from the Los Angeles port to stack department stores through the city. (Left, courtesy of Segura collection; below, courtesy of Pehdro Kruhz.)

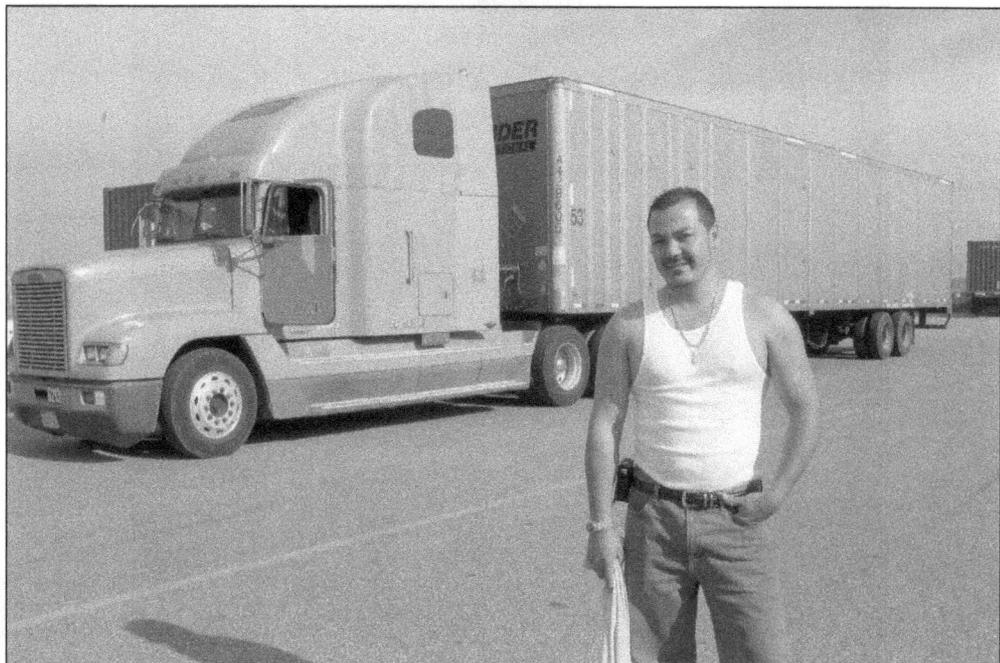

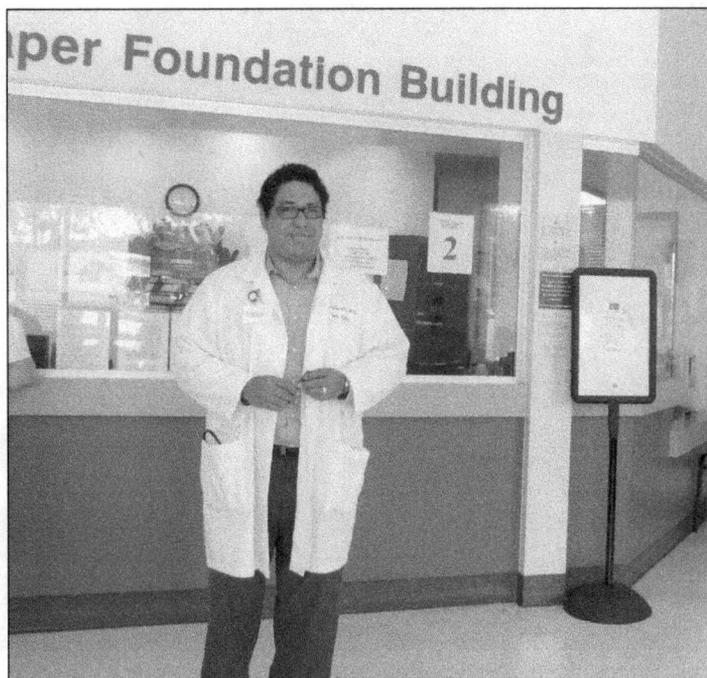

Felix Aguilar emigrated in his youth from Honduras. He worked his way up to medical school and graduated as a doctor from the University of California, Irvine School of Medicine. He currently holds the title of chief medical officer in a medical center in South Central Los Angeles. He has also volunteered for different humanitarian efforts, such as providing free medical services in New Orleans for hurricane victims, as well as helping different communities in Honduras. (Courtesy of Segura collection.)

Fred Lugo immigrated to Los Angeles in 1976 from Nicaragua; his first goal was to learn English. He took extra classes to achieve this goal and later graduated from Belmont High School. He owns and directs a television cable program dedicated to promoting Central American Culture. He also has a promotion agency for Central American musicians and sports celebrities. From left to right are (first row) three unidentified; (second row) Mateo Flores, Mario Anaya, unidentified, Eduardo Villamar, and Lugo. (Courtesy of Fred Lugo.)

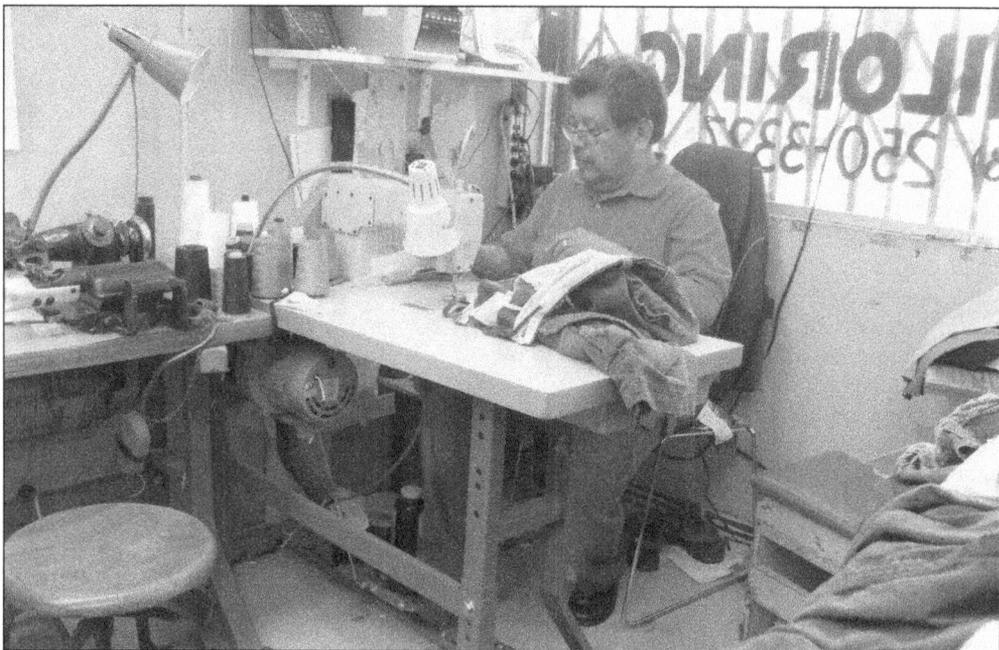

Luis Santos, a Salvadoran immigrant, came to Los Angeles in 1976. His first job was assisting a high-end Italian seamstress in Beverly Hills. He continued working with her until the mid-1990s, and then he opened his own business, altering clothes in the Echo Park neighborhood, where he continues to operate. (Courtesy of Segura collection.)

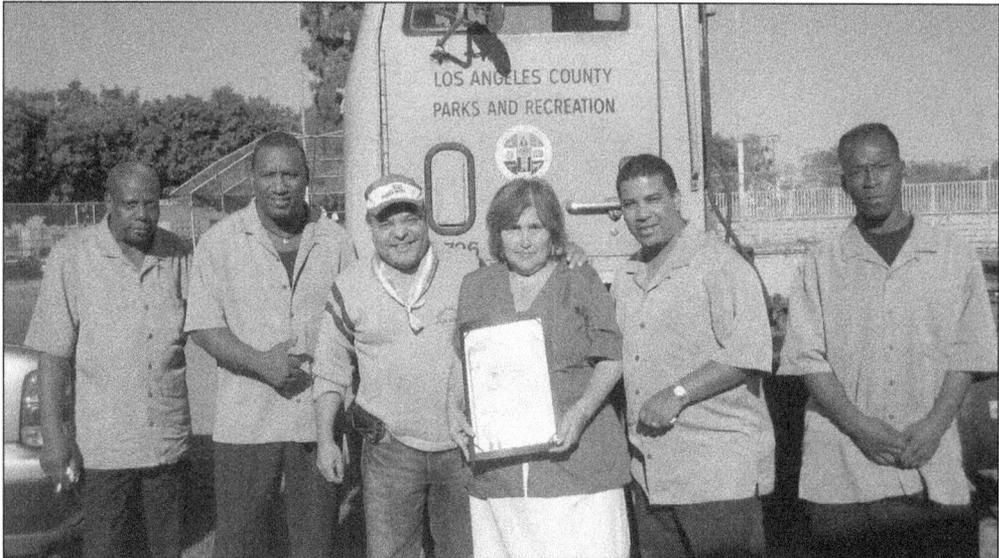

Carmen Suazo emigrated from Honduras to Los Angeles in 1970, following some relatives who had established themselves in the 1960s. Her first job was cleaning houses. In 1972, she sought the services of attorney Harrison Patrick McGarry to arrange her immigration status. A few months after their initial meeting, McGarry hired her as his assistant. This employment lasted 30 years. Then she opened her own notary and immigration agency, which she continues to operate. In this photograph, she is surrounded by the Honduran music band Punta Cartel. Standing on Suazo's left is Rafael Navarro. (Courtesy of Carmen Suazo.)

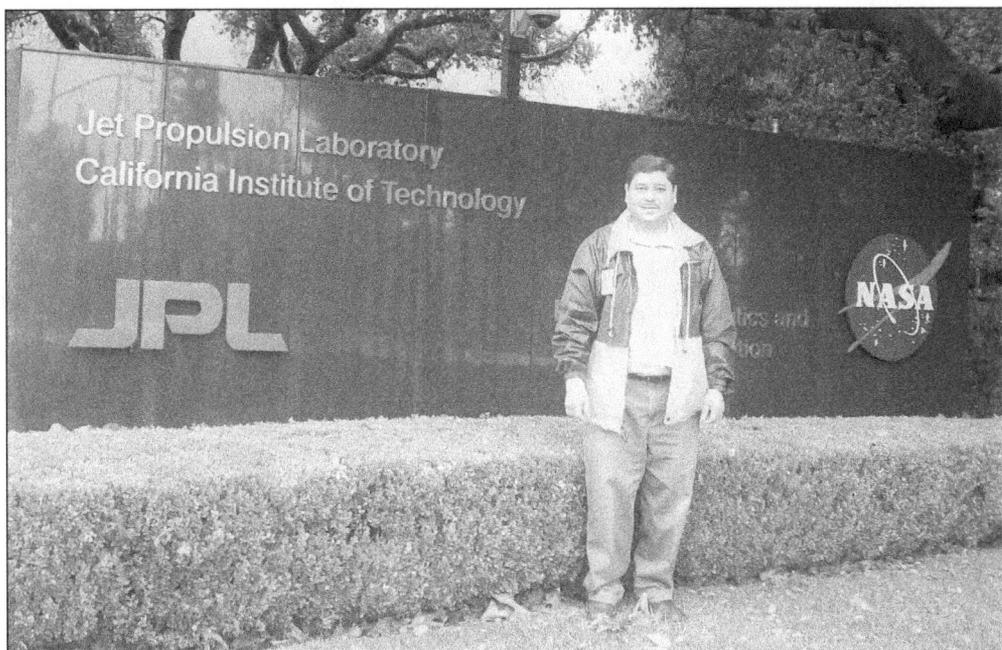

Mario Gee Lopez, above, was born in San Pedro Sula, Honduras. He came to Los Angeles at the age of 17. He made his way through university and graduated with a degree in architecture. After school, he went to work as a facility designer for the Jet Propulsion Laboratory in Pasadena, where he continues to work. Below, Ana Mercedes Romero (right) came from El Salvador in 1982. Since her arrival, she has remained in the same job at the Mistzuro grill. She is pictured at work with an unidentified coworker. (Above, courtesy of Mario Gee Lopez; below, courtesy of Joaquin Romero collection.)

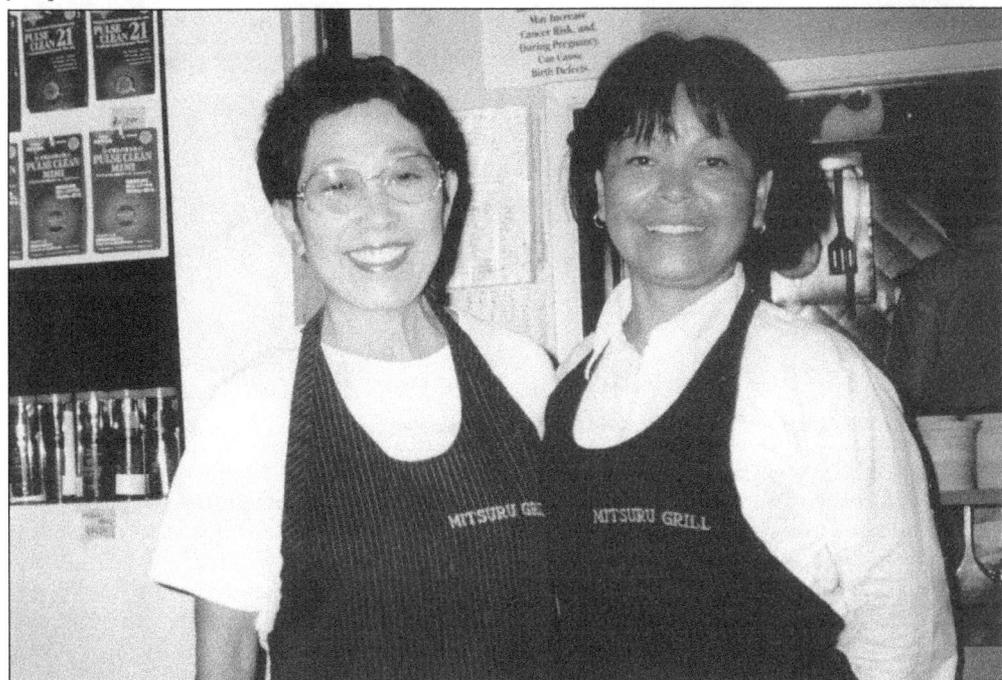

Nicolas Orellana came to Los Angeles with the 1980s wave of Salvadoran immigrants. He held various jobs, including door-to-door sales of Rena Ware products and driving a lunch truck. After saving enough money, he opened his own business in 1986. Today he and his family manage a chain of seven retail soccer goods stores throughout Los Angeles. (Courtesy of Nicolas Orellana.)

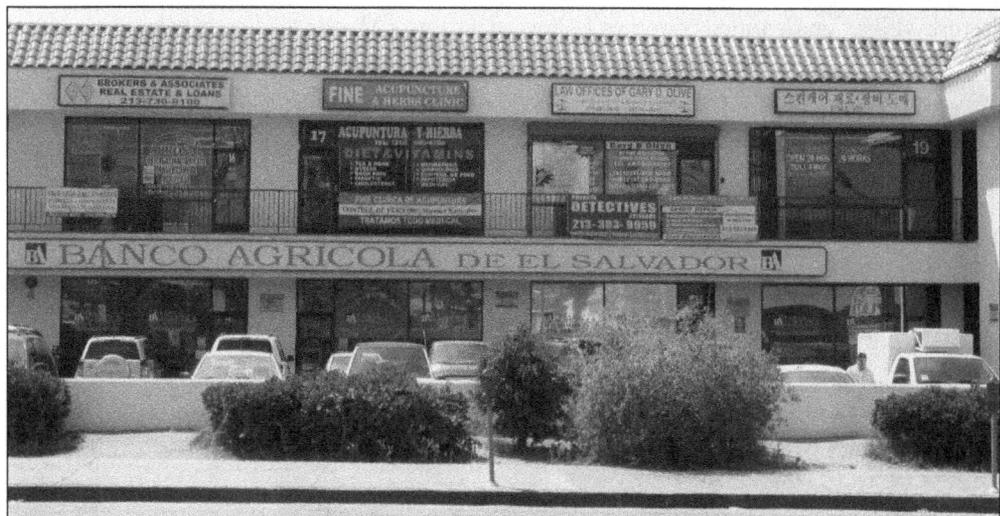

Over the last 30 years, Salvadorans living in the United States have become one of the largest sources of revenue to the Salvadoran economy. *Las remesas* (remittances) sent by Salvadorans have contributed to sustaining an otherwise very weak economy. As a consequence of this reality, a Salvadoran bank, Banco Agricola, opened an office on Vermont Avenue in the heart of the Pico-Union area. For many Salvadorans who send remittances to their families in El Salvador, it is convenient to have such a branch accessible to them. Nonetheless, this is not just an ethnic business; the bank could also be seen as symbol of the massive economic activity between the community living in the United States and their country, El Salvador. (Courtesy of Remberto Diaz.)

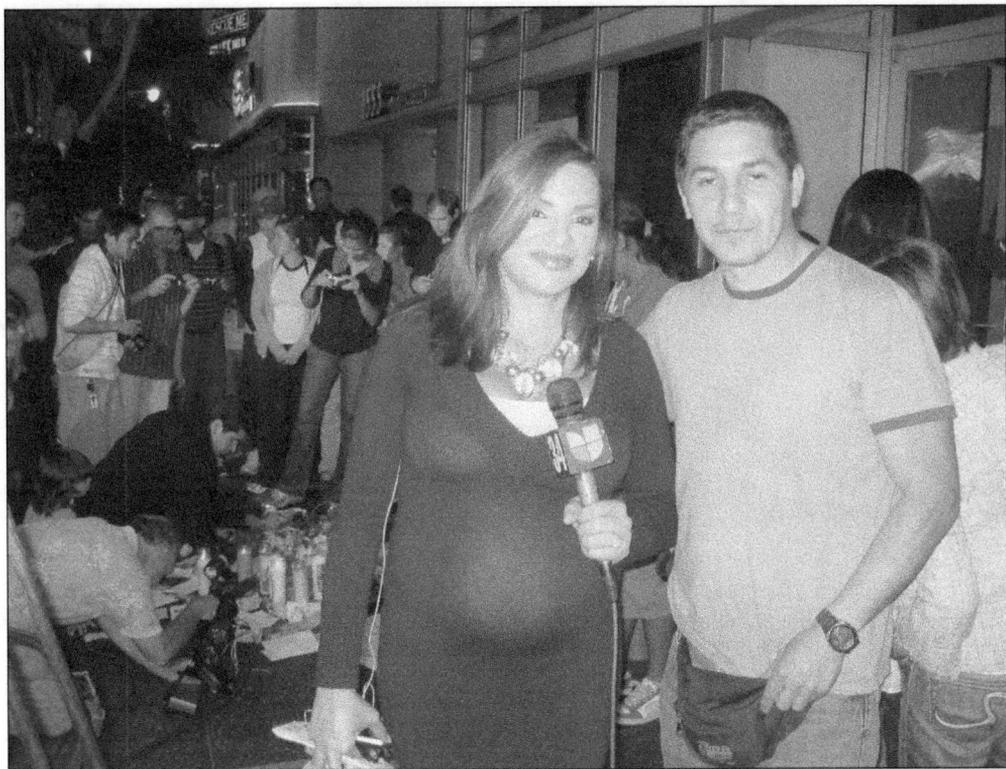

Cecilia Brogan and Norma Roque are two distinguished television news reporters in Los Angeles. Brogan, above, is an immigrant from Honduras; Roque, at right, migrated from El Salvador. In this picture, Roque is photographed while covering the inauguration of Pres. Mauricio Funes of El Salvador. (Above, courtesy of Cecilia Brogan; right, courtesy of Remberto Diaz.)

These images were taken by Salvadoran immigrant Remberto Diaz, who gives special attention to the lives of Central Americans on the streets of Los Angeles. Above is a grocery market that specializes in catering Central American products. On the left side of the street in front of the store, a street vendor sells *flor de izote* (yucca flowers), considered a delicacy in some Central American countries. The yucca flower is the national symbol of El Salvador. Below is a typical vehicle of a street vendor in the Pico-Union neighborhood. (Both courtesy of Remberto Diaz.)

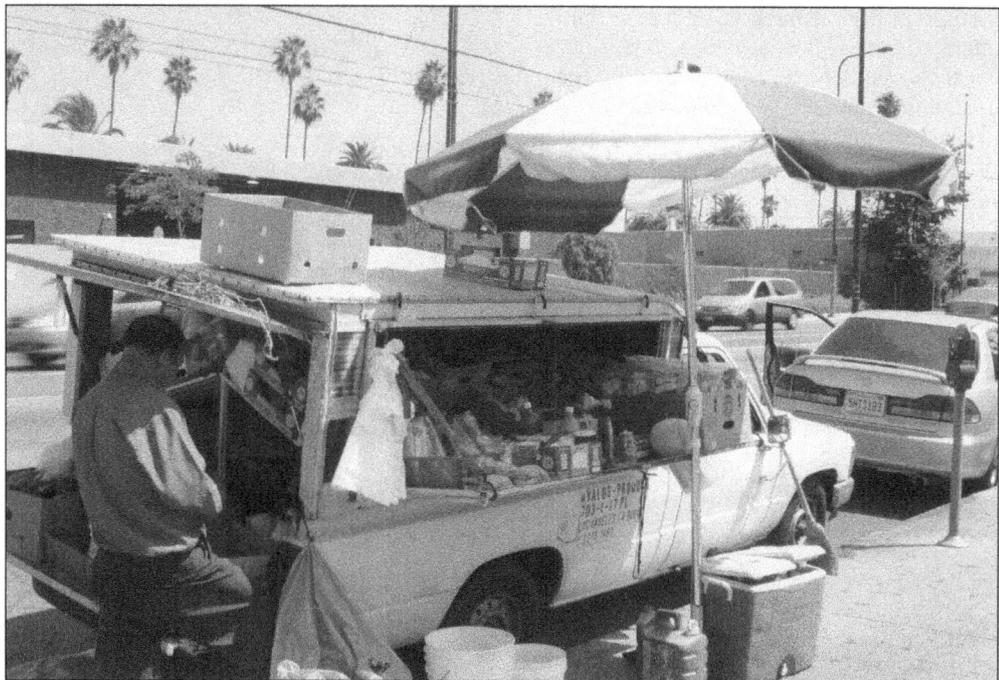

Four

CENTRAL AMERICAN ANGELENOS

By the early 2000s, as the Central American-Angeleno community matured, new priorities also emerged, such as identity, cultural pride, education, home ownership, and civic participation. And so, organizations and different individuals, artists, intellectuals, and scholars, as well as many dedicated citizens began working to raise consciousness in this new chapter of the Central American Angelenos.

It has often been the case that the first immigrant groups of Central Americans hide their origins, opting to claim that they are from Mexico or other Latin American nations in part because of their undocumented status and fear of deportation, or to protect their children from discriminatory stereotyping by other Latino or Anglo groups. Other factors include the desire to repress traumatic psychological war experiences in their respective countries, or the emotional scars of the perilous voyage over the borders of the northern continent, which often includes rapes, deaths, and body parts being scattered in the deserts, railroads, and seas. For these reasons, many second and third generations of Central American youths have struggled to find their own cultural identity and consequently have grown up unaware of their roots.

As a consequence, cultural identity is a pivotal subject, and artists and cultural devotees are successfully raising the issues of ethnic and cultural pride. For example, organizations such as the Salvadoran Group of Artists (GAS), Garifuna American Heritage Foundation United (GAHFU), and the Ballet Folklórico Viva Panama have been planting seeds of cultural pride throughout the neighborhoods of Los Angeles. New forms of collaboration have also come to light, as is the case of some consulate representatives working closely with local activists to promote recognition of the culture and identity of local residents. One of these cases is the Los Angeles–based Honduran consulate, which has a link on its Web page with images of local Honduran artists' fine art. With the improvements in telecommunications, several business interests have emerged, and local television networks are screening traditional events and scenes of different regions of Central America. An emerging group of authors and scholars are writing and researching the stories of these immigrant communities. Professionals working in local universities, medical sectors, and other specialized occupations have also played an important role in linking the layers of the new Central American Angelenos' mosaic.

The Salvadoran American National Association (SANA) commissioned an exact replica of El Divino Salvador del Mundo (the Divine Savior of the World) and brought it to Los Angeles in 2000. The replica was carved by an indigenous artist in El Salvador. The life-size image of Jesus has become a symbol of the Salvadoran immigrant, and the figure became a pilgrim itself, traveling in a pickup truck, replicating the journey of undocumented immigrants through the borders of Guatemala and Mexico and passing immigration inspections. *La bajada* (the lowering) is a ritual that involves lowering the figure into an earth-shaped globe and changing its purple robes. It is then lifted again in white robes, symbolizing a transformation. The celebration marks a Salvadoran tradition, an annual celebration during August, in honor of the Divine Savior of the World, who is the patron of El Salvador. SANA is an organization dedicated to promoting the history and culture of Salvadoran immigrants in Los Angeles. (Courtesy of Pehdro Kruhz.)

El Cristo negro (the black Christ) is probably the second most popular Catholic icon in Latin America. People throughout Central America make a pilgrimage every January to visit his shrine in Esquipulas, Guatemala. The name black Christ comes from its dark color. It is also known as el Señor de Esquipulas (Lord of Esquipulas), who is viewed as a healer and as a symbol of peace. A group of Guatemalans living in Los Angeles brought an exact replica from Esquipulas. The figure traveled the same route as Guatemalan immigrants and encountered various obstacles before arriving. For this reason, it came to be known in Los Angeles as *el Cristo mojado* (the wetback Christ; "wetback" is a derogatory term for an undocumented immigrant who crossed a river to enter the United States). Every year, the glistering black crucifix is carried on the shoulders of men and women walking in a procession followed by devotees who pray and sing along the way. (Courtesy of Guillermo Palencia.)

The shrine of the Lord of Esquipulas is in South Central Los Angeles in St. Cecilia Catholic Parish on Normandie Avenue. The initial idea of bringing the life-size image originated in 2002 with the collaboration of Guillermo Palencia and Veronica Turris, along with St. Cecilia's priests. The church has been popular among Guatemalans, but since the arrival of the Lord of Esquipulas in 2003, it has attracted people from across the nation for a special celebration held every January. In these pictures, unidentified devotees wore Guatemalan traditional dresses during the special annual mass in St. Cecilia church. (Both courtesy of Guillermo Palencia.)

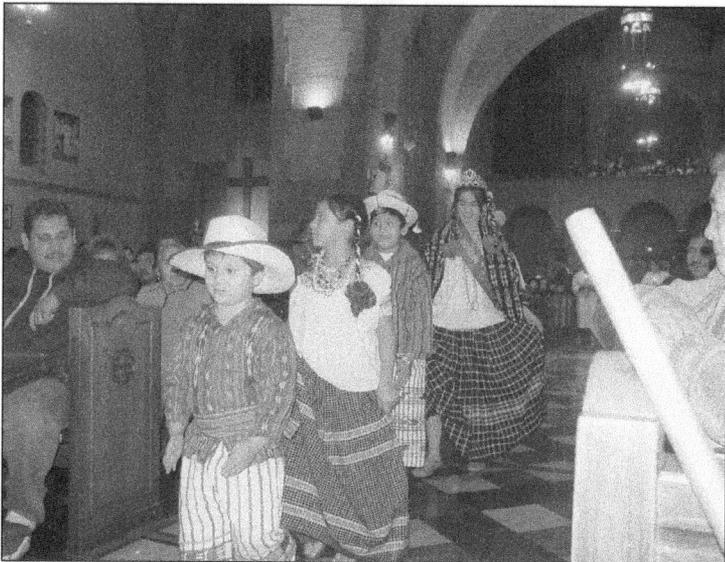

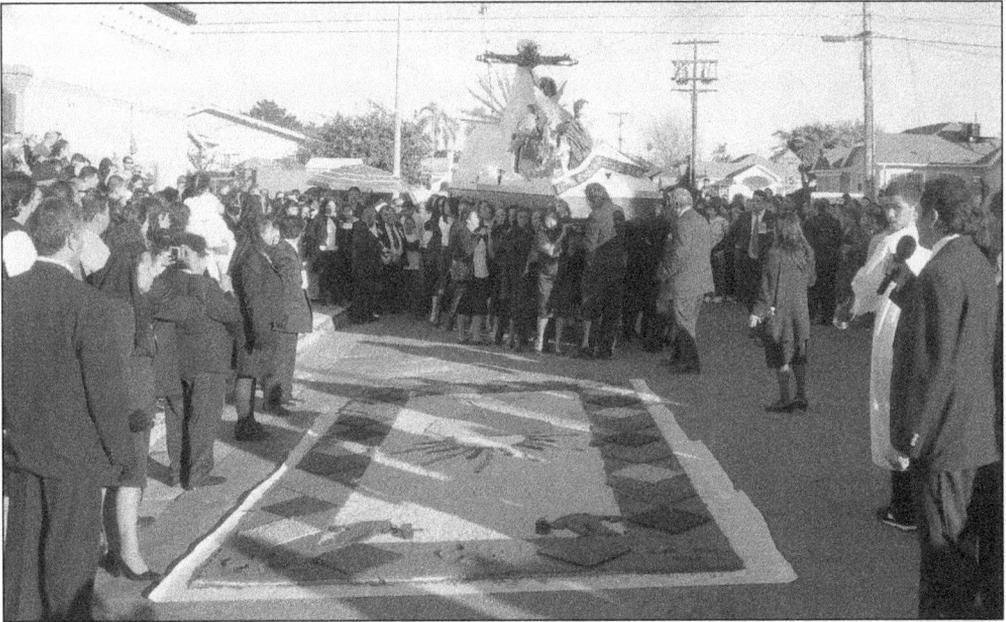

Devotees of the Lord of Esquipulas have brought to this country a Central American tradition of decorating the procession route with beds of flowers and colored sand. They also decorate the crucifix float with flowers and other ornaments. In this picture, the procession is approaching St. Cecilia church. (Courtesy of Guillermo Palencia.)

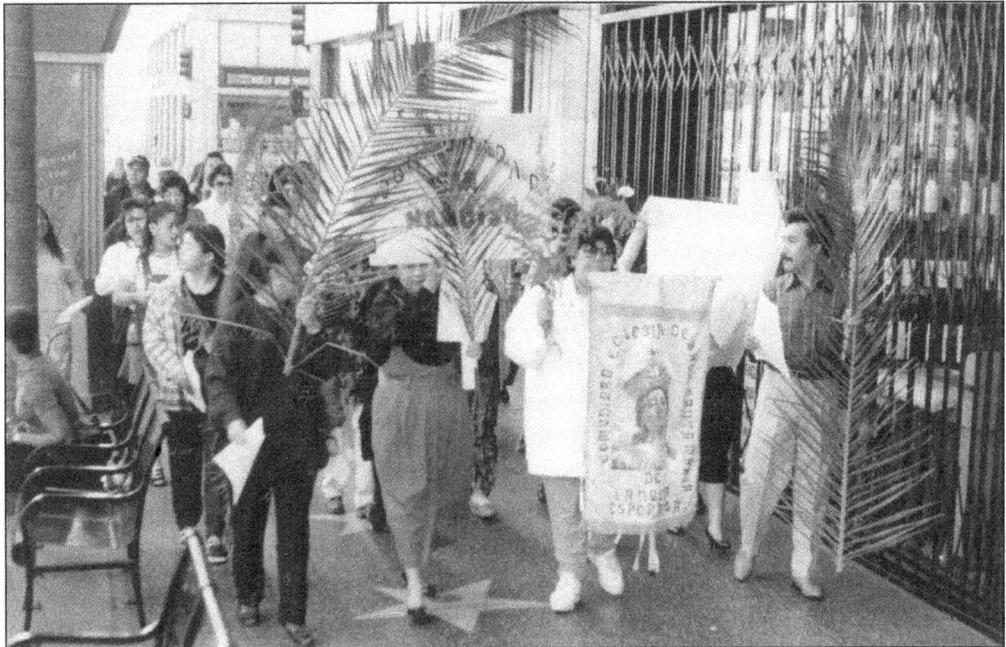

The religious experiences and expressions of Central Americans offer a colorful life on the streets of Los Angeles and sometimes send a complex message. This religious procession portrays the transnational lives of immigrants, showing that their hearts and minds are in two places. Walking on Hollywood Boulevard, the unidentified women in front carries a banner with the image of the patriot saint of her hometown. (Courtesy of Joaquin Romero collection.)

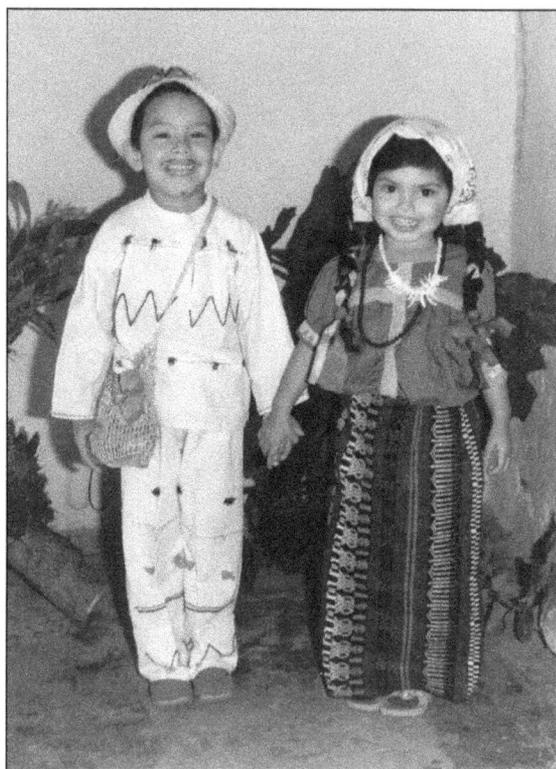

Many Central Americans are also devotees of the Virgin of Guadalupe, a representation of the Virgin Mary that appeared to Juan Diego, a Mexican peasant. Every December 12, children are dressed in indigenous peasant clothes, symbolizing the miraculous appearance. At left are Salvadoran children Roberto and Guadalupe Cabrera. Below is Andree Williams, a second-generation mixed Salvadoran and African American. (Both courtesy of the Williams family.)

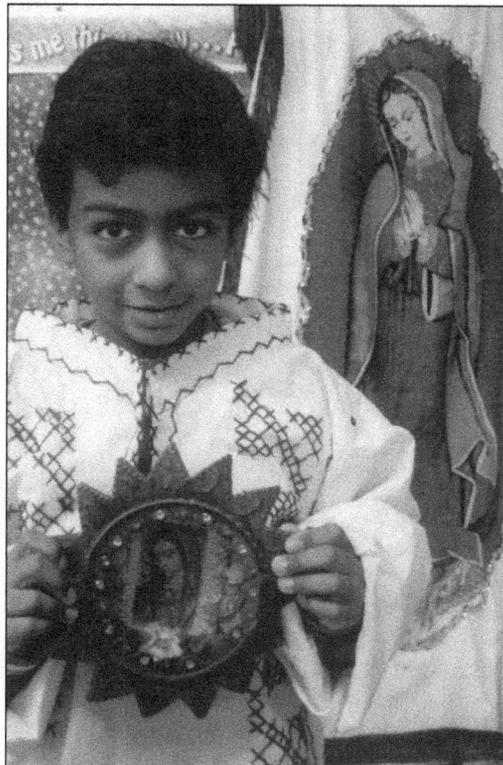

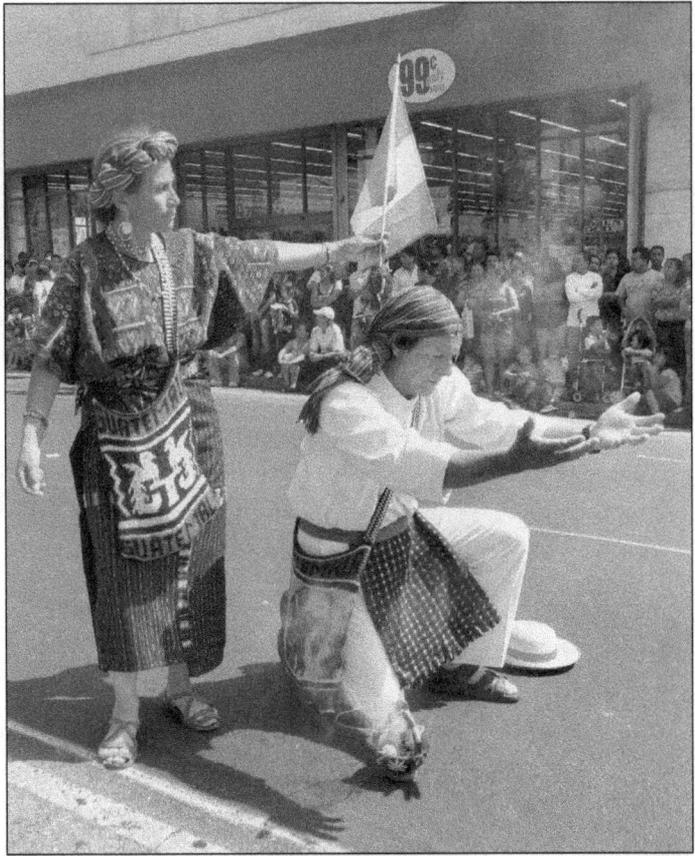

Central Americans have also taken their artistic expressions to the streets of Los Angeles. In these images, a group of unidentified performers is folk dancing in traditional dresses of Guatemala (right) and El Salvador (below) during a Central American street festival. (Right, courtesy of Central American Festivities Committee collection; below, courtesy of Association of Salvadorans in Los Angeles collection.)

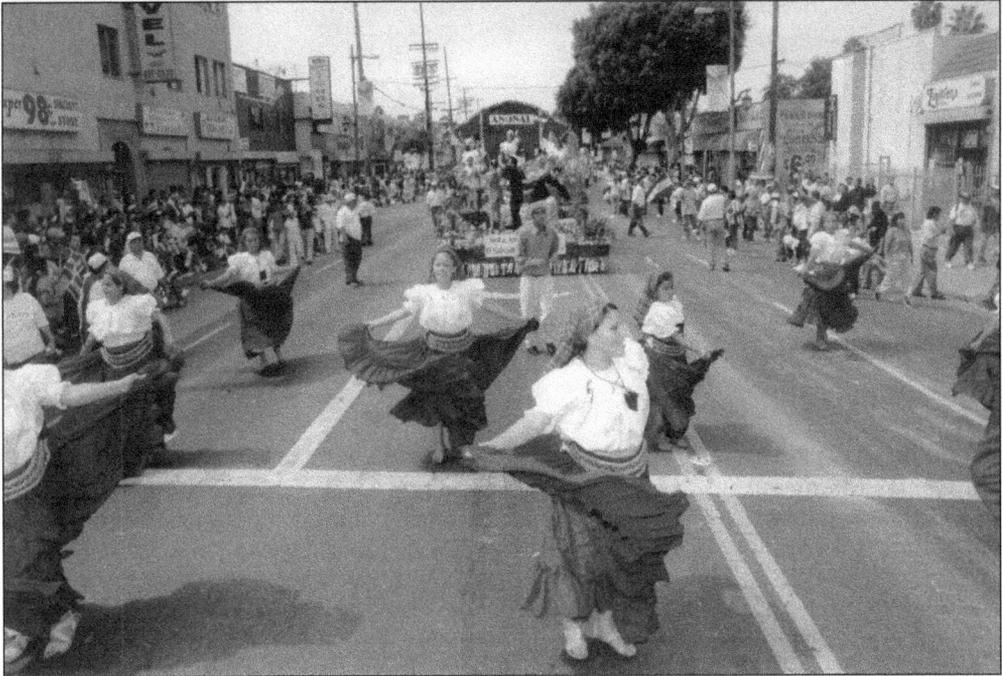

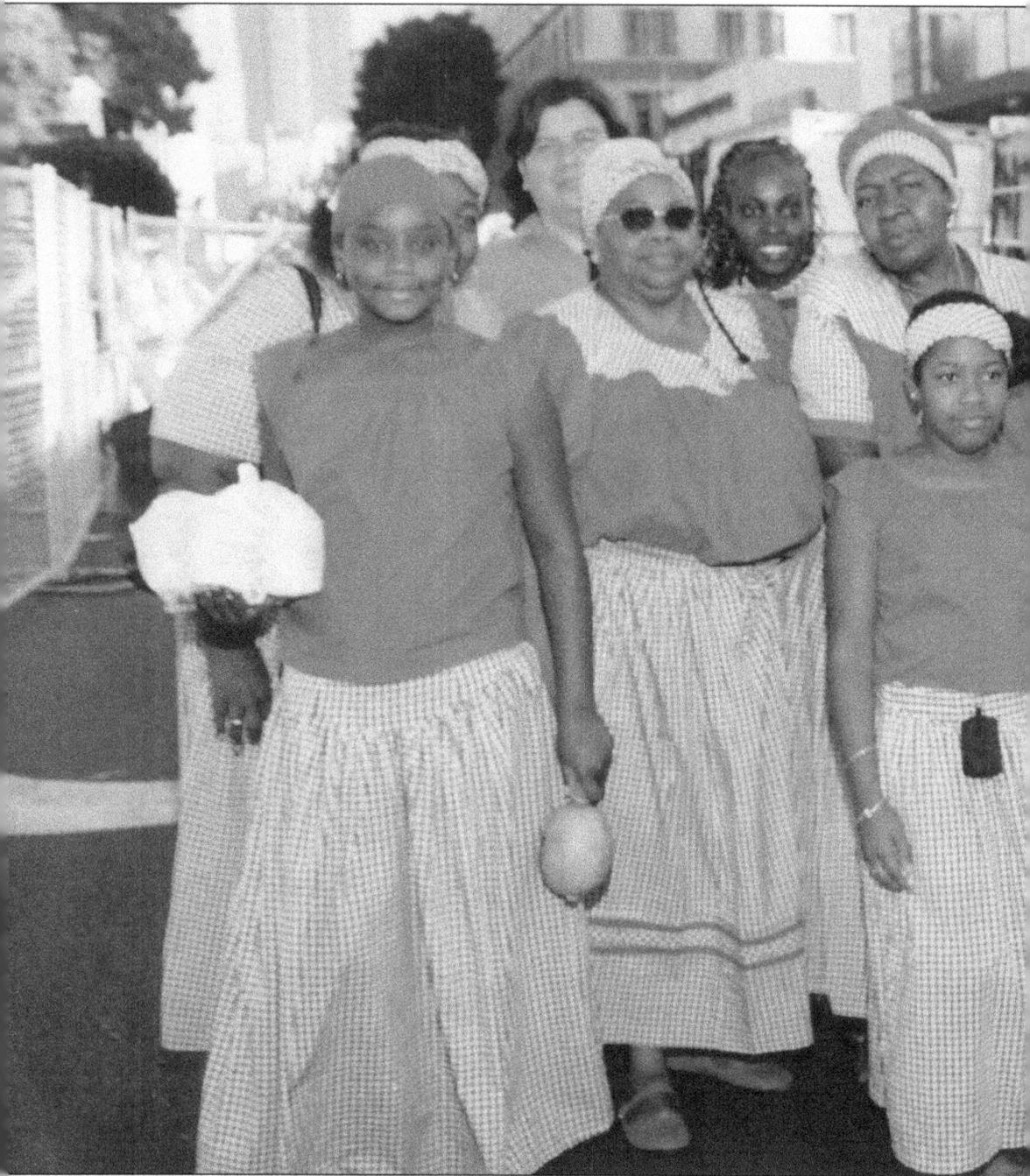

The Garifuna are a group of mixed ethnicity descendants of Carib, Arawak, and African peoples. The Garifuna originated on St. Vincent and Dominique Islands with intermarriages between the natives of the Caribbean and African slaves who had sought refugee after escaping from two shipwrecks off of St Vincent Island. Together these groups resisted the colonization of the English, French, and Spaniards for many years. In the late 1700s, some Garifuna were exiled in Honduras; later, they spread out along the Caribbean coast of Central America, settling in Belize, Guatemala, Honduras, and Nicaragua. In Los Angeles, the majority of Garifuna immigrants are

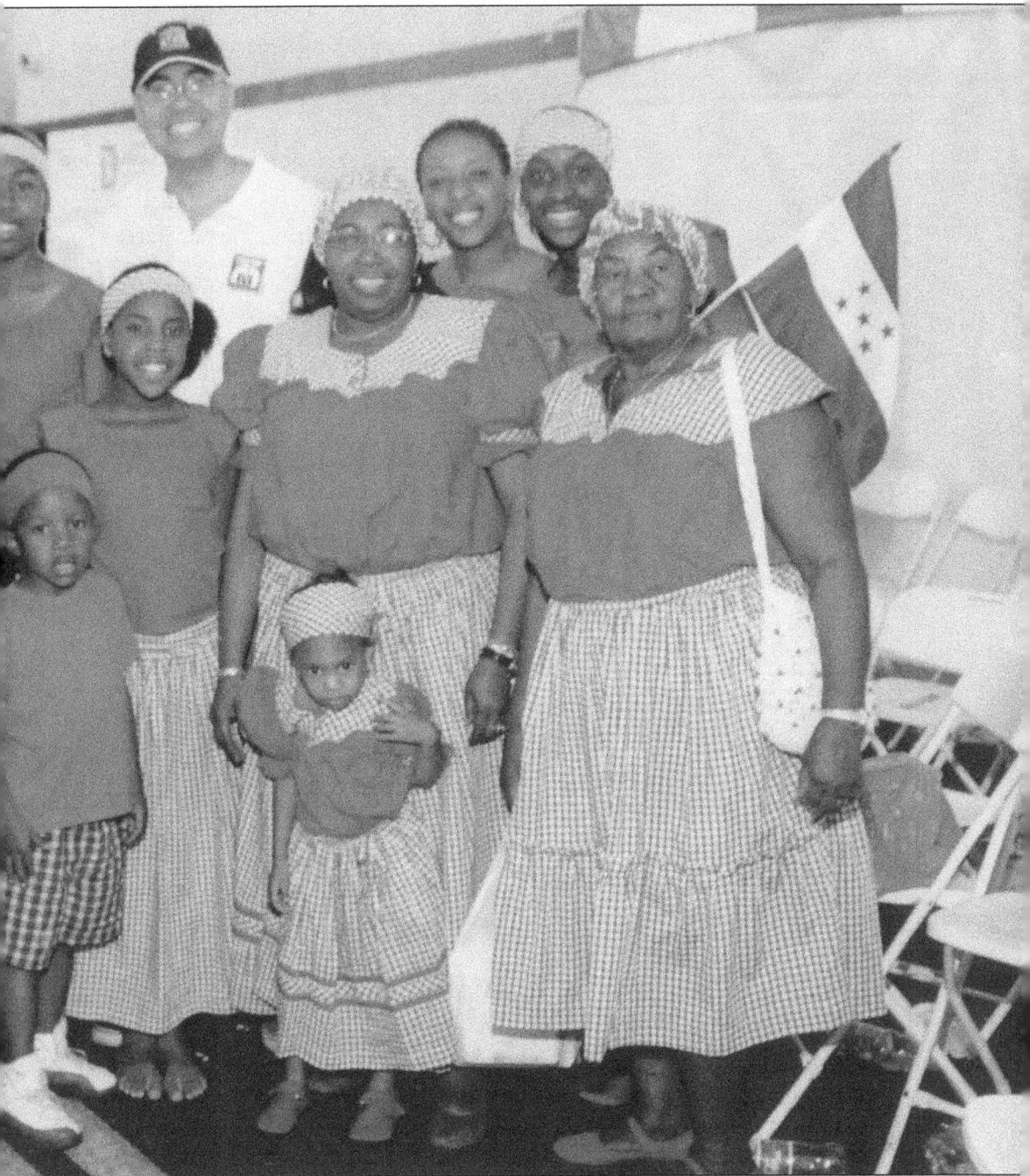

from Belize, the second-largest group is from Guatemala, and they are followed by Hondurans. Many Garifuna share the communality of the Garifuna language; a derivation of several African, Indian, and European languages, including English and French. Garifuna is spoken throughout the Garifuna nations; Belizean Garinagu usually speak Garifuna, English, Spanish, and a Maya language. Guatemalans, Hondurans, and Nicaraguans speak Garifuna, Spanish, and a Mayan language as well. In this image, Nicaraguan Fred Lugo, center, is surrounded by a group of unidentified Garifuna women. (Courtesy of Fred Lugo.)

The GAHFU is an organization in Los Angeles founded by Garifuna immigrants from different Central American countries. GAHFU explains that the Garifuna community in Los Angeles celebrates Christmas and New Years with Wanaragua dancers. The Wanaragua dance has war origins, representing a war between the Garifuna and the English. Garifuna men, disguised in women's dresses, tricked the English army, who was trying to gain possession of St. Vincent Island and the Grenadines. This male dance tradition has been passed on from elder Garifuna men to the young. Dancers wear women's costumes, including a mask, a headdress, and small rattles on their calves. Flavio Alvarez is the director of the Wanaragua Dancers of Los Angeles, the group illustrated in these images. (Both courtesy of Garifuna American Heritage Foundation Archives.)

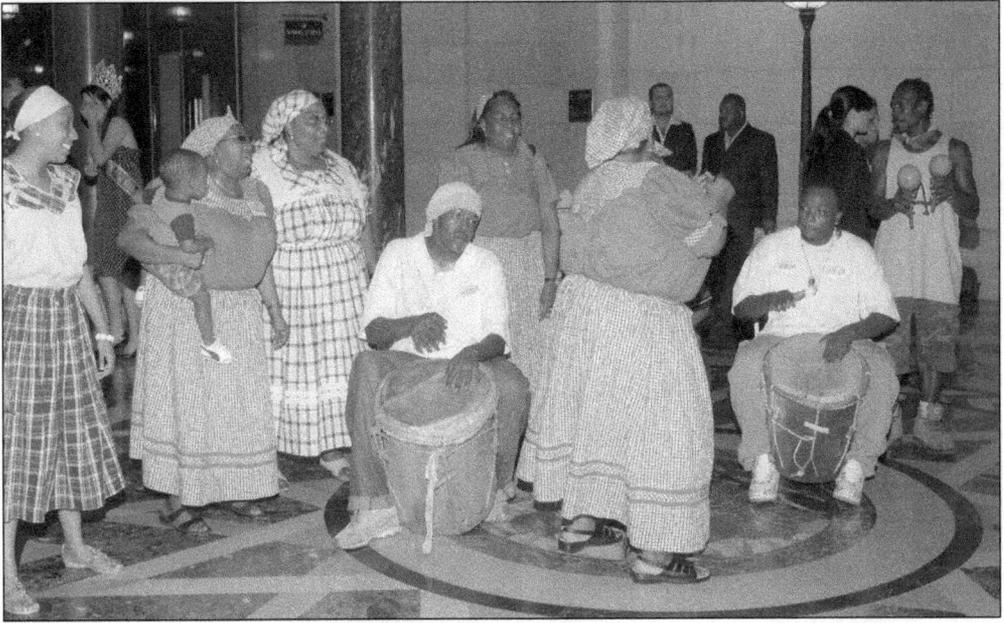

Drums play a very important role in Garifuna's celebrations and music. Generally they use a primera (tenor) and segunda drum (bass). They are played by men while the women sing and dance, as illustrated by the unidentified group in the above picture. Women singers are called *gayusas*. In general, the Garifuna drums are played by hands and are usually performed while seated. (Above, courtesy of Central American Festivities Committee Archives; below, courtesy of Garifuna American Heritage Foundation.)

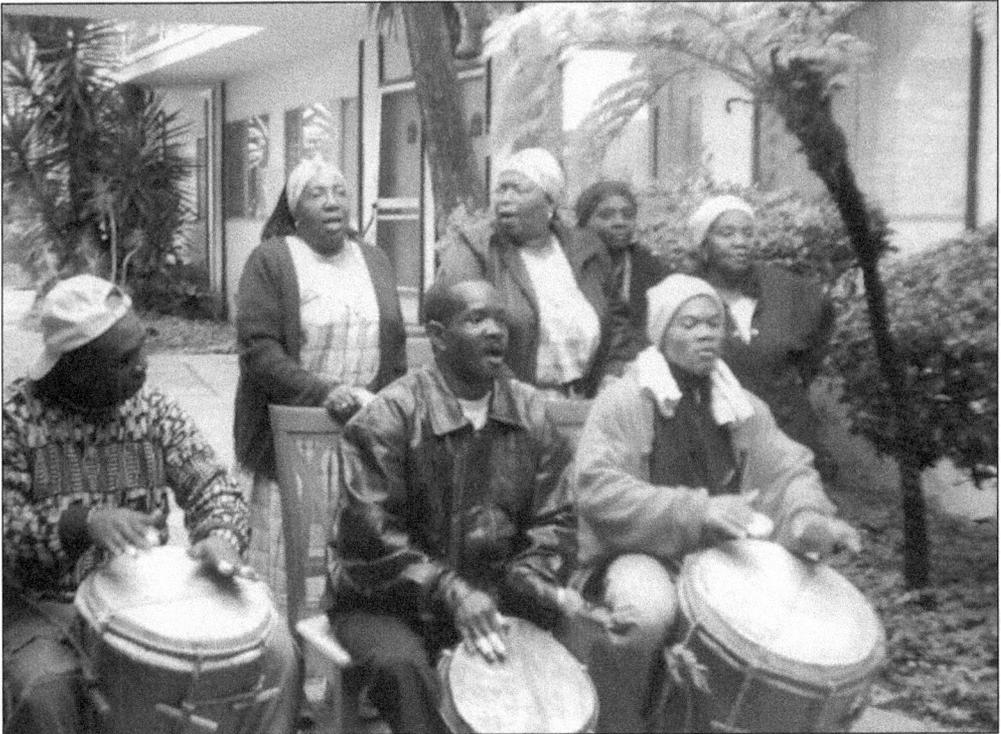

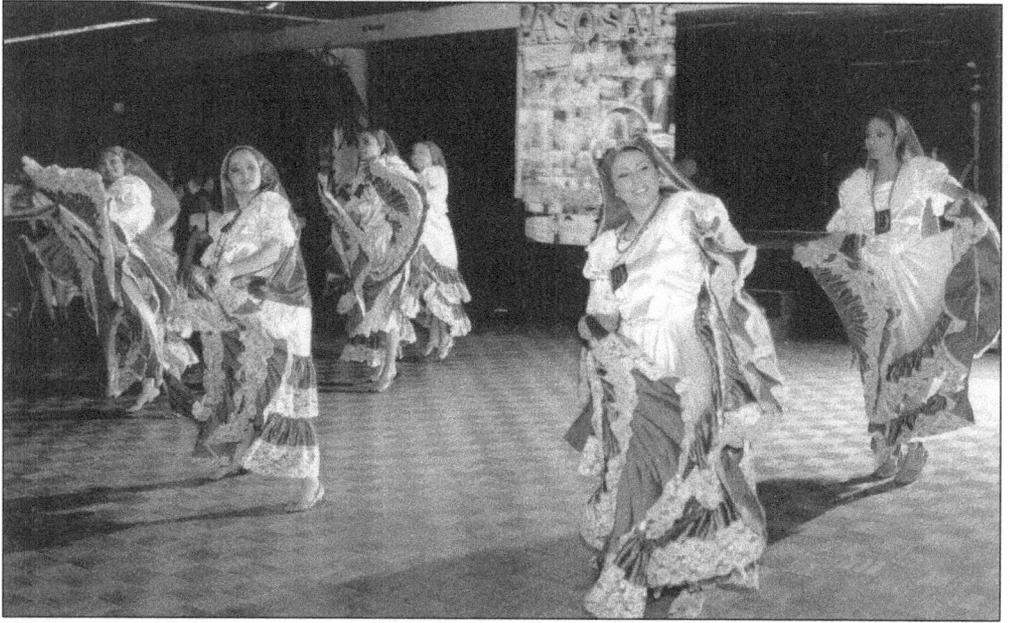

Performances of traditional folk dances have also flourished throughout Los Angeles. In these images, the Ballet Folklórico de ASOSAL perform traditional dances of El Salvador, above, and Guatemala, below. ASOSAL's dance company is formed of 25 members, including adults and children. Since its formation, the group has been invited to perform in Australia, Canada, and El Salvador. (Both courtesy of Association of Salvadorans in Los Angeles collection.)

The artistic creativity of Central Americans has also penetrated the performing arts. They have used their experiences to entertain the Angeleno community. In the above image, Salvadoran Carolina Rivera (right), accompanied on the stage by Honduran Oriel Siu, is performing at the Social and Public Art Resource Center in Venice. The drama was about the life of immigrant women, written by Rivera. Below, a group of immigrant performers from Guatemala is presenting a comedy titled *El Loteriaso* (the big lottery). (Both courtesy of Segura collection.)

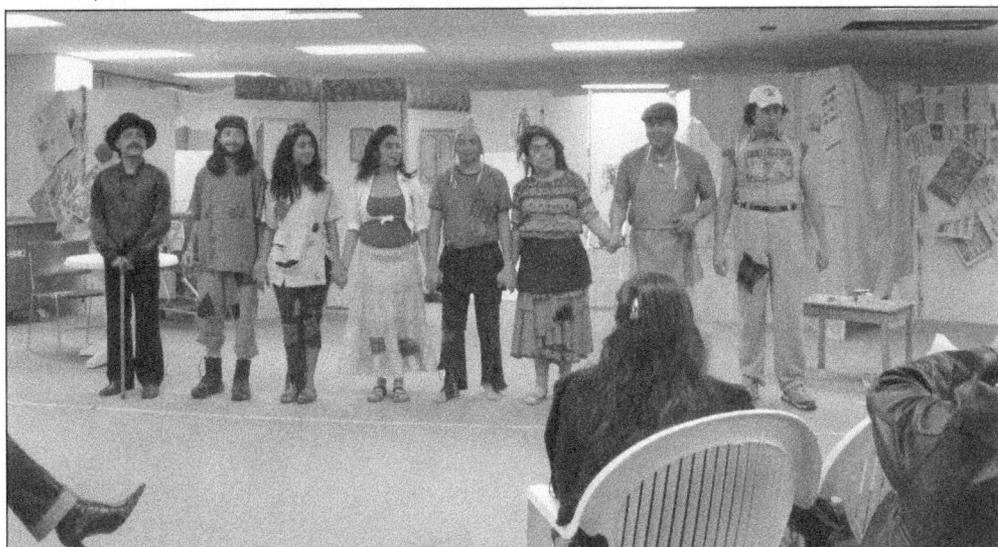

Central Americans have used different ways of expressing their culture and talents. Herbert Segura (left), a native of El Salvador, began weight lifting as a hobby. Later he began competing in body building contests. Segura is pictured in the city of Long Beach with an unidentified participant. Below, Marilyn Medina participates in a beauty contest for the title of Miss Honduras. (Left, courtesy of Herbert Segura; below, courtesy of Gloria Suazo.)

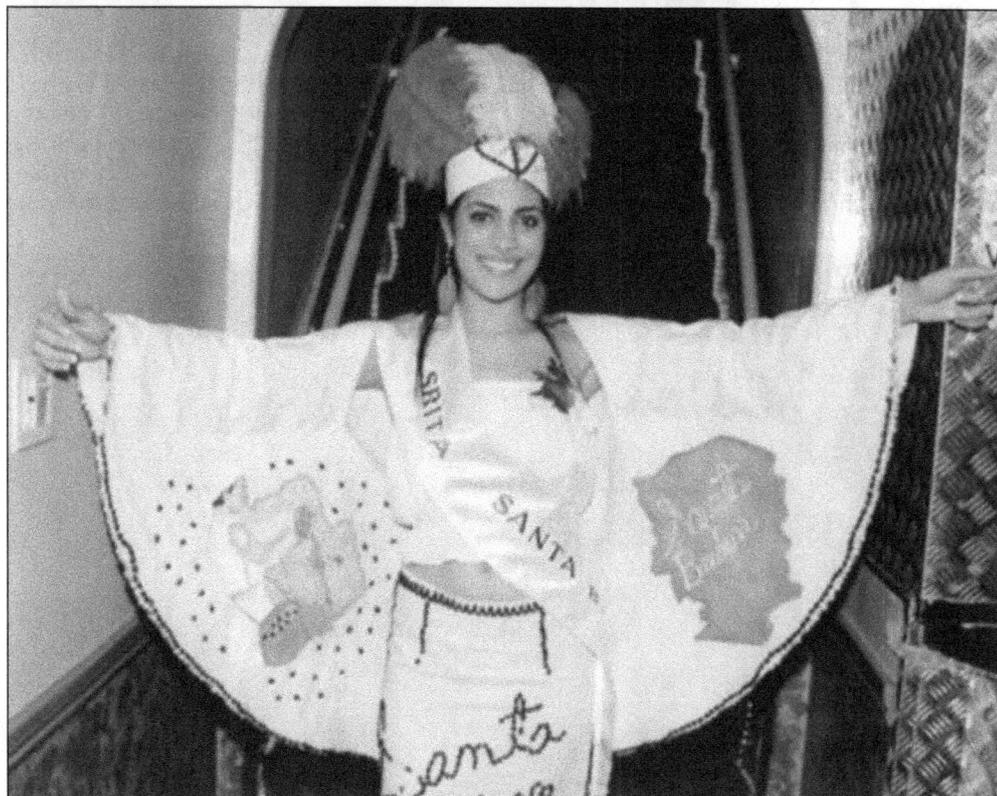

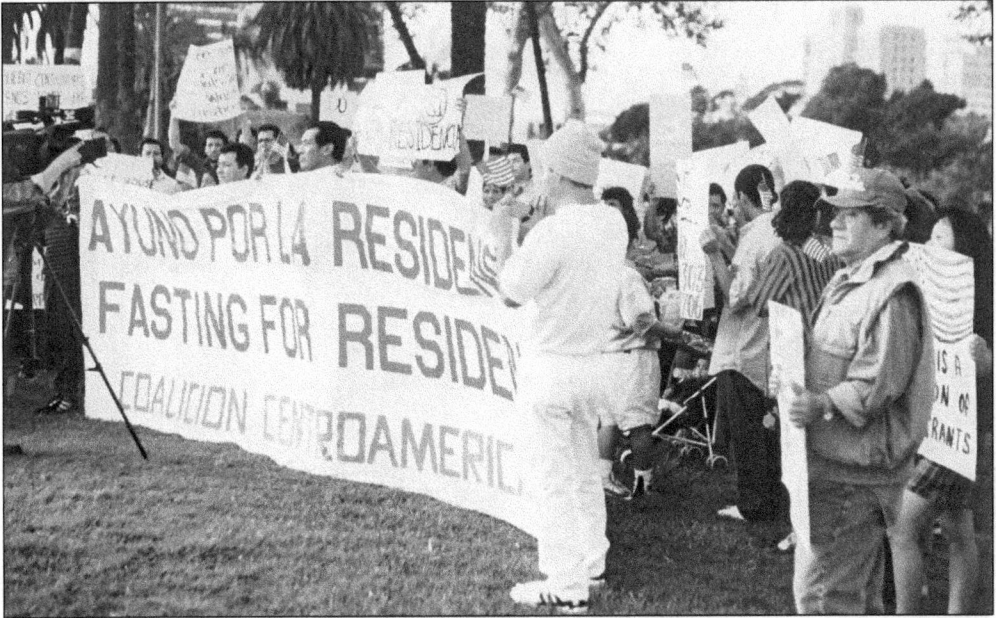

Hundreds of Central Americans continue to live in fear of deportation; even some who have spent more than half of their lives in the United State risk being deported. Many of them continue to make their voices heard. In the above image, taken in 2001 in MacArthur Park, a group of immigrants had been fasting for several days. The rally was organized by a Central American coalition advocating for just immigration reforms. Below, a group is holding a banner near Plaza Olvera in March 2006. (Above, courtesy of El Rescate Archives; below, courtesy of Omar Corletto.)

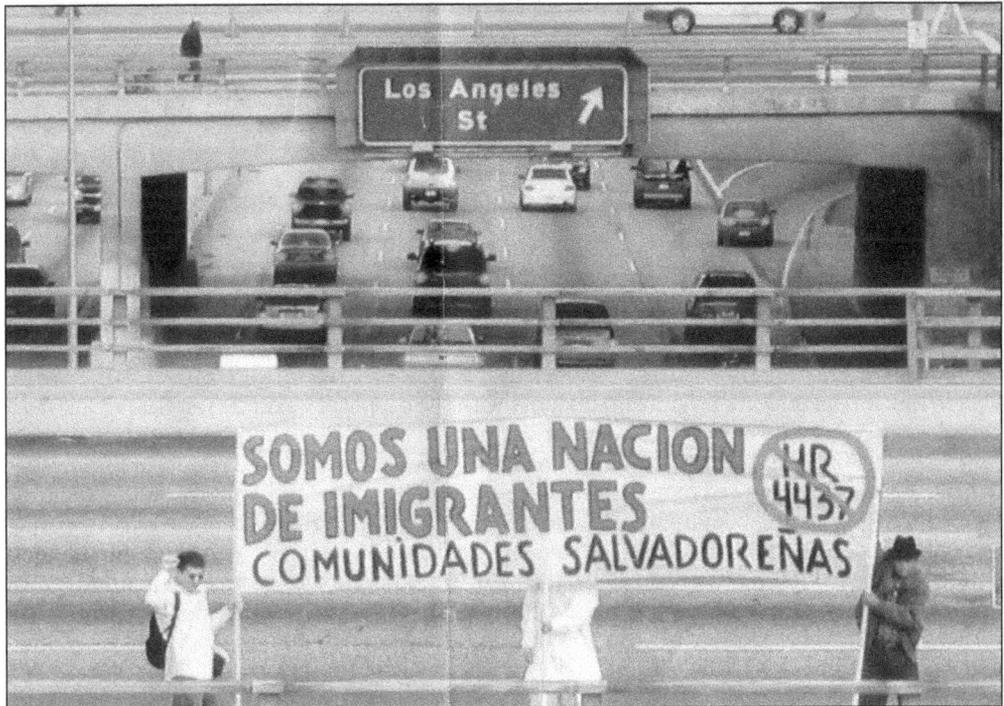

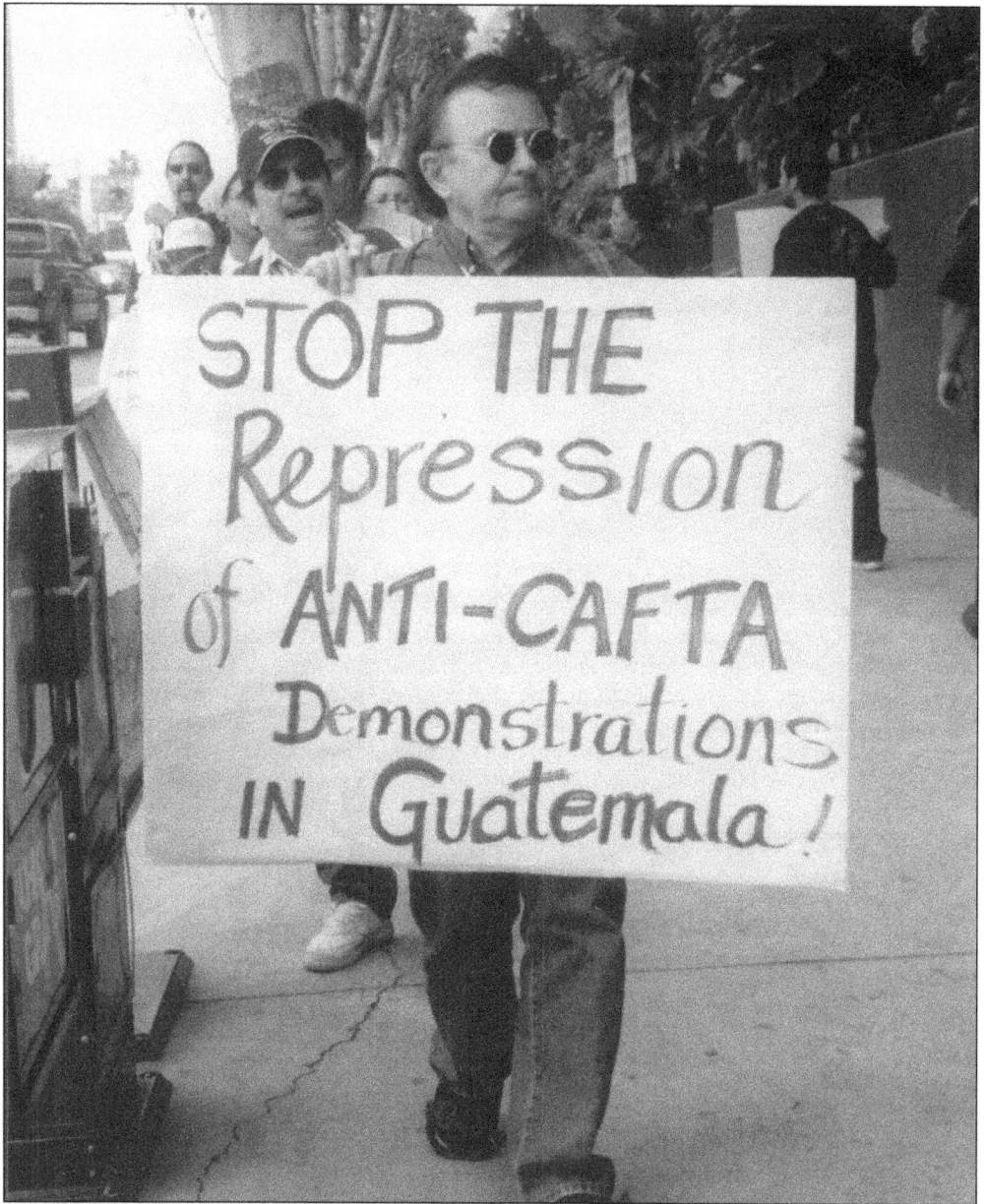

Don White was an important figure of solidarity with the people of Central America. He played a key role in the sanctuary movement, where local churches gave refuge to undocumented immigrants from Central America. He served on the Coalition in Solidarity with the people of El Salvador in Los Angeles and organized numerous fund-raising events, rallies, and demonstrations and took political delegations and humanitarian aid to Central America. In this picture, he is participating in demonstrations against the Central American Free Trade Agreement with the United States. White won the hearts and respect of Central Americans. The following is an excerpt from a poem by Elio Martinez: "Don White, men of heart, noble, sincere, untainted. Give me the honor to call you my brother, because you really are for me and for my beloved country brother Don White, You will always be a son of my beloved country." (Courtesy of Joaquin Romero collection.)

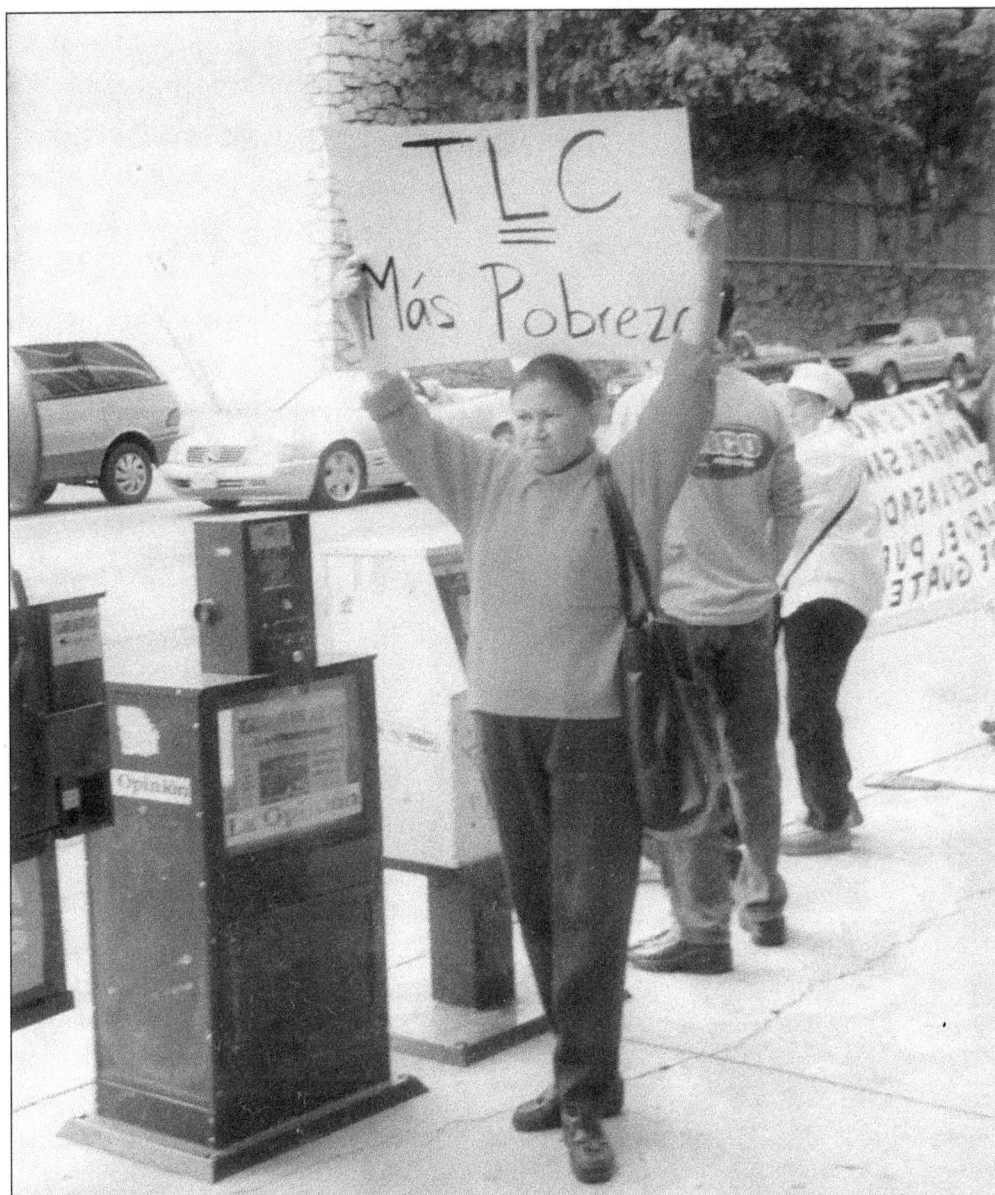

Maria Guardado, a Salvadoran refugee, has participated in numerous demonstrations, such as hunger strikes for human rights and for pro-immigrants. In this photograph, she is demonstrating against the Central American Free Trade Agreement. The sign reads, "Free Trade Agreements (TLC) = More Poverty." Her life has been the inspiration of a documentary film called *Testimony: The Maria Guardado Story*. She is also a dynamic writer of poetry; her poetry often reflects on the experience lived during the war. In a passage from her poem, "Mother," Guardado reveals: "Son of my soul. Searching for you in every one of the prisons, From where I came out with my heart strengthened by anger, For my only crime is that of being a mother, Yet, I was beaten without pity by beastly guards. Today, I said, I'll look for you no longer, beloved son, Even though my heart is broken, May God grant me peace of mind, So that I may embrace as my own true child, That thing for which you are still fighting, And which your often spoke of as so beautiful. which is called Liberty!" (Courtesy of Nestor Villatoro.)

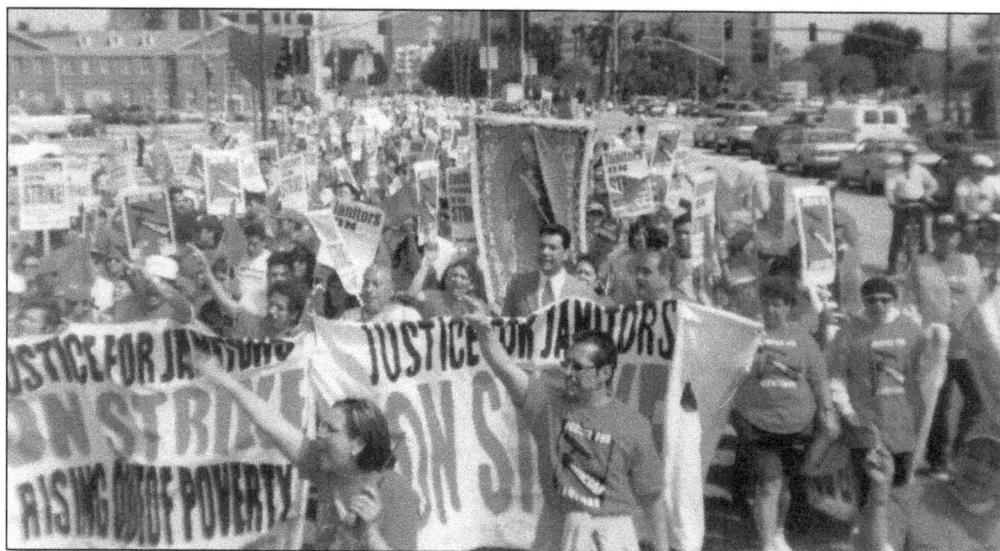

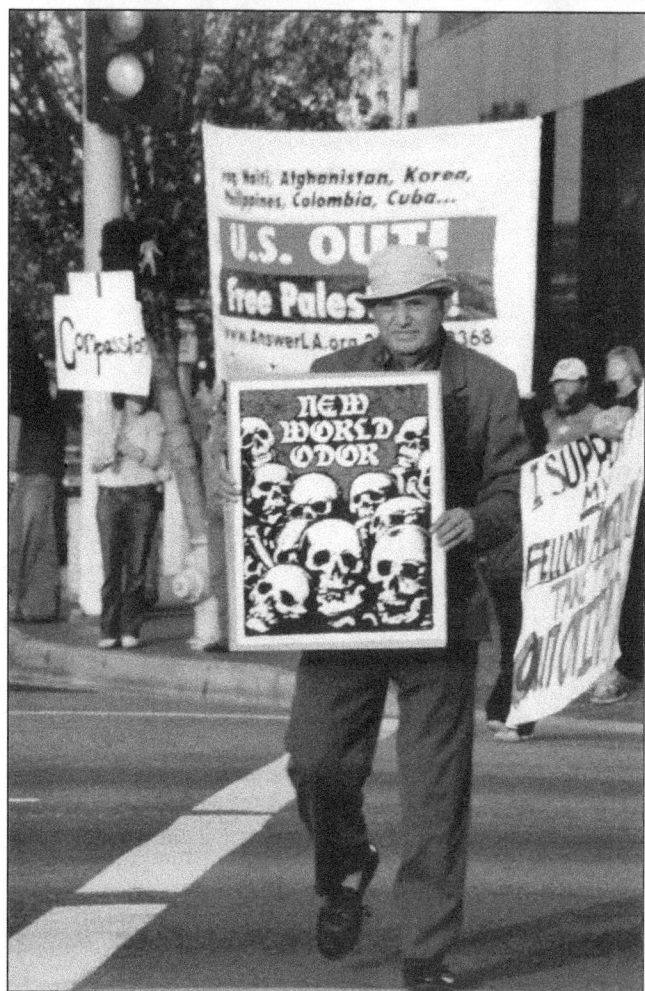

Numerous Central Americans have contributed to improving the employment conditions of workers in Los Angeles. For example, during the 2000 Justice for Janitors strike, hundreds of Central Americans played important roles in the struggle to improve salaries and working conditions. In this picture, Nestor Villatoro (first row, center), an immigrant from Guatemala, was one of the lead organizers of the strike. In more recent times, Central Americans have voiced their opposition against the United States's intervention in Iraq. At left is Ricardo Zelada, a Salvadoran immigrant. (Above, courtesy of Nestor Villatoro; left, courtesy of Ricardo Zelada.)

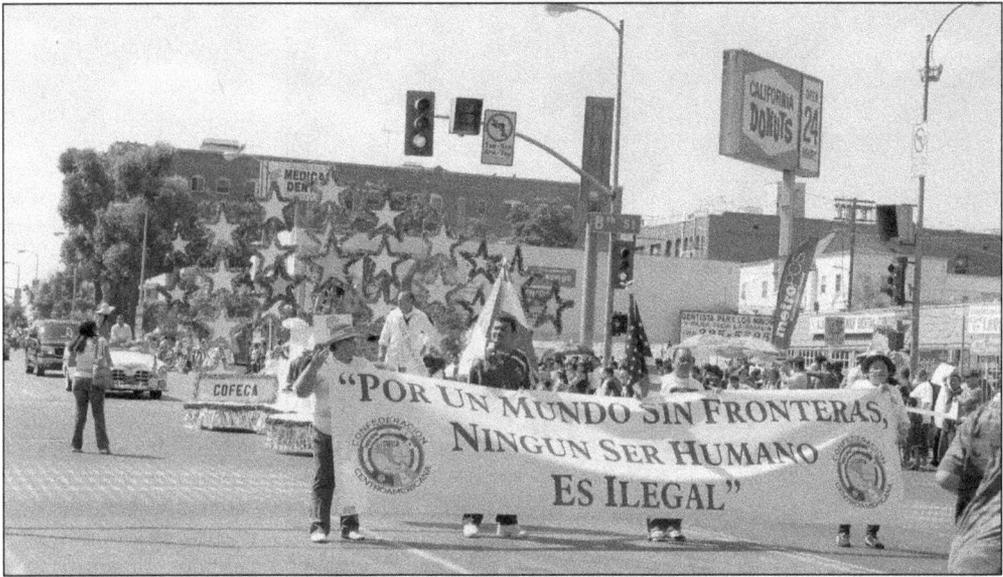

The Central American parade has been a tradition in Pico-Union since 1983. It is a celebration of the region's independence from Spain in 1821. During the early years of this festival, the parade route occupied only half of the street, sharing the other lanes with the traffic. In contrast, today the procession of floats, folkloric dancers, marching bands, and thousands of spectators occupies long stretches of the road. The festival lasts three days, attracting over 200,000 people from many different areas. The festivities include a beauty pageant, a city hall ceremony, and a carnival in MacArthur Park with traditional music and food from the different countries. Above, a banner is pictured, stating the theme of the parade: "No Human Being is Illegal." Below, the crowd in MacArthur Park is seen during a festival. (Both courtesy of Central American Festivities Committee collection.)

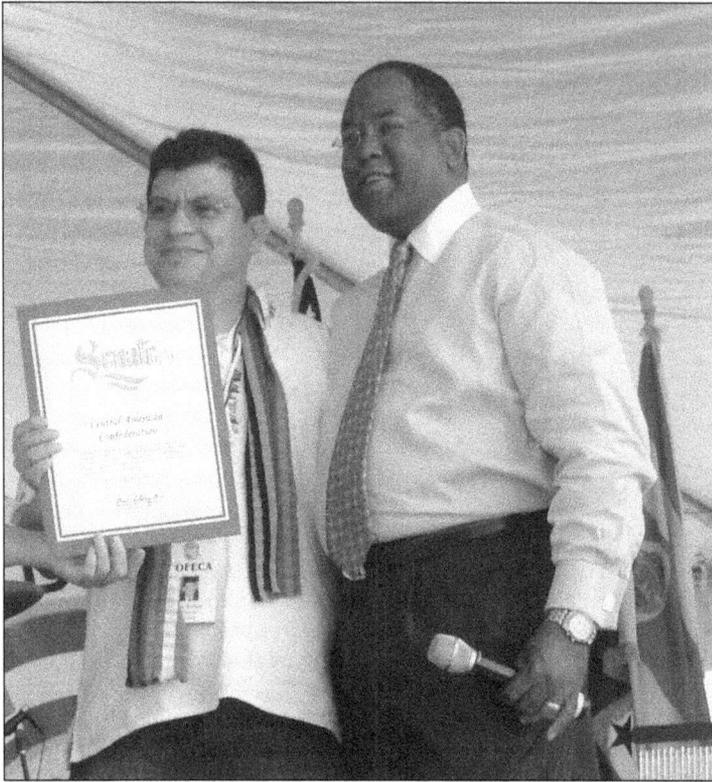

Omar Corletto (left), director of the COFECA, is pictured receiving a certificate of valuable cultural recognition by Los Angeles County supervisor Mark Ridley-Thomas during the opening ceremony of the 2008 festival. Below, is a group of unidentified Central American girls who participated in COFECA's beauty pageant. (Both courtesy of Central American Festivities Committee collection.)

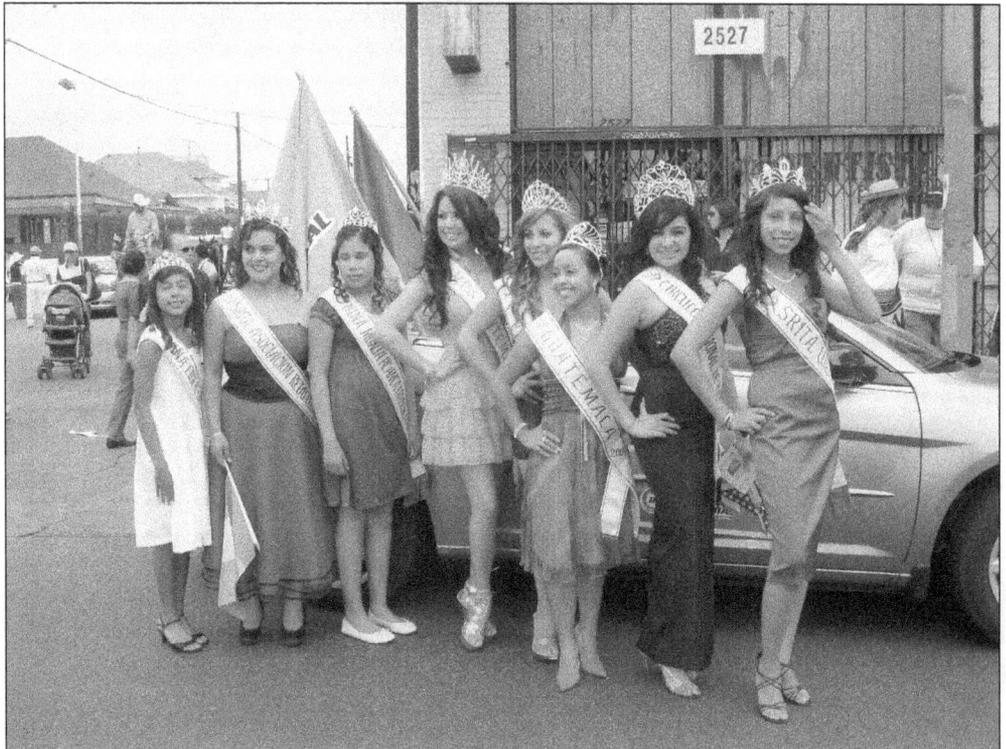

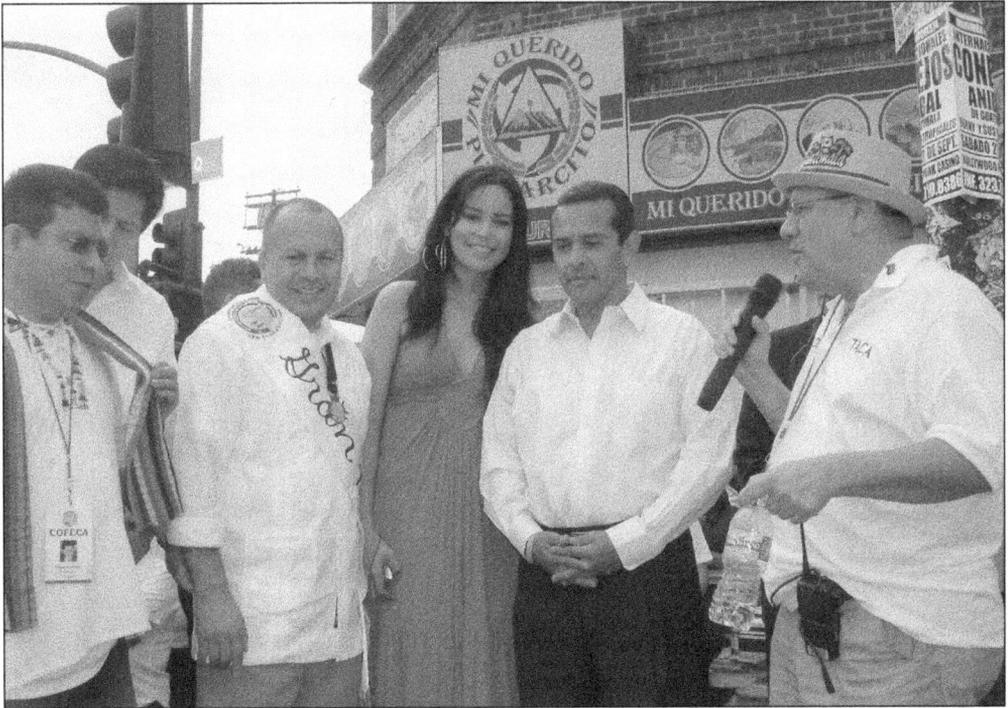

From left to right above, Corletto, councilman Ed Reyes, unidentified, Mayor Antonio Villaraigosa, and unidentified are seen during the Central American festival in front of El Pulgarcito Restaurant, a popular gathering place among Salvadorans. *El pulgarcito* (tiny thumb) is a nickname given to El Salvador as it the smallest country in Central America. Below, one of COFECA's floats is in front of Langer's Deli. The restaurant is a city landmark. Langer's opened in 1947, when the neighborhood was home to middle-class Jews. Today Central Americans enjoy the famous pastrami sandwiches. (Both courtesy of Central American Festivities Committee collection.)

During the Central American independence festival, each nation uses the opportunity to display traditional folk dresses. Some of the participants walk the parade displaying their costumes, and others are carried on decorated automobiles. In general, the women's costumes are of bright colors, ranging from oranges, blues, and reds, and made of glossy lightweight fabrics, like chiffon or satin. Others prefer printed fabric with bright colored flowers. Guatemalans usually wear hand-woven cotton and hand-dyed clothing done by local indigenous people. Men's costumes are usually of white cotton fabric. (Both courtesy of Central American Festivities Committee collection.)

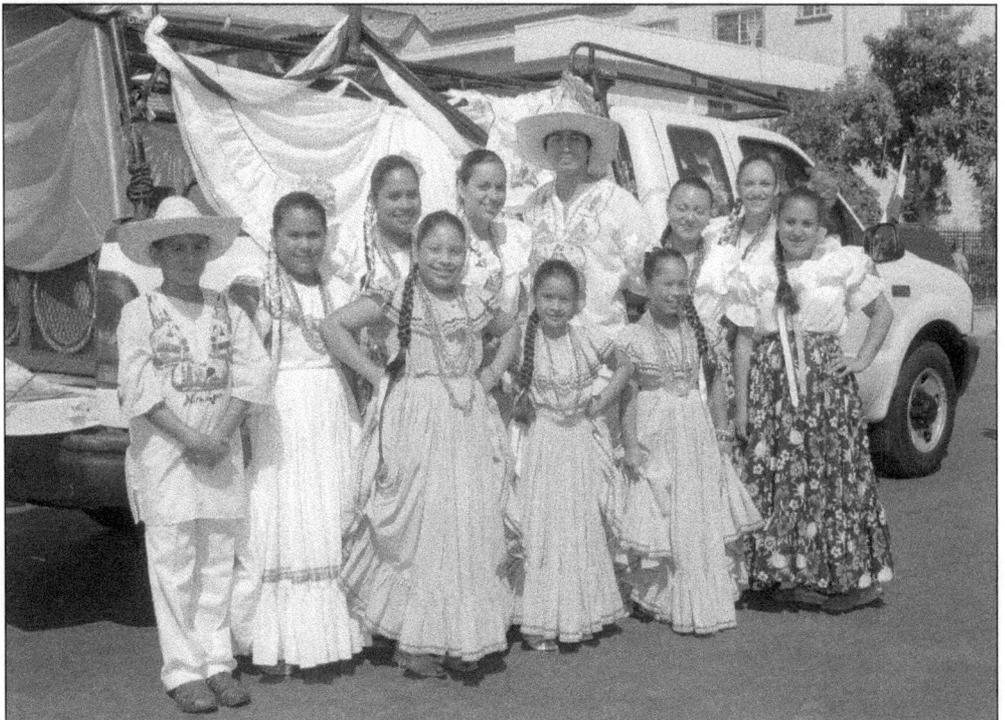

Another unique feature of the Central American festival is the floats. Often each float tries to represent a cultural element of a particular country. Above, the bus illustrates typical public transportation in some areas of Central America. Below, the float represents a sweeter memory of life in the home country. (Both courtesy of Central American Festivities Committee collection.)

Music is always a big part of Central American culture, and Central American festivals are full of music and song. In the above image, the float carries the band La Chanchona from El Salvador, playing cumbia music. Behind the band is a paper mâché globe of the world, with the flags of each Central America country emplaced. Below, the crowd always takes the opportunity to display the flag of its country; the unidentified woman in front is holding the Guatemalan flag. Behind the crowd, an unidentified group is holding the Salvadoran flag. (Both courtesy of Central American Festivities Committee collection.)

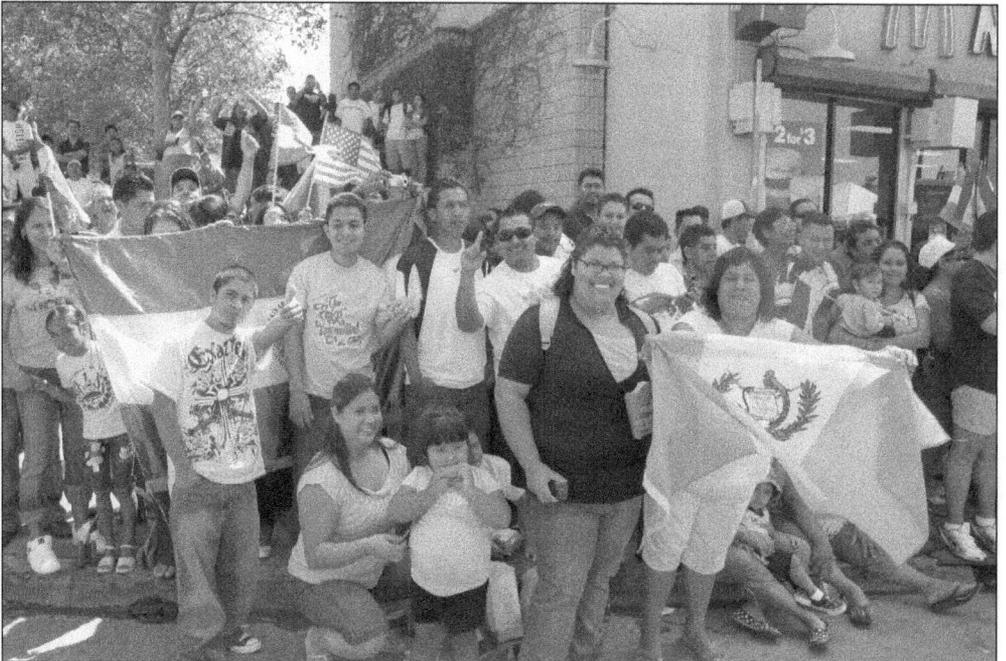

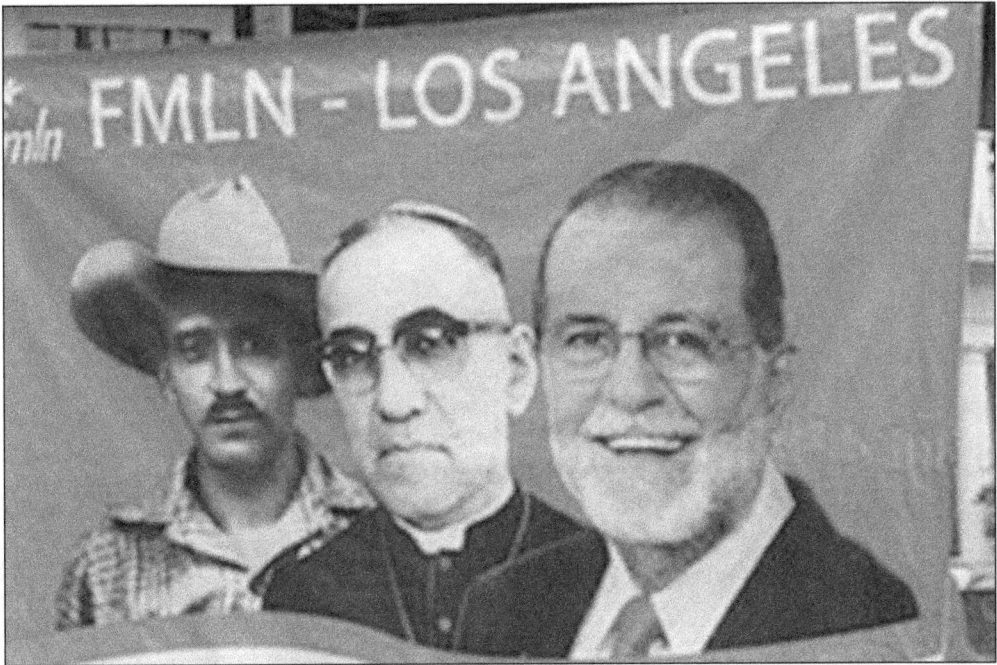

Many immigrants continued to be connected with the political affairs of their native land. In these pictures from the 2008 Central American festival, there were several banners campaigning for El Salvador's FMLN presidential election. Above is a large banner with images of Salvadorans' beloved figures Farabundo Marti, Msgr. Oscar Romero, and Shafik Handal. Below, members of Homies Unidos carry a banner with the face of Pres. Mauricio Funes. Homies Unidos is a Los Angeles–based organization working on gang prevention, alternatives to gang involvement, and violent behavior in Los Angeles and Central America. (Above, courtesy of Remberto Diaz; below, courtesy of Central American Festivities Committee collection.)

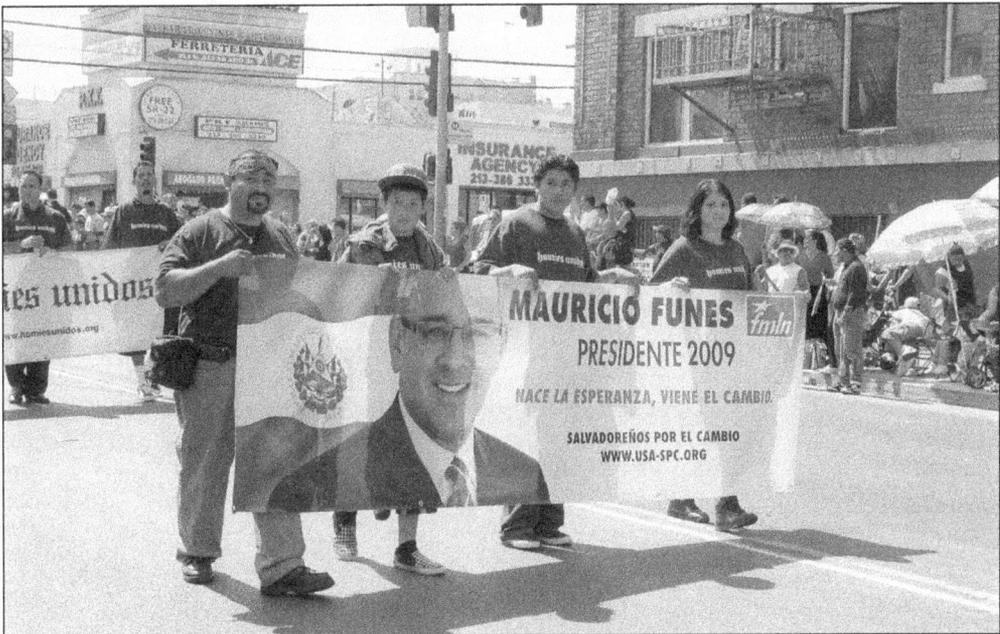

A group of marching band members and dancers called Nuestros Angeles de El Salvador traveled from El Salvador to Pasadena to participate in the 2008 Tournament of Roses Parade. The 230-member youth band had an exciting trip traveling through Guatemala and Mexico before arriving in Los Angeles. They encountered many problems. Notably, some of the members were denied a U.S. visa. Then available funding was insufficient to cover the high cost of air

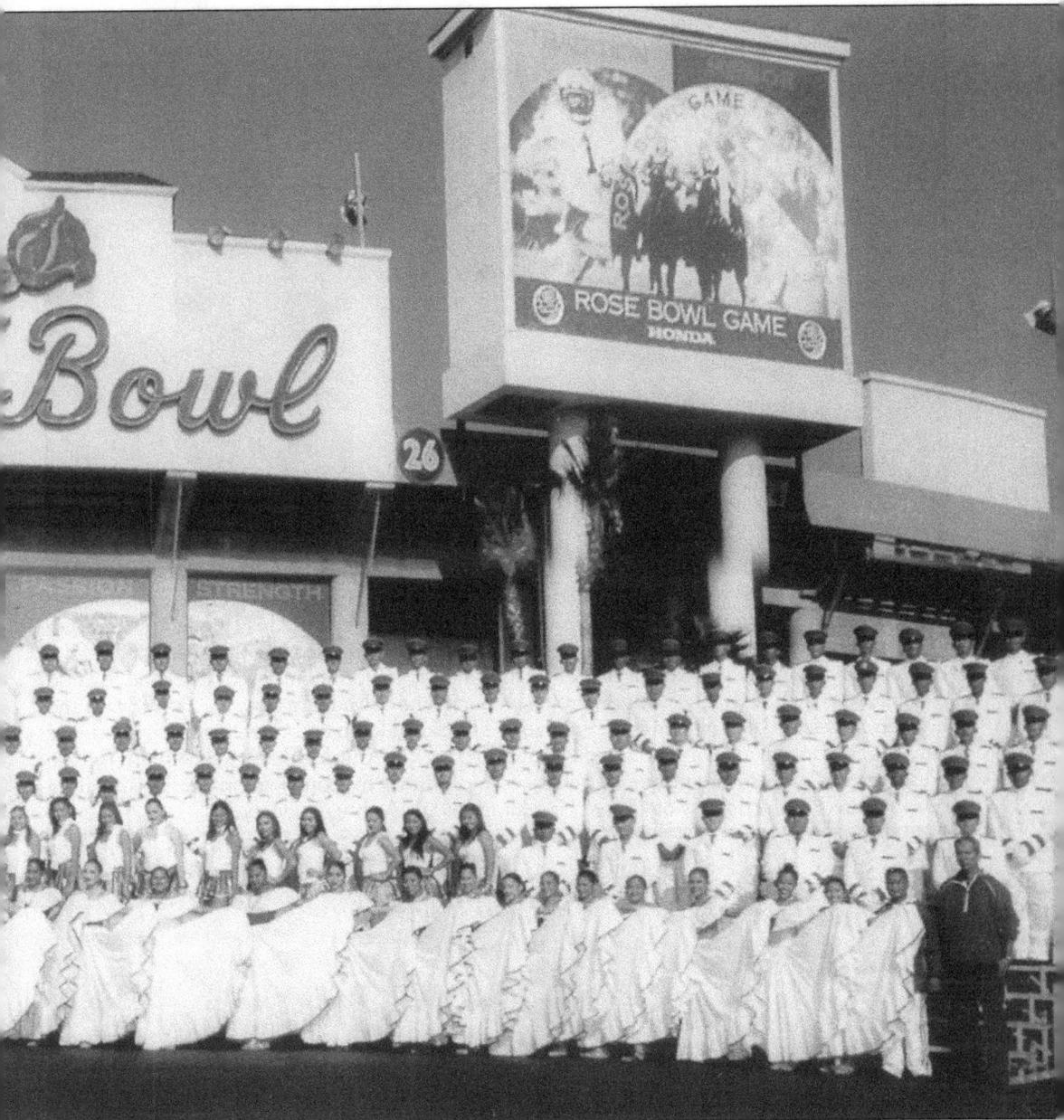

transportation. In the end, the band made it through the same road taken by most Central American immigrants—thousands of miles by bus, with painful and exhausting inspections at the borders of Guatemala, Mexico, and the United States. When they finally arrived, they received a tumultuous reception, with thousands of people warmly greeting them on the streets of Pico-Union. (Courtesy of Association of Salvadorans in Los Angeles collection.)

The City of Los Angeles has adopted various resolutions recognizing special days for particular Central American countries. For example, October 3 has been recognized as Honduran-American Day. In 2006, this group of Hondurans received a certificate acknowledging the importance of the Honduran community in Los Angeles. From left to right are former mayor of Lynwood Ricardo Sanchez, who is a native of Los Angeles from Honduran and Salvadoran parents, Gloria Suazo and Leoncio Velasquez, both Honduran immigrants. The Salvaldoran and Guatemalen communities have also been recipients of similar recognition. Below, Los Angeles County supervisor Yvonne B. Burke gives a certificate plaque to Velasquez, recognizing his contributions in disseminating their culture. (Both courtesy of United Hondurans of Los Angeles collection.)

A group of Salvadorans and other volunteers joined efforts to create a symbolic union between the city of Los Angeles and the City of San Salvador, El Salvador. On January 26, 2005, the partnership between both cities became official. Today in downtown Los Angeles, right, a sign hangs indicating the 2,305 miles to San Salvador. For some Salvadorans, the official joining of these two cities is more than symbolic because many immigrants living in Los Angeles remain connected in different ways to their native land through their remittances to family and friends, their frequent trips, and the very strong spiritual connection they maintain. For example, an unidentified group, below, is marching on a street in Los Angeles, holding a sign stating, "United with Atiquizaya," expressing their attachment to the homeland, a small town in El Salvador. During the 1980s and continuing into the 21st century, Central Americans have formed hometown associations. These associations offer help in the form of financial contributions, which serve to upgrade local medical and educational institutions. Additionally they provide funding for major civic improvements and sports equipment, and they supplement other important services for the cities from which they emigrated. (Right, courtesy of Remberto Diaz; below, courtesy of Central American Festivities Committee collection.)

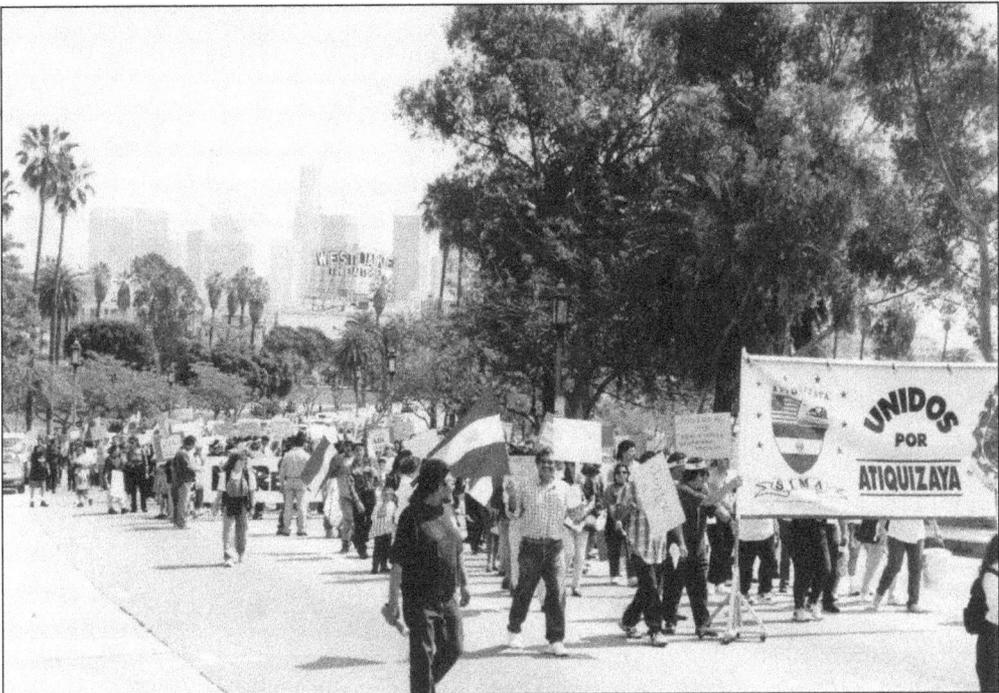

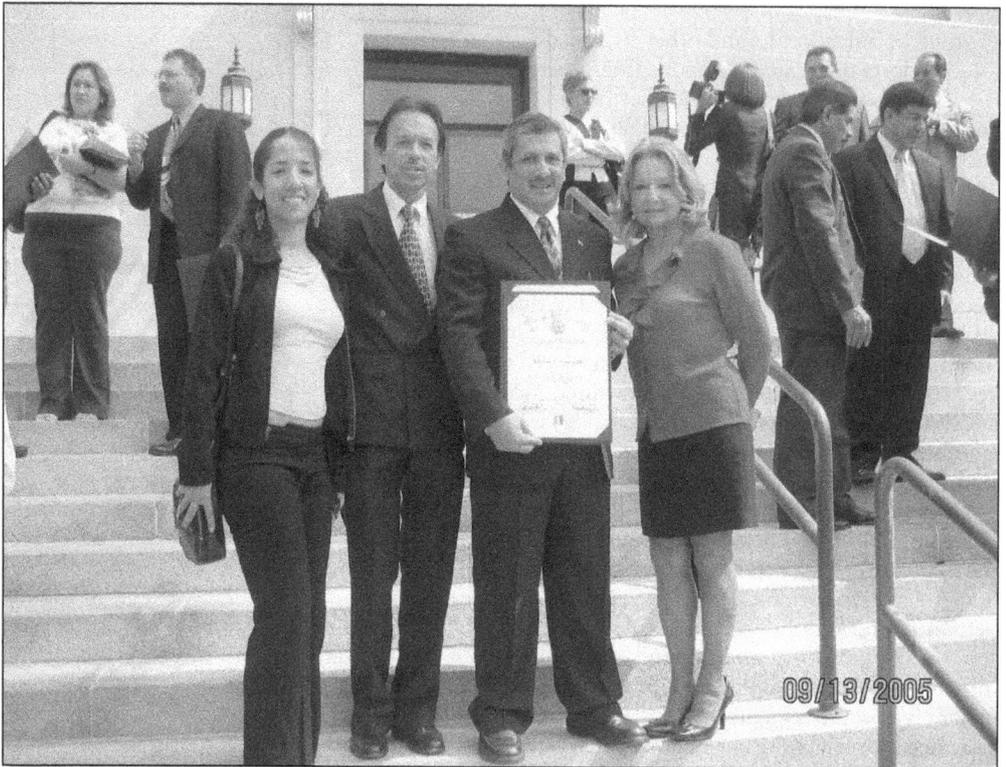

This group of Panamanians standing in front of the city hall receives recognition from the City of Los Angeles in 2005 for their leadership and cultural influence in Los Angeles. From left to right are Laura Echevers, coordinator of Ballet Folklórico Viva Panama; Hiram Laws, director of public relations for Viva Panama Organization; Victor Grimaldo, president of Viva Panama; and Marlene Sanchez, vice president of Viva Panama. (Courtesy of Victor Grimaldo.)

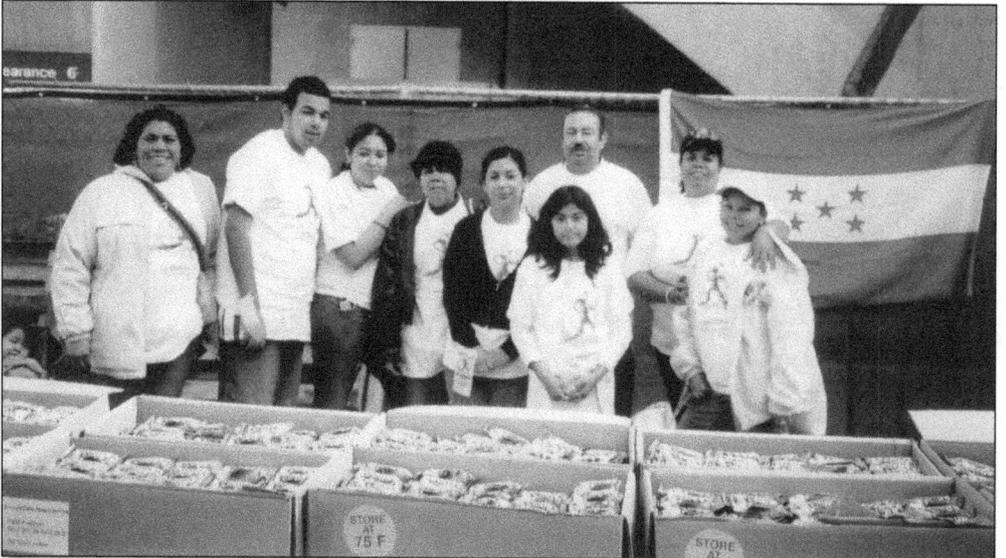

Honduran friends and families take to the new tradition of volunteering to serve refreshments to the runners of the Los Angeles Marathon. (Courtesy of Velasquez family.)

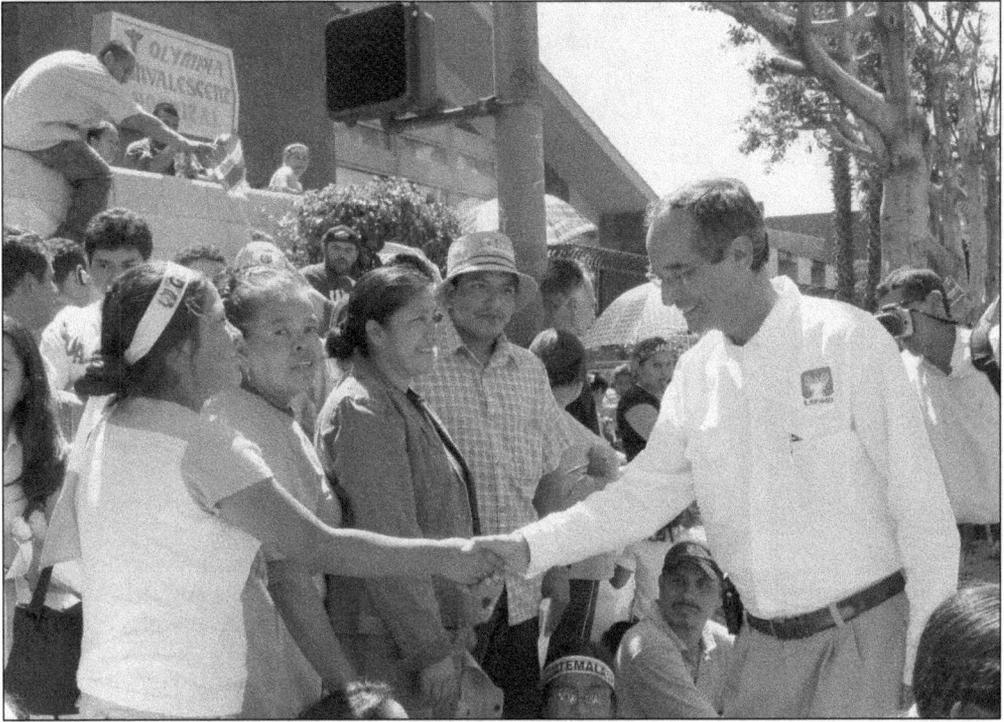

Political figures from abroad have recognized the potential for political support that Central American Angelenos represent, and they frequently come to Los Angeles to reconnect with these communities. Above, Pres. Colon Alvaro Colom of Guatemala is shaking hands with spectators on Alvarado Street. Presidential nominee Schafik Handal from El Salvador also visits Los Angeles (below). From left to right are Schafik Handel, Tania Handel, Werner Marroquin (behind an unidentified woman), and unidentified. (Above, courtesy of Central American Festivities Committee collection; below, courtesy of Pehdro Kruhz.)

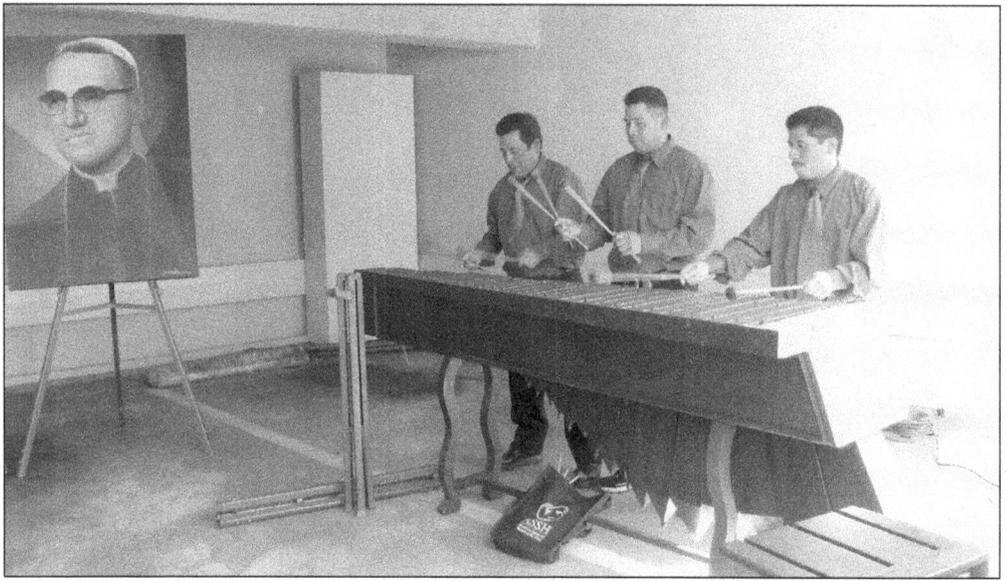

Music from the different regions of Central America has flourished in Los Angeles. Musicians have brought their talents and creative energy. A group of unidentified musicians play traditional Guatemalan marimba tunes during the 29th remembrance day of the life of Msgr. Oscar Romero, and in the background is an image of Romero by Los Angeles–based artist Francisco Mejia. (Courtesy of Segura collection.)

In this photograph, unidentified children practice the traditional Garifuna drumming beats at the Garifuna Culture and Language School of Los Angeles. The school was established in 2005 as a nonprofit agency to preserve the Garifuna language and culture, including traditional music and dance classes. (Courtesy of Garifuna American Heritage Foundation Archives.)

Throughout the first decade of the 21st century, different Central American individuals have united in efforts to safeguard their heritage and disseminate their culture. A more recent organization, the Center for Salvadoran Cultural Development, is working on the artistic and cultural development of Central Americans residing in Los Angeles. Above, some of the founding members from left to right are Mario Avila, an immigrant from Guatemala; Celia Marmol; Isabel Cardenas; and Ricardo O'Meany from El Salvador. In the image below, taken at Casa Nicaragua, an unidentified woman is wearing a traditional folk dress. On that occasion, Casa Nicaragua was honoring individuals who have been supporters of the Nicaraguan community; one of the recipients' was Pedro Arias, a Mexican immigrant. From left to right are Arias, unidentified, Julio Cardoza, and unidentified. (Above, courtesy of Pehdro Kruhz; below, courtesy of Pedro Arias.)

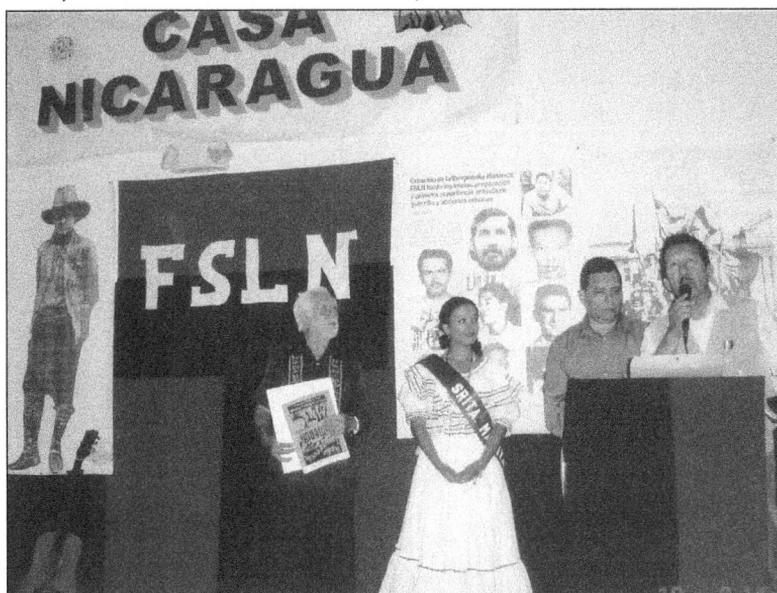

Horacio N. Roque Ramirez, a Salvadoran native, has dedicated much of his time working with the gay Central American men residing in Los Angeles. Roque Ramirez, above, along with others, has put together several projects involving writing, poetry, and culture among gay Central American men. In 2003, Roque Ramirez and Santiago Bernal were responsible for organizing an event, pictured at left, of readings by local gay Central American participants. Roque Ramirez is a professor at the University of California, Santa Barbara, where he teaches lesbian, gay, bisexual, transgender/queer studies in Latino communities plus courses on Central Americans in the U.S. and the Salvadoran diaspora. Roque Ramirez has a forthcoming book titled *Memories of Desire: An Oral History from Queer Latino San Francisco, 1960s–1990s.* (Both courtesy of Santiago Bernal.)

Central American families continue with traditional rituals, above, where an unidentified group of Central Americans is celebrating Erika Maciel Rojas's *quinceañera*. The occasion is held on a girl's 15th birthday, symbolizing entering adulthood. The celebrations often combine rituals taken from both Mexican and Central American traditions. Below, Salvadoran youth enjoy a camping trip. From left to right are Rubi ?, Gris ?, and the others are unidentified. (Both courtesy of Pehdro Kruhz.)

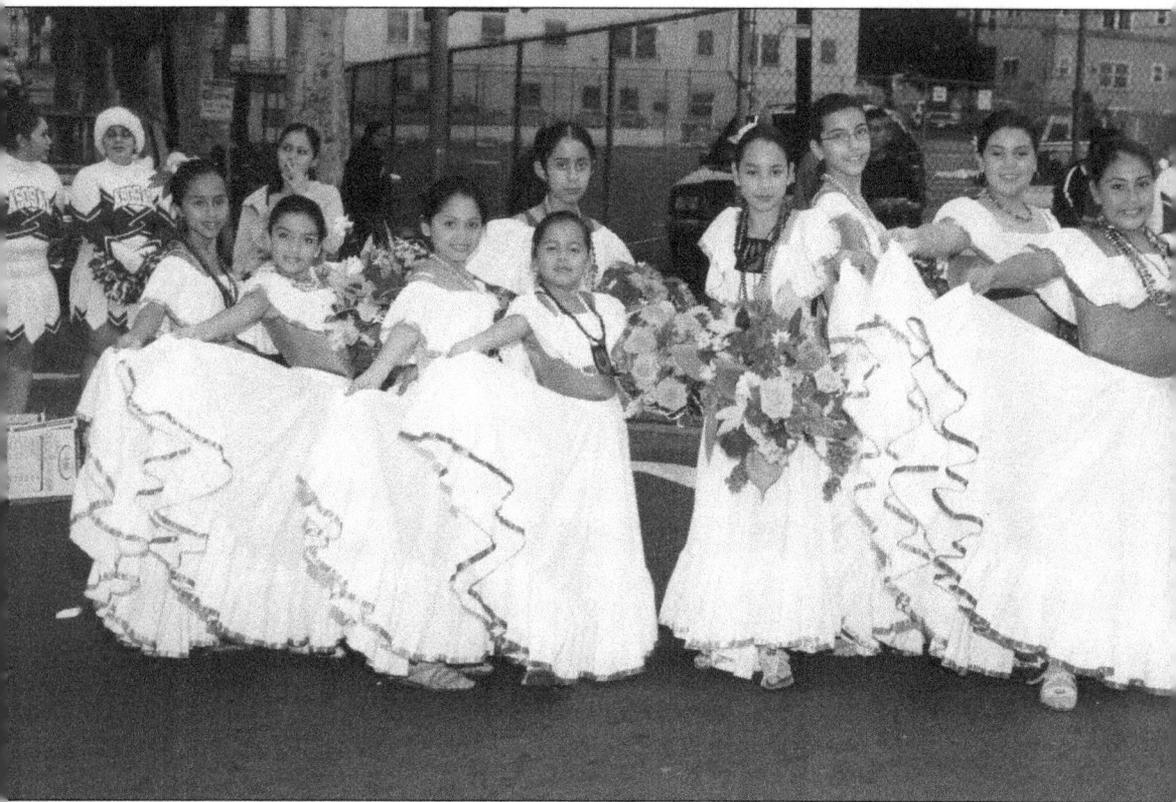

Young Central Americans growing up in Los Angeles are often overshadowed by the presence of Mexicans and Mexican Americans. Frequently they are challenged to find their own identities as Central Americans. However, many of these children grow up with little information about their heritage. Sometimes parents prefer not to talk about their origins because of their traumatic experiences, fear of stereotyping and discrimination, and the more serious fear of deportation. Nonetheless, all the efforts for cultural affirmation by various social welfare organizations provide opportunities for families and youths to come together and rediscover the richness of their heritage. But the challenges for youth to maintain their cultural identity continue in school and in their subsequent lives. In this picture, a group of unidentified ASOSAL children proudly displays their Salvadoran traditional folk dresses. (Courtesy of Association of Salvadorans in Los Angeles collection.)

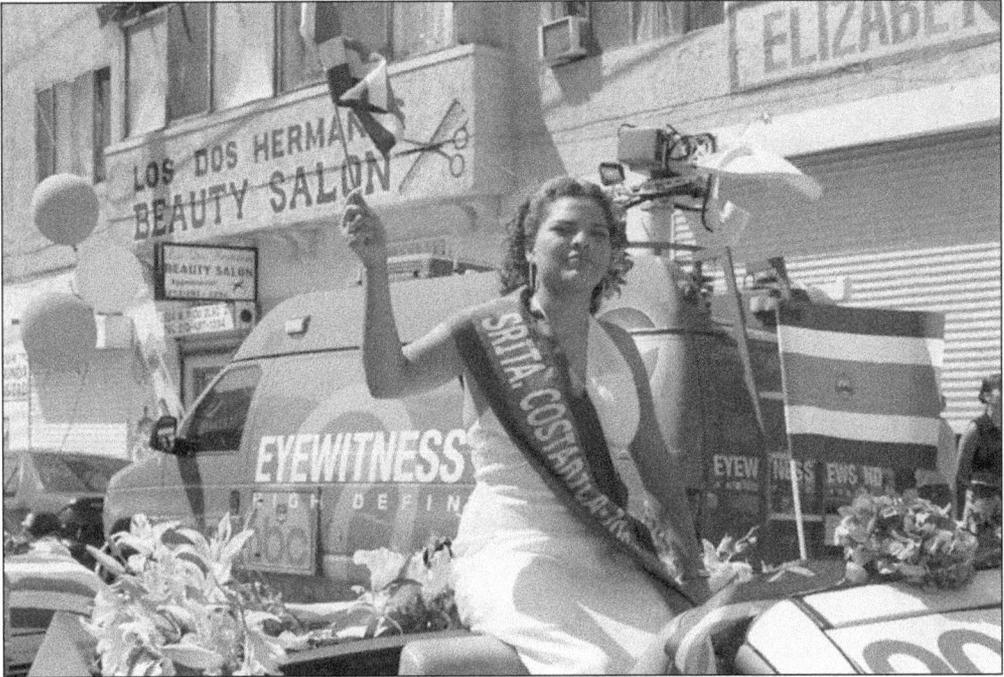

Some Central American youth are full of pride in their heritage despite the challenges of peer pressure. Above, a young *tica* proudly represents her country during a Central American festival. Below, Sheila Martinez (left) and Jessica Amay, *catrachas*, are showing the Honduran flag. Costa Ricans are usually referred to as *ticos* and Hondurans as *catrachos* in a friendly and respectful way. (Above, courtesy of Central American Festivities Committee collection; below, courtesy of Gloria Suazo.)

The challenges for Central Americans' younger generations to uphold their identity are numerous. For example, children face difficulties fitting into school among other dominant cultural groups that are non-Spanish speakers. Also, growing up in a society that emphasizes physical appearance can be a barrier for little children seeking to preserve their identity as they grow. At left, Digna Castro is a student of the ASOSAL ballet folklórico, wearing a traditional dress of her Honduran origins. Below, an unidentified child is pictured during ASOSAL's Festival de Las Flores (carnival of the flowers) a traditional annual spring festival celebrated on the month of May in El Salvador. ASOSAL follows the same tradition in Los Angeles and uses the opportunity to teach children about Salvadoran culture. (Both courtesy of Association of Salvadorans in Los Angeles collection.)

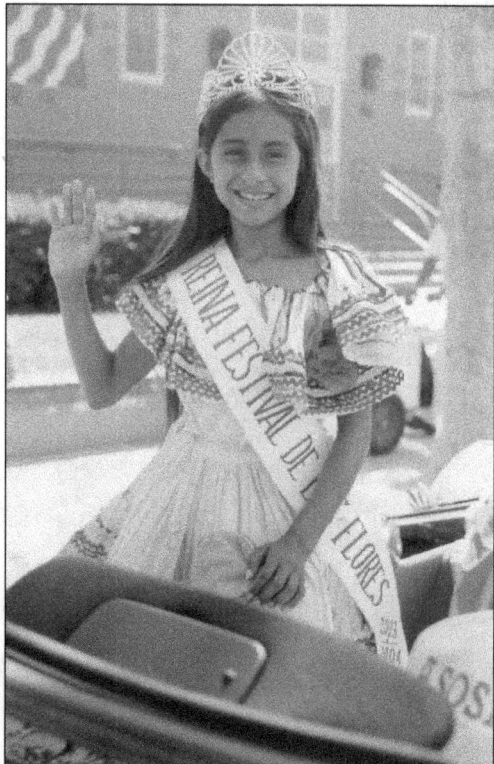

In Los Angeles, various organizations have been formed to study and preserve the Garifuna culture. The list includes the Belize Cultural Foundation, Garinagu Empowerment Movement, Garifuna Cultural Group, and GAHFU. The latter has established a resource center to maintain the Garifuna culture and a school to teach the Garifuna language and music. Additionally, the organization helps the community to build stronger family ties by bringing families together through mutual cultural identity. Above, a group of unidentified Garifuna youth is in front of Los Angeles City Hall. The children are holding flags of some Garifuna nations. From left to right, the flags belong to Nicaragua, United States, Guatemala, the United Garifuna Community, Honduras, and Belize. The colors of the United Garifuna Community are symbolic: white, for hope and freedom; yellow, for Amer-Indian; and black, for black people. (Courtesy of Garifuna American Heritage Foundation Archives.)

The services provided by ASOSAL gives the opportunity to children like the one on this picture to reconnect and to safeguard their Central American roots and to meet others who share an interest in folk dancing. These unidentified children are wearing traditional folk Salvadoran dresses and are holding El Salvador's flag. Salvadorans are usually referred to as *guanacos* in a friendly and respectful way. (Courtesy of Association of Salvadorans in Los Angeles collection.)

Sisters Marilynn (left) and Jeanine Segura are of mixed Salvadoran and Mexican ancestry. Marilynn remembers that, as a preteen, she did not like to talk about her ethnicity. Later she became proud of both of her parents' backgrounds. However, she feels that her Mexican side has been more influential on her. Today she sometimes experiences stereotyping by individuals who believe that Mexicans and Salvadorans do not get along with each other and who question her family roots. (Courtesy of Marilynn Segura.)

Frequently, second- and third-generation immigrants are bicultural and tricultural. For example, Roberto Miranda, at the left in this picture, is mixed Salvadoran and Chilean; his son Dylan Miranda Caballero has Filipino ancestry from his mother, who was born here of Filipino immigrants. Miranda thinks that his son could have a hard time identifying with his Salvadoran heritage because the Salvadoran roots have been mixed with the two other cultures. Below, Camilo Losada, left, has Salvadoran, Spanish, and Anglo ancestry; and Olympia Velasquez (center), a native of El Salvador, is the great-grandmother of Jake Sebastian Burimiend (right). Burimiend's mother is a second-generation Salvadoran, and his father is a Cambodian immigrant. (Both courtesy of Segura collection.)

Maureen (center), who is of mixed Salvadoran ancestry, explains that during her younger days, it was difficult to identify with her ethnic roots because she attended schools that were predominantly Armenian and Asian, and her Hispanic friends preferred not to speak Spanish. But now she is proud to talk about her heritage, and she tries to speak Spanish as often as she can. She also tries to teach her culture to nieces Amanda (left) and Ashley (right), who are Salvadoran and African American. (Courtesy of Williams family.)

The Villatoro sisters, Marilynn (left), RoseAnne (center), and Sandy, are second-generation Guatemalan. Sandy thinks of herself as 100 percent *chapina* because her parents always talked to her about their country and exposed her to the culture. She was able to appreciate more about their country during the family trips to Guatemala. Guatemalans are usually referred to as *chapinos* in a friendly and respectful way. (Courtesy of Nestor Villatoro.)

Marielena Castillo Ramirez is from San Jose, Costa Rica, where she met her husband, Anthon Lewis, a native of the United States. In 1967, she came to the United States and married Lewis. To stay connected with her country, the family takes annual trips to Costa Rica. Ramirez also taught her daughters traditional dances that now are being taught to her granddaughters by her daughters. In this picture, the family is photographed with their grandchildren. From left to right are (first row) Kaelyn, Kourtney, Kolton, and Kyle; (second row) Lewis and Ramirez. (Courtesy of Marielena Castillo Ramirez.)

Maria Siu, center, was born in El Salvador but resided in Honduras until 1998. Her job as a doctor in Honduras for the Standard Fruit Company gave her the opportunity to visit the United States. After becoming familiar with Los Angeles, she decided to move to California so her daughters could attend local universities. Alicia (left) attended UC Davis and Oriel (right), attended UCLA. (Courtesy of Pehdro Kruhz.)

More recently, some colleges and universities have become places where Central American-Angeleno youths search for their ethnic backgrounds, and a variety of clubs and affinity groups have been formed. Students from across California have recently formed an organization called USEU, or Union Salvadoreña de Estudiantes Universitarios (Salvadoran University Student Union). Their goals include promoting awareness of cultural, political, and social issues, preserving Salvadoran historical and cultural identity, and promoting higher education. During the first general conference held at the University of California, Los Angeles in 2008, students from different California universities, including California State University, Los Angeles; University of California, Los Angeles; University of California, Santa Barbara; University of California, Santa Cruz; and University of California, Berkeley, came together to reconnect with their heritage. Additionally, as the Central American community in Los Angeles gains recognition and influence, some universities have added curricula, teaching the history of Central American immigrants. For example, California State University, Northridge offers a bachelor of arts degree in Central American studies, and California State University, Los Angeles offers a minor degree in Central American studies. (Courtesy of Remberto Diaz.)

The influence and contribution of Central Americans in Los Angeles is well recognized abroad. President of El Salvador Mauricio Funes is another political figure who has visited Los Angeles. This picture was taken during a community forum held at Jaragua restaurant on Beverly Boulevard. From left to right are Vanda Guiomar Pignato, first lady of El Salvador; Funes; minister of foreign affairs Hugo Martinez; and Omar Corletto. In the background on the wall is a work of art by Los Angeles–based Salvadoran artist Rafael Escamilla. (Courtesy of Omar Corletto.)

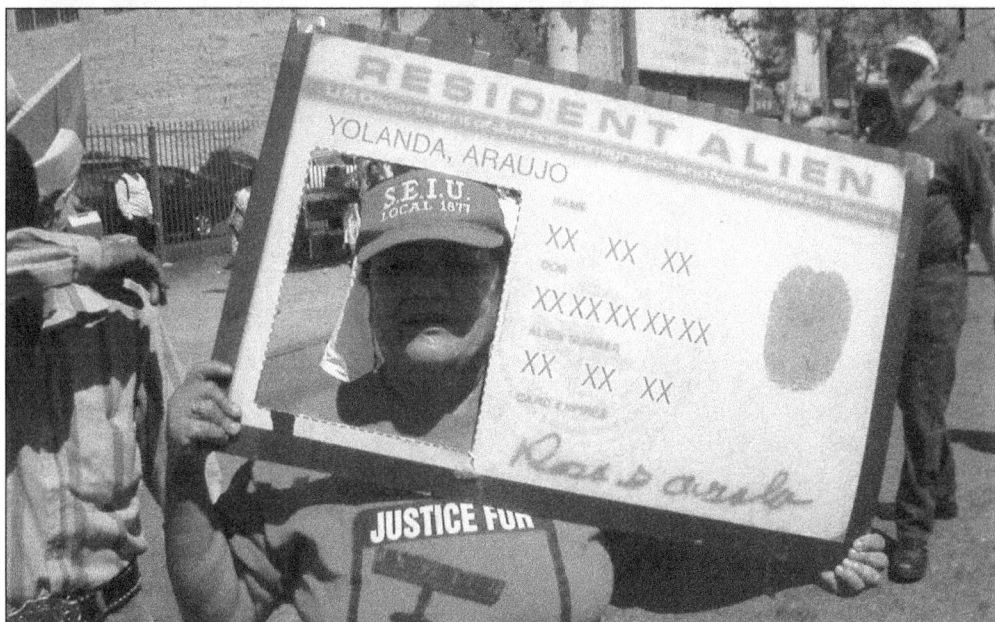

The future continues to be uncertain for many Central American immigrants. Families live in fear of being separated because some of them lack the proper documentation. This photograph of an unidentified woman was taken by Salvadoran photographer Remberto Diaz during a pro-immigrant rally. (Courtesy of Remberto Diaz.)

Pictured above, the Westlake Theatre on Alvarado Street near MacArthur Park was once a movie house gem in the area. The historic landmark opened in 1926 and finally closed its doors in 1991. Today the theater is a swap meet filled with tiny stores, selling clothing, toys, and various products. The place attracts many local Central American consumers. (Courtesy of Remberto Diaz.)

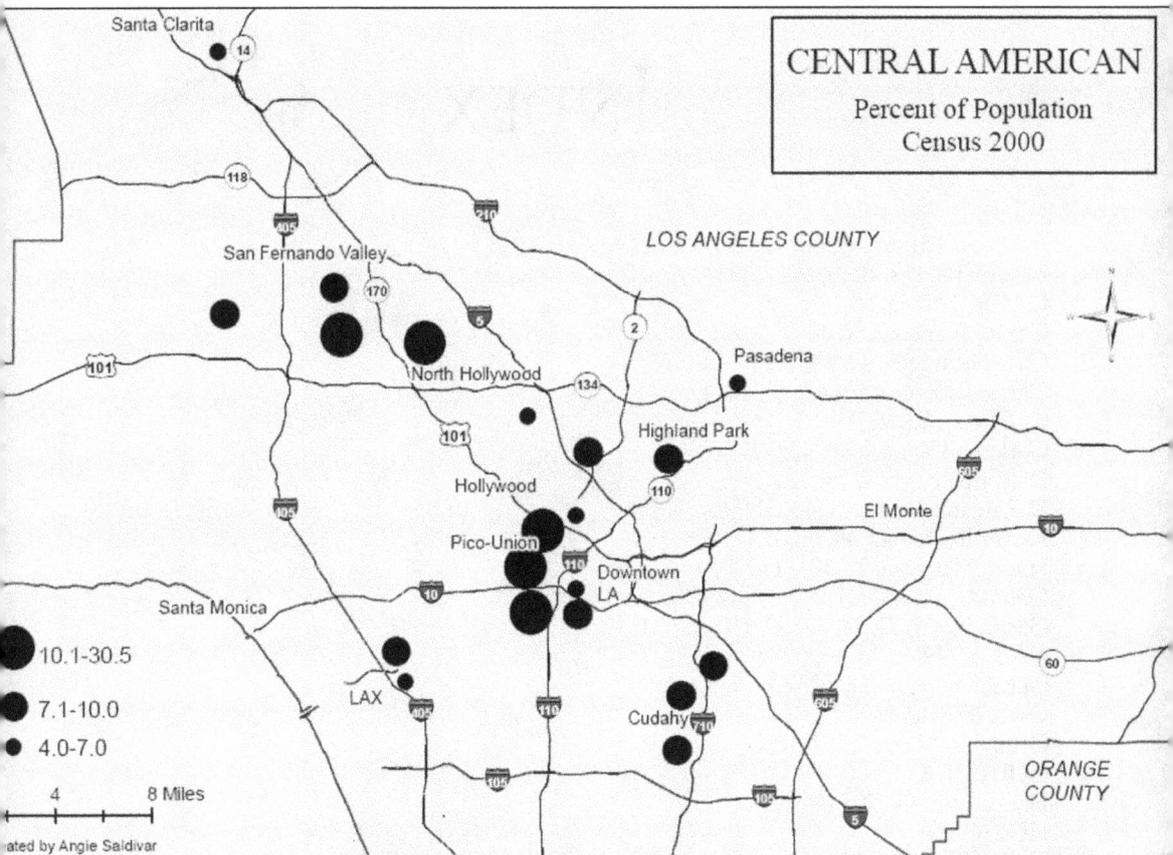

CENTRAL AMERICAN
Percent of Population
Census 2000

Santa Clarita

14

118

405

210

San Fernando Valley

LOS ANGELES COUNTY

170

5

2

101

North Hollywood

134

Pasadena

101

Highland Park

Hollywood

110

110

El Monte

Pico-Union

405

110

Downtown
LA

Santa Monica

10

405

10

● 10.1-30.5

● 7.1-10.0

● 4.0-7.0

LAX

405

110

Cudahy

710

605

60

ORANGE
COUNTY

4 8 Miles

105

105

5

ated by Angie Saldivar

The information on this map is based on the 2000 census counts. The map is a general representation of the residential areas with higher concentrations of Central Americans. However, the total number of Central Americans is higher than the figures estimated by the U.S. Census. The discrepancies are associated with several issues, including the wording of questions used by the census. For example, in the 2000 census, specific questions about nationality were not asked and other frequently used words that could have caused confusion and miscalculations were problematic terms, such as "Spanish," "Latino," or "Hispanic." Nonetheless, the areas reflected on this map are substantially representative of the current residential patterns. Much of the early Central American immigrants originally resided in the area surrounding Pico-Union; however, after these immigrants established themselves, they moved to other areas, and so increasing numbers of newly arrived immigrants tend to settle in other neighborhoods farther away from Pico-Union. (Courtesy of Angie Saldivar.)

INDEX

BIBLIOGRAPHY

Allen, James Paul, and Eugene Turner. *Changing Faces, Changing Places: Mapping Southern Californians*. Northridge, CA: California State University, 2002.

Avalos, Hector. *Introduction to the U.S. Latina and Latino Religious Experience*. Boston, MA: Brill Academic Publishers, 2004.

Chinchilla, Norma Stoltz, and Nora Hamilton. *Seeking Community in Global City: Guatemalans & Salvadorans in Los Angeles*. Philadelphia, PA: Temple University Press, 2001.

Moore, Joan and Raquel Pinderhughes. *In the Barrios, Latinos and the Underclass Debate*. New York: Russell Sage Foundation, 1993.

Ochoa, Enrique, and Gilda Ochoa. *Latino Los Angeles Transformations, Communities, and Activism*. Tucson, AZ: University of Arizona Press, 2005.

Waldinger, Roger, and Mehdi Bozorgmehr. *Ethnic Los Angeles*. New York: Russell Sage Foundation, 1996.

Weaver, Frederick Stirton. *Inside the Volcano, the History and Political Economy of Central America*. San Francisco: Westview Press, 1994.

Visit us at
arcadiapublishing.com

www.ingramcontent.com/pod-product-compliance
Lightning Source LLC
Chambersburg PA
CBHW080608110426
42813CB00006B/1440